WILL TO LIVE

WILL TO LIVE

Dispatches from the Edge of Survival

Les Stroud

with Michael Vlessides

HARPER

NEW YORK • LONDON • TORONTO • SYDNEY

HARPER

All photographs, including cover, by Laura Bombier except the following: p. 7 © Wolfgang Shuler; p. 43 © Bettmann/Corbis; p. 71 by Les Stroud; p. 79 courtesy of Douglas Robertson; p.117 © Phil Schofield; p. 141 © Time & Life Pictures. Getty Images; p. 169 courtesy of Dartmouth College Library; p. 197 Photograph by Frank Hurley/ National Library of Australia NLA. PIC-AN10932811-47-V; photo section, pp. 2–3 (plane crash) and p. 10 (rubber rafts).

The Sea Survival Kit list that appears on pages 85–86 is adapted, by permission, from F. Golden and M. Tipton, 2002, *Essentials of Sea Survival* (Champaign, IL: Human Kinetics)

First published in Canada in 2010 by Collins, an imprint of HarperCollins Publishers.

HarperCollins books may be purchased for educational, business, or sales promotional use. For information please write: Special Markets Department, HarperCollins Publishers, 10 East 53rd Street, New York, NY 10022.

FIRST U.S. EDITION

Library of Congress Cataloging-in-Publication Data is available upon request.

ISBN 978-0-06-202657-6

11 12 13 14 15 RRD 10 9 8 7 6 5 4 3 2 1

For my dad, Ron Stroud, whose last few words were
"This is my son. He's a bushman."

CONTENTS

FOREWORD

Those of us who study the kinds of survival ordeals related so powerfully and intelligently in this book would heartily agree with Les Stroud's central thesis: sometimes the only explanation for why some people survive a hell beyond hell is their steely will to live. Survival often goes so far beyond the capacity of psychologists to explain it that there is simply nothing else left to say, and experts themselves can only stand—like everyone else—in awe of the power of the human will. I have read hundreds of real-life survival stories and interviewed dozens of survivors since I began studying the subject over thirty years ago, and the resiliency, ingenuity, and toughness of these people still confounds and moves me. Sometimes survival is more poetry and mysticism than it is psychology and physiology. Les Stroud conveys this brilliantly, all while remaining true to the practical "survivorman" that he is.

The more I have studied survival, the more I have come to admire Les for his courage to do what precious few (including me) have ever willingly done: go to the edge of survival to see what he can learn and if he has what it takes, using himself as a guinea pig. Since he has been there and done it, Les Stroud's credibility is peerless. Les has not only mastered the practical science of survival (as this book and his previous one, *Survive!*,

show), he is also a master of the creative art. This book shows he is a master teacher as well, drawing lessons from people's ordeals.

In this book, Les has chosen well from the vast array of survival literature. He recounts a range of stories, from the heroic to the foolhardy, the inspiring to the informative. Very few people set out on solitary ordeals. At most, they set out to have adventures or are on journeys of exploration when things go terribly wrong. Some are merely living their lives and stumble, or are wrenched, from everyday life into living hell. Les blends accounts of these ordeals with his observations, criticisms where appropriate, and recommendations, then inserts his signature lists of practical pointers and survival kits. He adds the counterpoint of some of his own experiences, which gives further perspective to the reader as well as the opportunity to reflect.

I applaud Les for including the stories of two of my own personal heroes, who are among the most inspirational survivors ever: Nando Parrado and Douglas Mawson. In the exclusive survival fraternity where so many merit the label "hero," very few deserve it more than these men. Nando Parrado's courageous journey (with fellow trekker and hero Roberto Canessa) out of the High Andes for the entirely selfless reason of rescuing their stranded, starving, and freezing friends is not only one of the greatest survival treks of all time, but also an act of epic humanity, ranking up there with Shackleton's journey over violent Antarctic seas and then icy mountains to save his stranded men. Secondly, the survival story of Douglas Mawson, whose tale is told by Lennard Bickel in the very fittingly titled *Mawson's Will* (2000), is equally powerful. Mawson's long, cold slog out of the Antarctic while frozen, starving, and severely ill is surely one of mankind's greatest examples of surviving against all odds. If Parrado (or Canessa) is the essence of the selfless hero, then Mawson is the icon of the epic hero. Thank you, Les, for including these powerful stories.

Even though Les draws lessons from hardscrabble wilderness survival, it is clear—whether we realize it or not—that we read these accounts because, in the end, survival stories are about having what it takes to cope with life. Sure, Les gives us practical advice about making it in the real wilderness, but what we learn, too, are lessons about coping with the wilderness of Life: *Plan ahead. Get your stuff together. Think things through before you act. If you get your *** in a crack, remember that you are tough, not fragile.*

Remember, too, that you are smart; be creative—whatever stuff you have you can use in a helpful way.

Les focuses on the pragmatics of surviving extreme ordeals, but he also captures the universal humanity of those who suffer. In doing so, he finds the poetry that causes our eyes to well up as we consider what others have endured . . . and somehow managed to overcome. Ultimately, we *all* have to find our own way—and what it takes to make it in the world. Survivors are pure inspiration, role models, examples to emulate. (If Parrado and Mawson can make it through life-and-death struggles, we should be downright embarrassed by the puny stuff we complain about.) Survivors are also reassuring figures in a world of uncertainty. And the Les Strouds of the world (there are too few of them) are our reassuring guides. They know what to do and how to do it, and they remind us that inside each of us is the hard-to-encompass, mysterious, and powerful will to live.

—Richard D. Logan

RICHARD D. LOGAN is a psychologist with many years' experience studying the psychology of solitary survival. He has written several articles on the topic, some of which focused on the ordeals of Charles Lindbergh, Sir Francis Chichester, and Admiral Richard Byrd. He also wrote the book *Alone: A Study of Those Who Have Survived Long Solitary Ordeals* (Stackpole, 1993), which used survivors' first-person accounts to illustrate both the psychological effects of ordeals as well as the means of coping with them. More recently, he is the primary author of *Alone: Orphaned on the Ocean* (Titletown, 2010), the story of the four-day ordeal at sea and improbable survival of eleven-year-old Terry Jo Duperrault, who escaped the sinking yacht *Bluebelle* on which her family had been murdered.

INTRODUCTION

As long as there is an adventurous spirit living in the hearts of everyday people . . .

As long the weather proves bigger than man's best-laid plans . . .

As long as there are people more interested in getting somewhere quickly than considering the journey . . .

And as long as our species defines itself by exploring the remote regions of the world . . .

There will be survival stories to tell.

Welcome to *Will to Live*, a collection of what I feel are some of the most compelling survival stories the world has ever known. These tales run the gamut from world-famous, well-funded extravaganzas to the rarely told (yet equally fascinating) narratives of quiet determination. Yet they share a common thread: every one of them has sent my mind soaring with thoughts of how *I* would fare under similar circumstances, when life and death hang in uncomfortable balance. I may have watched *Tarzan* on TV, but Douglas Mawson was real. I may have practiced my shelters in a survival class, but Yossi Ghinsberg did it for real.

Therein lies one of the greatest problems I and other survival instructors have always faced. We rarely get the opportunity to really do

the one thing we are best at: getting caught and subsequently tested in a true survival situation. We know too much, prepare too well, rarely get lost. Yet beneath it all, our hidden desire, our secret guilty pleasure, is to one day put our skills to the test when life hangs in the balance.

So, over the years, through countless books and stories, I have filled my head with the experiences of others caught in surreal, sometimes horrific, and always life-altering situations. I did my best to put myself in their shoes. In my television series *Survivorman*, I stranded myself with minimal supplies and no camera crew (I shot all the footage myself) in some of the most remote regions on earth, usually for a period of seven days. Seven days alone to put my survival skills to the test . . . it was as close as I could get to the real thing. When I first started *Survivorman*, I expected I would acquire some new knowledge in the field. But I never imagined just how much I would learn. At each location, before setting out on my own I spent a week training with local survival experts. After several years, my expertise had grown substantially. No longer would I focus only on a microcosm of North America; the world became my survival arena.

It was then that I began to notice a change in my perspective. I started developing opinions on the various survival stories I read. I pulled lessons from them with much more confidence than before. And, most surprising—although I would never dare to compare my experience with those of other adventurers—I could on some level relate to what they were going through. When Dougal Robertson and his family talked of never getting comfortable in their little life raft as the salt water filled the bottom of the craft, I knew what it felt like. When my heroes of survival talked about bone-chilling cold, horrific dehydration, sleep deprivation, food hallucinations, debilitating loneliness, physical exhaustion with no respite, fear of forest predators, or endless hunger pains, I could relate. I had experienced them all at one time or another.

Sometimes, when I put students through particularly tough survival experiences, I caution them on one important point: they may well share their experiences with their family and friends, but no matter how patient they are or how interested they seem, their friends and family will never, ever, truly understand what they have gone through. Only other survivors will be able to really relate to their stories.

It is with this empathy as a backdrop that I came to write about the

stories I have read myself. Let's face it: nobody—and that certainly includes me—can ever truly know what the people in this book went through. I was not there. Decisions were made because they had to be made. So, even if I state that someone made a poor decision, I am doing it through the lens of time and distance. All I have to base my opinions on are the words in a book or comments from the press. Ultimately, I am in no position to pass judgment on any of the characters in this book, especially since most of them survived. And in the end, that's all that matters..

I have always preferred to describe people who endure survival ordeals as *victims*. After all, nobody went looking for the circumstances that placed them in a race against death. I also prefer to use the word *ordeal*, especially after spending so much time alone in survival situations. They were manufactured, to be sure, but they were also ordeals I had to endure. Here's how Richard Logan defined *ordeal* in his book *Alone*:

- **a situation of prolonged physical suffering, pain, and debilitation.**
- **a prolonged threat to life.**
- **the prolonged stress of fear and arousal.**
- **being forced to live with one's freedom severely confined by circumstances.**
- **having to cope with prolonged and extreme uncertainty.**
- **facing demands that constantly threaten to overwhelm one's physical and psychological resources.**

If that doesn't adequately describe all the victims in *Will to Live*'s stories, I don't know what does.

In his book *Deep Survival*, Laurence Gonzales says, "To survive you must first be annealed in the fires of peril." I don't believe this to be true. I was looking for stories of people who eventually had to employ an array of methods to keep themselves alive, rather than simply enduring an ordeal for a short period of time. I find it fascinating that these victims came to their scenarios from vastly different backgrounds and for vastly different reasons. As a result, they reacted in very different ways.

The crew of the *Karluk* and Douglas Mawson were pursuing science. Chris McCandless was searching for himself. Yossi Ghinsberg was pursuing adventure. The Robertsons were on a family vacation and looking for a new life. The Stolpas and Nando Parrado were simply en route.

Yet they all ended up with their lives in their hands. True, some of them perished along the way. But their mistakes leave a powerful legacy for the rest of us, and the lessons learned from their tragedies may prevent someone else's someday.

If, as Gary Mundell (who ran aground while sailing alone in the South Pacific) wrote, ninety percent of surviving is in the head and the difference between adventure and ordeal is attitude, then I'm interested in the other ten percent. I don't feel for a moment that Douglas Mawson would like to consider what he suffered in Antarctica an adventure. The same goes for the Stolpas, who nearly lost their lives *and* that of their infant. Looking back on their ordeal, which led to their toes being amputated, I don't believe they just had the wrong attitude. The victims in this book went through hell, not adventure, and they did not intend to be "annealed in the fires of peril."

With that in mind, I have tried to focus on the pragmatic side of their experiences. Where did they first go wrong? How did their initial reactions affect their survival? How did their actions change along the way, and were they for better or worse? What do I think they should, or could, have done? What would I have done in that situation?

Sometimes, I have been critical, as with Mawson, who taxed his energy reserves by pulling useless scientific equipment on a sled, long past the point of necessity. More often than not, I have been blown away by the apparently limitless human powers of ingenuity and inventiveness, such as Lyn Robertson realizing she could get more water into her family by giving them enemas with otherwise unpalatable water.

More than once, I shook my head while reading incredible accounts of dogged willpower to keep going, to push through, to survive, no matter how horrific the circumstances. Yossi Ghinsberg likely didn't seem like a rugged outdoorsman to his other three travel mates, but his will to live was unyielding. Nando Parrado lost his mother and sister on that mountain in the Andes and had to suffer through the grisly ordeal of eating his dead teammates, but he never lost sight of his ultimate goal: survival. These people did what they had to do in horrific circumstances. They did what they could. They used their minds and their bodies. They used their humor and their determination. They used their love and their sense of duty. They employed their will to live.

In and of itself, survival is a fascinating phenomenon. Yet, as these

stories illustrate, even more fascinating is how different people react to different survival situations. And it is these reactions that determine whether they survive or perish.

As Gonzales points out, "The first rule is: Face reality. Good survivors aren't immune to fear. They know what's happening, and it does 'scare the living shit out of them.' It's all a question of what you do next."

And what they did next is what this book is all about.

1

Alone in the Amazon

THE YEAR WAS 1982. TWENTY-TWO-YEAR-OLD **YOSSI GHINSBERG** WAS SEVERAL MONTHS INTO ONE OF THOSE MAGICAL OVERSEAS **JOURNEYS** WE ALL DREAM ABOUT AT ONE POINT OR ANOTHER IN OUR LIVES, MAKING HIS WAY ACROSS **SOUTH AMERICA.** BOLIVIA WAS SUPPOSED TO BE ONE OF MANY MORE STOPS ON THE TREK. IT TURNED OUT TO BE YOSSI'S **LAST.**

In *Survive! Essential Skills and Tactics to Get You Out of Anywhere . . . Alive*, I talked about the four additive forces at work in the struggle for survival, one of which is luck. Well, if there was ever a survivor who demonstrates how important luck, both good and bad, can be in a survival situation, Yossi Ghinsberg is that person. Bad luck saw Yossi forced to survive on his own in the uncharted Amazon jungle for nearly three weeks. Good luck? Well, let's get into the story first.

One day, in the Bolivian capital of La Paz, Yossi met with a mysterious Austrian expatriate named Karl Ruprechter, who introduced himself as a geologist and wove tales of jungle adventure for the young Israeli. Karl told Yossi he was planning a three-month expedition deep into the jungle to look for precious metals and lost Indian tribes, and offered to take Yossi along with him.

Enchanted by Karl's stories and thirsting for a taste of untamed adventure, Yossi—along with two other *mochileros* (backpackers) he had met in La Paz—agreed to join the Austrian, who described himself as a born survivor of sorts: gold miner, jaguar hunter, jungle master.

And while Yossi may have had pure intentions, he was sorely lacking in many aspects of wilderness travel, particularly when it came to planning and preparation. He was young, carefree, and looking for adventure. So when he, Kevin Gale (a burly American, legendary among travelers for

his strength and endurance), Marcus Stamm (a sensitive Swiss man), and Karl met to discuss the trip at length, Yossi ignored the hard-line details and practicalities and instead focused on the romance the trip promised.

It was an ill-fated decision, because there was a lot about Karl that should have raised red flags with Yossi: Karl often changed his story about his experience in the jungle. He first offered to lead the expedition for free, then turned around and charged the *mochileros* a hefty guide's fee. He threatened to cancel the trip because of an obligation to a mysterious uncle who supposedly owned a ranch in another part of the country. But Yossi's connection to Karl was based on Yossi's spirit of adventure, not analytical thought. So he didn't ask enough questions.

Yossi certainly isn't the first person to be guilty of this mistake. Many would-be adventurers consider planning and preparation to be an annoying waste of time, and one that only serves to get in the way of "fun." A carefree attitude may be fun in some circumstances, but the Amazon jungle is not the place to play it by ear. The experienced traveler knows that you can be prepared and still have fun and adventure. Had Yossi and his newly found friends recognized this, perhaps tragedy might not have occurred.

With a few free days before he headed into the jungle, Yossi set about informing people of his plans. He left a note with the Israeli embassy, sent a message to a local friend's family, and mailed a lengthy letter to his brother Moishele in Israel, detailing what little he knew about the upcoming adventure.

It was the right thing to do. Telling three people of your plans is the best way to make sure someone will take notice if you don't return. Most travelers, even the most thoughtful ones, tell only one person. This can be adequate, *if* that person is very close to you and is responsible. Otherwise, it makes sense to tell as many people as possible. But above all, the best strategy is to establish a firm drop-dead date for your return. If you have not gotten in touch with your contacts by this date, they must take swift and decisive action (of a sort that you and they have clearly predetermined) and either come looking for you or send out a search team.

Yossi left many of his belongings behind in La Paz, including his wristwatch. Again, his motivation was pure, as he thought he'd have no need to keep track of time or schedules in the jungle, but ultimately, it was a bad move. Yossi didn't count on being in a survival situation, where

he could have used the watch to determine travel time, or even use it as a survival tool, but there was no practical reason for him to leave it behind.

The four men boarded a flight over the Andes to the village of Apolo, where their trek would begin. Karl's plan was to hike from Apolo to the neighboring village of Asriamas, then through the jungle to their final destination, the village of Riberalta.

It wasn't long before Karl got the chance to demonstrate his expertise. Their first night out of Apolo, he impressed his compadres by improvising a shelter from bamboo and nylon sheeting (even though they had a tent) and carpeting it with a bed of leaves. Karl clearly knew how to handle himself in the jungle, but he was no leader. He was a ruffian and a drifter, one whose inability to keep the group focused on a collective goal would ultimately contribute to the trip's descent into discord and failure.

Nevertheless, their first days proved idyllic, largely because they were still within the confines of civilization. They hiked from ranch to ranch, enjoying the hospitality of locals who housed them, fed them, and treated them as honored guests. During one such stop, Karl insisted on buying an emaciated dog, which he said would protect them from jaguars once they got deeper into the jungle. The dog proved to be much more of a burden than it was worth and ultimately ran away. Karl's nearly neurotic insistence on buying the dog, despite his friends' protests, should have been another red flag for Yossi.

The first cracks in the group dynamic began to develop shortly thereafter. One morning, Karl rushed along a jungle path with Flaca ("Skinny") the dog, leaving the others behind. Yossi, Kevin, and Marcus soon came upon a fork in the trail, and only by luck picked the path that eventually brought them to the spot where Karl and Flaca were resting.

This was another Karl red flag. He was the one who knew the territory, he was the guide, and he should have known enough to wait at every junction for those trailing behind. When you're traveling in a group in the wilderness, you always need to assign a lead person and a tail person. The lead person is responsible for stopping at all forks in the trail, while the tail person ensures that nobody gets left behind and that the rate of travel is comfortable for the slowest person. In addition, all of the members of the group should always be either in sight, or, at the very least, within earshot of one another. Karl ignored this basic rule of group wilderness travel.

Four days after setting out from Apolo, the group arrived at the village of Asriamas, on the banks of the Tuichi River. There they had the opportunity to eat, rest, and replenish their dwindling food stores. Karl's plan was to follow the nearby Asriamas River upstream for a few days, then cross a range of mountains to the Cocus River. They would descend the Cocus and continue crossing mountains until they came to the Colorado-Chico River, which would then lead them to the authentic "Indian village" and the gold they sought. An ambitious plan!

With full bellies and backpacks, the four set out from Asriamas. The going was difficult from the start, and Yossi soon began to worry about the amount of food they had. Trusting your instincts is everything in survival, and Yossi was beginning to experience this instinctual characteristic of a true survivor, though he didn't know it. Karl had assured them there would be loads of game to hunt along the way, though. The jungle, he promised, was practically bursting with animals they could hunt with the rifle they brought along from La Paz.

For several days, they fell into a comfortable routine. Karl would wake before everyone else and prepare breakfast. He never asked for help and never chided the others for lying in bed while he worked. Then again, he was a loner, and likely preferred his time alone. The group had come to rely on Karl so much that they started calling him "Poppa."

And while things seemed relatively safe at this point in the journey, the cracks in the group dynamic that had begun to form before Asriamas began to rear their ugly heads again. Karl and Marcus began spending most of their time together; Kevin and Yossi did the same. Yossi was smart enough to broach the changing group dynamic with his good friend Marcus, but in the end they walked away without having resolved anything.

Never underestimate the powerful negative effect that group dynamics can have on a survival situation. Bad ones have been the cause of hundreds of emergencies. Once tempers flare and emotions rule the day, tactical reason and intelligent travel perspectives get thrown out the window. Of course, nobody wants to see their travel mates come to ill fate, but if emotion begins to take the place of reason, then stupid moves are made that can put other people's lives in jeopardy. Therefore, it's vital that groups in remote wilderness situations keep things running smoothly and that they clear the air during the trip rather than staying quiet and letting

things reach the boiling point. After all, that boiling point may be hit in the middle of a dangerous set of rapids—clearly, no place to lose focus by yelling at your partner.

At the headwaters of the Tuichi, Karl led the group on the climb that would take them over the mountains to the Cocus. Their poor excuse for a map confirmed little of this, but the group again put its collective faith in Karl. Of the many mistakes Yossi and his new friends made in going on the trip, failing to familiarize themselves with Karl's map was one of the biggest. The map was not particularly detailed—they couldn't find anything better in La Paz before they left—but, at the very least, each person should have spent some time studying it, to get a feel for the terrain.

Nobody should venture into the wild without basic map-reading skills. And if your guide is the only person in your group to have a map, don't be shy: ask to see the map as often as possible, familiarize yourself with the area and the route you are traveling. It can also be helpful to use a global positioning system (GPS) device, which uses satellites to display your location anywhere on the planet. Satellite messenger devices such as the SPOT, which use one-way text messaging and e-mail to inform your contacts of your location and progress, can save your life when things go wrong.

For what it's worth, Karl knew his way around the jungle. He taught the others how to collect water from the bamboo shoots that grew in abundance in the area; he seemed to know the geography of the area like the back of his hand; and when he shot a monkey from the treetops, he expertly built a domed structure in which to smoke the meat. Yet Karl's greatest flaw as a leader was that he taught the others very little about route-finding. Similarly, the boys didn't seem interested in learning where they had come from, or how to find their way back should something go wrong.

If the others had been smart, they would have made detailed mental notes of the trails they had been on and the ranches they had passed, the time between locations, direction, and landmarks. But this kind of meticulous attention to detail is difficult to maintain, especially when you're with a few buddies and the experience is about the adventure. Noting your surroundings is not a difficult thing to do; you just have to set your mind to it.

When I was hunting tapir in the Amazon with the native Waorani people of eastern Ecuador, I made sure to keep detailed mental records of where we had been and how I would get back to the village if need be.

I knew that anything could happen out there, and it might have been me who had to run back for help. So I played something like a reconnaissance map in my head: "Okay, I came about fifteen minutes and then turned left. Another hour and turned right. Past the waterfalls, then past the cave, then turned right again." I knew if I replayed that in reverse in my head, I could make my way back, even by myself. I wouldn't have expected Yossi, Kevin, and Marcus to do the same, but they should have at least tried to remember how to get back to the last populated village.

As Karl predicted, the journey over the mountains brought them to the banks of the Cocus River. Karl wanted to follow the river, then cross the mountains back over to the Colorado-Chico, where they could pan for gold. Although the other members of the group started to doubt the route at this point, there was little chance that Karl's mind could be changed. He was operating on sheer determination and probably figured he was quite right about things.

When this happens to the leader, the other members of the group usually put their heads down and follow along, danger signs be damned. It's a classic Pied Piper scenario. But what Karl didn't do was devise a backup plan. He seemed to have no idea what he would do if the group ran into trouble, and this played a huge role in the ultimate downfall of the trip. Planning a trip is one thing, but you should always do it with an eye toward survival, especially since the most common cause of death in the wilderness is unpreparedness.

It was also around this time that the group's collective hunger became much more acute, even though they were less than a week out of Asriamas and had been lucky enough to bag some wild game en route, including a goose, a monkey, and a sloth. Nevertheless, their reliance on hunting as their primary source of food was a huge mistake. It's one thing for a traveler to depend on hunting when there's only one mouth to feed. But looking after four grown men is another story.

It's a common mistake. Accomplished hunters who have successfully provided for themselves while alone in the bush often underestimate what it takes to feed a larger group. A sloth is a lot of meat for one man and can last a long time. Add three other adult men, and it's barely a couple of meals.

With their stores of food rapidly dwindling, their gear disintegrating, their feet beginning to rot from being constantly wet, and the route ahead

unclear, the group could not face the prospect of another grueling climb over the mountains. They decided to return to Asriamas, where they could restock their supplies and alter their plan. (In my mind, the change should have included getting out of the jungle—and away from Karl.) Once there, they discussed new options. Although Marcus wanted to return to La Paz, the decision was ultimately made to stay in Asriamas and build a raft, then float down the Tuichi River to a town called Rurrenabaque.

The week-long stay in Asriamas was good for their health. Marcus, who had developed a bad case of trench foot, healed to the point that he felt able to go along with the others rather than return to La Paz. But while their physical health may have improved in Asriamas, the respite did nothing to improve group dynamics, which continued to deteriorate. By the time they set off down the Tuichi, they had separated into two factions: Kevin and Yossi; Karl and Marcus.

The decision to raft down the river was a critical one in the evolution of the journey. But despite its importance, the group didn't seem to spend much mental energy discussing it—or its potential dangers. I suspect that by that point they were all tired and wanted to get home—a dangerous mindset to be in when you are taking on the jungle—and floating down the river seemed like a much friendlier option than hiking back to Apolo. It was an understandable position, but it set in motion the wheels of impending peril.

The group's apparent inability to anticipate the danger of the river was no doubt exacerbated by the fact that its members were no longer getting along. This may explain why they never took the time to devise a plan should things go wrong and they get separated in the vastness of the Amazon. This small gesture—anticipating the worst-case scenario and preparing for it—is almost always overlooked in situations such as these. *What do we do if we get separated? Where will we meet? And when?* I have seen situations where discussions like these have even annoyed careless and impatient people, but the fact is that they can save lives. Yossi and his mates never had such a discussion, and they paid the ultimate price.

With the raft construction complete, the group was again ready to set out. They had ten pounds of rice, eight pounds of dried beans, a bunch of plantains, some vegetables, and spices. For some inexplicable reason, Karl—who had been appointed to care for the group's finances—traded

off most of their survival gear during their second stay in Asriamas. He gave away almost all of their fishing line, all but three fishing hooks, and nine of the ten lighters they had when they arrived in the village, leaving only one (and half-full at that!) for the remainder of the journey. This did not seem to deter anyone, though, as they set off down the Tuichi for the last time as a group of four.

If anyone in the group had any nagging concerns about their lack of preparation for what lay ahead, this was certainly the appropriate time to adamantly voice their opinion and insist on beefing up their survival supplies. Nobody did, and it was only a matter of minutes before they realized they were woefully ill equipped for what lay ahead. The river's personality changed from placid to frenzied with a single bend in the shoreline, and the raft bashed from rock to rock before the four travelers were able to get to shore and regroup. They practiced a little after setting out again, and seemed to hit a comfortable rhythm, a sensation aided by the fact that they happened to be in the midst of a particularly calm section of the river once again. They pulled to shore for the evening at the top of a tumultuous section known as Eslabon Pass.

Here, Karl did the right thing (though perhaps motivated by his own self-preservation) by insisting that they portage around the pass, after which they would again take to the river. The other three were anxious to get going, though, and chose to ignore his warnings. While Karl was out hunting, Yossi and Kevin boarded the raft to take it through the pass; Marcus grudgingly joined them. The three somehow made it through the pass alive, though they lost all their oars and poles en route. Luckily, Kevin was strong enough to jump into the water and pull the raft to shore, with Yossi and Marcus still on it. They hiked back through the jungle, gathered up Karl and the rest of their gear, and returned to the raft.

The next few days followed a similar pattern: idyllic and calm, turbulent and frantic. Yet things changed forever when they approached a notorious section of the river known as Mal Paso San Pedro, a rock canyon that ends in a precipitous waterfall. Here, Karl suddenly decided he was going no farther down the river, and would instead spend a few days walking to a village he thought to be in the vicinity, where he would rent donkeys to take him back to Apolo. Marcus agreed to go with him, while Yossi and Kevin decided to take the raft through the Mal Paso San Pedro and down

the river. It may seem like a foolish decision, but it was no more risky than Karl's alternative. In fact, I think Karl and Marcus should have pressed on with Yossi and Kevin, which might have seen them all make it to safety. But the group dynamic had deteriorated so much by that point that it was almost fated that they would go their separate ways in pairs.

With the decision made to split up, the next order of business was to divide their survival gear. Land-bound Karl and Marcus took the rifle, giving the fishing gear and most of the nonperishable food to Kevin and Yossi. The machete went to Kevin and Yossi; Karl and Marcus got the tent. Early the next morning, they bade farewell to one another. It would be the last time Yossi ever saw Karl or Marcus.

Kevin and Yossi set off down the Tuichi on their raft, with a smaller life raft tied on top in case of emergency. Things went wrong immediately; as the river narrowed and the banks rose from gentle beaches to rock walls, the raft became pinned up against a rock at the entrance to the Mal Paso San Pedro. As water rushed furiously all around, Kevin decided to swim for shore, where he would throw Yossi a vine and pull him to safety. Yet as soon as Kevin dove into the water, the weight of the raft shifted and it came loose from the rock. Yossi hurtled down the river and into the Mal Paso San Pedro by himself. For what seemed like an eternity, he careened from rock to rock, until he was finally thrown over the falls and into the torrent of the river. He somehow managed to survive the drop uninjured, and miraculously found the raft floating not far away. When he swam to it, though, he was shocked to find that the little life raft—which had all the food and survival gear strapped to it in what Yossi called a "lifepack"—had become dislodged and was lost. He was now well separated from Kevin and alone in the Amazon, without a backup plan in place.

Yossi saw the lifepack raft trapped between some rocks on the far shore and made an attempt to retrieve it, but the current was too strong. So he did the right thing by improvising a shelter for himself and deciding to wait until the following day to try to rescue the raft. He fed himself that evening by uprooting a palmetto tree and eating the palm heart, as Karl had taught him. He had paid attention, and it served him well.

At this point, he had two choices: give in to desperation or pull himself up by the bootstraps and soldier on. For Yossi, the decision was clear: he would survive. And in those moments when he began to feel

hopeless, he would whisper his new personal mantra to himself: "Man of action, man of action." This was a terrific survival strategy, whether Yossi knew it or not. Repeating a phrase or a comforting thought can be a strong motivational tool in a survival situation, one that helps keep the mind focused on the positive aspects of the situation, not the desperation.

There are several other ways to bolster your will to live in these situations; most revolve around thinking about the people you love, and how wonderful it will feel to be reunited with them. Some people turn to spirituality or religion in times of great stress, and derive comfort, confidence, and strength from prayer and meditation. There is also a benefit to talking out loud—to yourself, nearby animals, trees, or rocks. This can help clear your head and put you on the road to survival.

The next morning, Yossi decided to go back and look for the life raft in the river. His innate survival instincts began to demonstrate themselves

SURVIVAL KIT FOR RAFTING

bandana	map and compass
belt knife (with sharpening stone)	marker or "surveyor" tape
bug netting	money
candle	multi-tool or Swiss Army–style
cup (metal, collapsible, for	knife (with saw blade)
boiling water)	needle and thread
dried food	parachute cord (or similar rope)
duct tape	pencil and notebook
fire-starting devices	protein bars
fire-starting tinder	safety pins
first aid kit	signal mirror
fishing lures	snare wire
flares	solar blanket
flashlight	SPOT personal tracker
folding saw	water purification tablets
garbage bags (orange)	water purifying straw
GPS unit	whistle
hand lens (small)	Ziploc bags

immediately. He was careful and meticulous in the route he chose down to the river, recognizing how dangerous it would be if he hurt himself on the way. Eventually, he made it down to the raft, where—through a huge stroke of good luck—he found the lifepack, too! Inside, he was delighted to find its contents—rice and beans, flashlight and matches, lighter, map, mosquito netting, poncho, first aid kit, insect repellent, and wallet—intact.

Yossi's ability to think clearly in an otherwise desperate situation was amazing. In his first day completely alone in the jungle, he used his red poncho to make a signal in case Kevin wandered nearby; he successfully killed, skinned, and gutted a poisonous lora snake (which he later used for fishing bait), harvested an unidentified yellow fruit from a tree laden with fire ants, and improvised a shelter in a stone wall. Yossi's response in these early stages is a classic example of how a person's individual ability can come to the forefront when the other members of the group are no longer around to overshadow it.

He began walking back toward Kevin, but his feet were in bad shape. He had begun to develop the same trench foot that had plagued Marcus for so long, only worse. To help ease the pain, he swallowed a pill from a box labeled UPPERS in the first aid kit, then made his way back up the Tuichi.

I've found that strong pain medications can be very helpful in a survival situation. I usually take Demerol with me, in case of a major pain-inducing injury like a broken femur. It not only erases the pain, but also helps calm you down, thereby preventing the shock (which can be as dangerous as the pain) that often accompanies such serious injuries. As long as you are trained in the proper use of strong painkillers (and it's vital that you are), you can get yourself through some pretty debilitating injuries.

Yet the drug, combined with Yossi's relatively empty stomach, was too much. Like a man possessed, he ran through the jungle with reckless abandon for hours on end. At one point he came to a sheer rock face. The Tuichi flowed some two hundred feet below, but Yossi—determined to find Kevin and fueled by a feeling of invincibility from the drugs—scrambled up the cliff, putting himself at great risk. At one point, he even fell off the wall, but had his fall broken by the pack on his back.

In those first few days, Yossi was often stricken with fear at the thought of the many potential dangers lurking around him, but he took

active measures to stave it off. He looked for a stick that he could use as a club or spear, an excellent choice in a survival situation as it can be used for many tasks, including protection from jaguars—the main large jungle predator. Unable to find anything suitable, he practiced using his insect repellent as a flamethrower, another brilliant bit of innovation.

Yossi settled down on a plateau not far from the river and waited for five days before concluding that he was not going to find Kevin. In the meantime, his feet began to heal and his fever settled, so waiting proved to be the perfect strategy. Too often, people ignore their bodies and try to push through the pain, when they should instead stop, rest, and take care of themselves before moving on. Five days later, Yossi was in much better condition, and he decided to walk downriver to a small seasonal camp called Curiplaya, where he hoped to find people.

As Yossi started his journey to Curiplaya, he could not stop obsessing about food, a classic reaction in these situations. I have done the same thing during every one of my survival episodes. Usually, around the fourth day without food, I start craving big, hot pieces of pizza dripping with gobs of melted cheese because my body is craving fat, and melted cheese is the perfect solution. My mind makes the connection, and dreams of pizza invariably plague me on long nights alone in the wilderness.

Yossi soon decided that traveling along the riverbank would be too slow and arduous, so he made for higher ground and meticulously picked his way up the steep mountainside that fell sharply down to the river below. After his close call on the cliff nearly a week earlier, Yossi realized that getting injured would have been the kiss of death. He was right. Even something seemingly as minor as getting poked in the eye with a branch—not to mention tearing an ankle ligament—is enough to turn someone from survivor to victim. All movements must be measured and calculated and made calmly.

Back near the top of the mountain, Yossi realized he had no idea which direction to travel, as he could no longer see the river, which had been his only reference point. Dejected, he decided to return down the treacherous slope; he seemed to have no other choice than to pick his way along the steep banks of the Tuichi. That trip had to wait until morning, though, as darkness was setting in. He was near panic when he realized there was no suitable place to find shelter and he was unable to make a

fire. He fashioned a makeshift tent from the mosquito netting, armed himself with what few items he had in his pack that he could use in self-defense, and sat nervously as total darkness fell.

A few hours later, Yossi heard sounds coming from the brush around him. He tried to ignore them, but when the rustle of leaves was accompanied by what sounded like footsteps, he turned on his flashlight to reveal a jaguar standing a few yards away, staring at him and waving its tail slowly from side to side. Yossi screamed, but the jaguar was not deterred. Near panic, he reverted to his insect-repellent flamethrower: he pressed down on the nozzle and lit the spray with his lighter, spitting out a jet of flame. When the can was empty, Yossi was scorched and temporarily blinded, but the jaguar was gone.

The next morning, Yossi was overjoyed at seeing the sun, a feeling I've experienced every time I've been on a survival expedition, when waiting all night for the dawn can be an agonizing experience. All you want is for the sun to rise, but the darkness plays tricks with time and dawn never comes fast enough. Your otherwise-helpful wristwatch can become your nemesis, too. There's nothing worse than looking at your watch and expecting to see 5 A.M., only to find out it's just past midnight. These are the lost and lonely hours of survival situations, when you feel a chill rip up your spine and realize that daylight is still hours away. It's then, more than any other time in a survival ordeal, that all you want is to be home.

With the sun up, Yossi began the trip back down to the Tuichi. The brush was too thick to show the way, so he again relied on his wits and began following streams, knowing they would eventually lead him down to the big body of water at the base of the mountain. This was another smart decision. As a general rule, following a river downstream is advisable, if you are fairly certain of what lies along the way. Following a watercourse downstream also works well in the continental United States, where just about any river will eventually lead to a town or city.

Yossi eventually made it back to the shores of the river, where he swore never again to venture into the heart of the jungle. At the rushing water's edge, he felt safer, more secure. As light faded into dusk, he came upon a cave at the edge of the jungle, another of his many lucky breaks during his time alone. Here, Yossi holed up for the evening, knowing that the cave would provide protection from the wind, which had chilled him

after an entire day of rainforest downpours. Wind is one of the most dangerous weather elements you can face in the wilderness, particularly if you're wet and already chilled, even in the jungle.

All too often, people may remember a warm summer rain and figure they can't get chilled in the tropical heat. But rain and wind can lower your body temperature to the point of hypothermia just about anywhere on the planet. At the very least, this deadly combination can lower your core temperature enough to draw precious energy reserves from your body when you need them most. Continuing to think and act like a true survivor, Yossi warmed himself by pulling his rain poncho over his head and breathing heavily into it to create a bit of warmth. He correctly recognized that you sometimes have to put up with a little hardship (in this case, claustrophobia) to protect yourself from further jeopardy.

Having now spent nine days alone in the jungle under extreme and sometimes horrific circumstances, Yossi decided to spend a day at his new campsite to rest, heal his deteriorating feet, and dry his clothes. While exploring the area, he came upon a tree, some fruit of which was lying on the ground. Getting the fruit off the tree was nearly impossible, however, until Yossi again relied on his ingenuity to solve the problem. He tied some of his fishing line around a rock and hurled it at the tree, where it wrapped around a branch and caught. By tugging on the branch, Yossi was able to dislodge quite a few of the fruits. It was a bounty for an otherwise starving man, and a whole new twist on fishing.

I am continually impressed by Yossi's survival mentality. He had an extraordinary will to live, the creative genius to solve the many challenges that were thrown at him every day, and a fair bit of luck. Of course, he was also helped immensely by the fact that he had a survival kit with him, and that he knew enough to keep himself in good physical shape.

After resting at his shoreline campsite, Yossi set off down the Tuichi toward Curiplaya. According to the map, he thought he would make it there the following day. He was right. He soon stumbled into Curiplaya. It was abandoned, but he was overjoyed to find four well-built huts waiting for him. And beds! Yes, he would sleep well in Curiplaya.

Yossi used his time in Curiplaya to plan the next part of his journey. He would walk to a town called San Jose, which he estimated he would reach in a few days. His rationale was sound: Curiplaya was used as a

It may be tempting, but deciding to eat fruit or other wild edibles you have no knowledge of is potentially dangerous, too. One way to determine whether you should indulge in a possibly life-saving food source is through the **Edibility Test**, which ensures that only small parts of the plant contact your body at one time, in slowly increasing increments. The Edibility Test requires a lot of time and effort, so make sure there is enough of the plant in question to make your efforts worthwhile. A final note: the Edibility Test is also a last-ditch effort, and does not work on all poisonous plants.

1. Test only a single plant type at a time, and don't eat anything else during the test period.

2. Rub the plant on a sensitive part of your body, such as your wrist. Wait forty-five minutes for signs of any adverse effects like nausea, hives, dizziness, or shortness of breath.

3. If no effect is detected, take a small part of the plant and prepare it the way you plan on eating it.

4. Before eating, touch a small part of the prepared plant to your outer lip, to test for burning, tingling, or itching.

5. If there is no reaction after five minutes, place the plant on your tongue. Hold it there for fifteen minutes.

6. If there is no reaction after fifteen minutes, chew a very small amount for fifteen minutes; be alert to any adverse effect. Do not swallow.

7. If you still feel fine after chewing for fifteen minutes, swallow it.

8. Wait eight hours. If you begin to notice any adverse effects, induce vomiting and drink as much water as possible. If there are still none, eat a small handful of the plant.

9. Wait another eight hours. If there are still no negative effects, you are likely safe.

seasonal camp by people who lived in San Jose, so the trail between the two places must be well marked and easy to follow. He again afforded himself a little time to rest, exploring the camp and looking for the trail that would lead him to safety. I agree with his decision to move on. It showed proactivity in a tough situation. Staying put was not a viable option.

Yossi set out the next day. The trail began wide and well marked, but soon narrowed considerably, forcing Yossi to search for machete marks on trees to find the route. He sang while he walked, another great mind trick to make you feel better and keep you motivated in an otherwise desperate situation. In a handful of my survival situations, I have either sung aloud or played harmonica while walking. It accomplishes a few things: it kills time, it gives you a focus other than your pain or dire circumstances, it can lift your and your travel mates' spirits, and it can scare off predators ahead on the trail. I use this method in thick bear territory all the time.

Yossi's confidence had grown to the point that he actually hoped he wouldn't be rescued. He wanted to walk into San Jose on his own. He soon came upon a sandy beach littered with driftwood. Still thinking like a survivor, he piled the logs into the shape of the letter Y and the number 12, representing his first initial and the date. Yossi correctly recognized that every opportunity to be proactive in effecting survival—or rescue—is golden. He rarely seemed to miss a chance to better his circumstances. Later, he stumbled upon a nest with four spotted eggs. When he cracked one of the eggs open, he was shocked to see a tiny baby bird curled up inside. He couldn't bring himself to eat it, but finding the eggs was yet another sign of Yossi's good fortune. He happened to be in the Amazon at nesting time, which provided another opportunity for food. The same thing happened to me when I spent a week on one of the Cook Islands. It just happened to be the one week when the brown boobies were learning to fly, a ritual that begins with them falling to the ground, where they waddle around helplessly. Like Yossi, I first held back on making an easy kill of the young birds. But a day or two into surviving without food, they no longer looked like cute little birds to me. They looked like dinner.

Later in the day, Yossi was extremely discouraged to find that he had been walking in circles for hours. It was a heartbreaking moment for him, but one that again illustrated his mettle. With desperation gnawing at his soul, he did not give in to the situation, but decided to make the best

of it. He would learn from his mistake and continue on. Famished and exhausted, he trudged back to the bird nest and ate the embryonic contents of each egg. He slept that night in a makeshift shelter that protected him from the incessant rain.

The next day, he was lucky enough to come across the nest of a wild chicken, brimming with six freshly laid eggs. He feasted on four of them and carefully stowed the others in his pack. Then disaster struck. Walking down a steep, grassy hill, Yossi slipped on some wet grass and impaled his anus on a dry stick. Drenched with blood, he pulled out the spear and tried to stop the bleeding, which seemed impossible. Half an hour later he began to move on again, cursing himself for having become careless. Yet Yossi's bad day continued when he stumbled through a thicket of bushes and disturbed a hornets' nest. The hornets swarmed Yossi and stung him mercilessly, until he threw himself, nearly blind and hysterical, into the river for relief. For whatever reason, this was the day when Yossi's luck turned bad, and this particular additive force in the struggle for survival no longer benefited him.

The jungle had begun to take its toll on Yossi. The rash on his feet returned with a vengeance thanks to the near-constant rain, and his clothes were in tatters. Yet he continued on, occasionally finding eggs and the odd bit of sunlight to sustain him. The thought that he would soon be in San Jose—which he calculated to be some thirty miles downstream of Curiplaya—kept him going. During these, his lowest moments, Yossi began to hallucinate and daydream, his mind's own form of self-defense from the harsh reality of his situation. These kinds of fantasies, which are extremely common among people who survive long ordeals, can go one of two ways: they either keep you going or torment you into craziness. Luckily for Yossi, the dreams kept him going.

Like Yossi, I often dream during my survival expeditions, sometimes very vividly. Usually, it's around my fourth night alone that the dreams become very real. I find myself in some wonderful place, often with my kids, only to wake up and remember that I am still sleeping in the mud. Words cannot describe how demoralizing that can be.

For Yossi, though, the dreams came at a perfect time, because his journey was now bordering on intolerable. He was constantly hungry and getting weaker by the day. Yet he trudged on mechanically through

the jungle. The trail was still visible, but often blocked by thick brush and streams that seemed to become more difficult to cross with each day's new rain. Like so many people in survival situations, Yossi also found strength in prayer and faith that someone was looking out for him.

When he finally found the place where he believed he needed to cross the Tuichi to reach San Jose, the skies opened up and a terrible storm ensued. The rain poured down all night; by morning, the Tuichi had risen dangerously and was filled with debris. It may seem incredible, but torrential rains can cause a jungle river or stream to rise fifteen to twenty feet in just a few hours. In Ecuador, I fell asleep in a hut while the rain poured down. I was awakened by a great rush of sound and ran to the river's edge, only to find my dugout canoe—which had once been on dry land—about to snap the rope that secured it to a nearby tree. It took a great deal of patience and careful manipulation to get close enough to it (now in four feet of rushing water) to be able to untie it and bring it to higher ground. Without it, I would have been stranded for good, as it was my only transportation.

Yossi lay down to wait out the storm, but soon felt water running down his back. When he got up to fix the makeshift roof of palm fronds he had erected the night before, he was shocked to see that his entire campsite was being flooded. Both the Tuichi and a nearby stream had crested their banks. In only minutes, the water was up to his waist. Yossi was almost swept away in the flood, but grabbed onto trees to keep himself on his feet. He slowly made his way, sinking in the newly formed mud with every step, to higher ground, where he found a place to spend a cold, wet, and windy night. On a survival expedition in New Guinea, I once built my shelter too close to the river, and when the rains began to teem down, the river rose quickly and dangerously. I spent the night awake, watching the flood as it came within a foot of my shelter—four feet higher than it had been when I bedded down. Luckily, it stopped there and I didn't have to go to higher ground. The additive survival force of good luck served me well that night.

Yossi awoke the next morning—*his seventeenth alone!*—and was determined to make it to San Jose. As he fought his way back through the newly formed swamp to the Tuichi, he imagined he heard a sound high above. Looking up, between the treetops, Yossi saw a small plane glide overhead. He screamed and waved, to no avail.

When you are on the ground and can clearly see the plane overhead, all you want do is yell out, "Why can't you see me? I'm right here!" But to them, you are, at best, a small speck on the ground. The smoke from your campfire may look just like the million other wisps of steam rising from pockets of water below. Your clothing is dirty and blends in with the forest, your shelter green, brown, and gray . . . the perfect camouflage. So unless you have a time-tested signal method at your disposal—bright colors, a huge, smoky fire, words spelled out in massive letters on the open ground, a signal mirror, or a perfectly timed shot from a flare gun—your chances of being seen are dependent on luck.

As the plane flew away, so did Yossi's last bit of optimism. Finally, he cracked. He threw himself to the ground and prayed for death. But as he asked God to take him, a beautiful young woman appeared before him, weeping. Yossi knew it was his responsibility to comfort the woman and lead her to safety. Once again, he regrouped and forged ahead, determined to save the imaginary woman.

Yossi's choice not to fight this hallucination and instead run with it could quite possibly be the most important one he had to make, and it speaks to Yossi's greatest strength as a survivor: he made decisions. He never sat back and waited for things to happen to him. As a survivor, you must be willing to make a decision, right or wrong, and stick with it. Survival is a proactive undertaking; there is no room for passiveness. So you must make your own decisions, or, as the adage goes, the decision will be made for you. Making your own decisions is vital, even if it means following a hallucination.

I think the hallucination represents some kind of greater inner survival mechanism that most of us don't ever tap into, let alone understand. It would seem that when Yossi had given up all hope, some part of his spirit rose to the forefront to push him along even farther. It created a focus and a purpose for him in otherwise intolerable circumstances. He was no longer fighting just for himself. He had a responsibility, if only to an imaginary girl.

He eventually made it back to the Tuichi, but there was no bank, only a bluff dropping twenty feet into the turbulent waters. Yossi decided to lead the girl back to a large beach he had rested upon a few days earlier. Here, he rightfully decided, he'd have the best chance of being seen by the plane.

This is an important tactic in any survival situation, especially if you think that people are looking for you. In essence, you must always help them find you. Being rescued is not a one-way street, it's an interactive undertaking. Your job is to do all you can to be visible to your rescuers. Finding a person lost in the Amazon jungle makes finding a needle in a haystack seem easy. On a very long drive through the jungles of Peru while shooting my series *Les Stroud Beyond Survival*, I looked out the side window of the Jeep 4x4 to a drop-off that was about a thousand feet down and completely thick with dark-green jungle foliage. This went on for hundreds of miles. If I had crashed off the road at any spot along the way, during the constant rain storms (and of course it was the middle of the night), I am confident that, without military-style infrared search-and-rescue abilities (an impossibility in the middle of Peru), I would have been lost forever.

The quest for the beach was a race against time. Yossi was physically drained, not much more than skin and bones, and his body was breaking down rapidly. His trench foot had worsened to the point where walking was almost unbearable. At times, he crawled on all fours to ease his suffering. But he continued on, determined to get the young woman to safety. As evening fell, Yossi came to a puddle of water in the mud and walked through it without thinking. In an instant, the puddle swallowed him and he began to sink. Yossi panicked and began to thrash around; that only made the quicksand take him more quickly. Now immersed to his waist, Yossi contemplated suicide, but yet another sense of determination took hold. He calmed down, regained his composure, and methodically wiggled his way to freedom. Clearly, Yossi's great supply of the first additive force of survival, the will to live, was able to override the force of bad luck.

Half dead, Yossi curled up on the jungle floor for the evening, wrapping himself in his poncho and mosquito netting, convinced he would be rescued the next day. Sometime during the night, he realized he needed to urinate, but was too exhausted to get up. With no other choice, Yossi relieved himself in his pants. He enjoyed the feeling of warmth so much he did it twice more during the night.

As the night wore on, Yossi was startled by something pinching hard into his thigh. He reached down to the spot to find that what he thought was an ant had dug into his flesh and would not let go. Yossi killed the creature, but was startled by more bites down his legs. He began to fight

like a madman, but the biting continued incessantly. All night long, he was overwhelmed by what he thought were ants. They came at him from all sides. They bit his face, the back of his neck, his chest, waist, and legs. One even took several bites of flesh from his rotting foot before Yossi was able to kill it.

As morning dawned, Yossi pulled himself to a sitting position and was horrified to find that the earth around him was teeming with thousands of swarming red termites. They had been attracted to Yossi's urine, eaten through the mosquito netting and poncho, and latched themselves onto anything they could find, including Yossi's flesh. Horrified, he shot up and ran from the spot, crunching termites under his feet. This is a perfect example of how just one brief moment of giving in (urinating in his pants) can snowball into something quite horrible. In a survival situation, you must measure every action carefully to make sure that it won't turn into something you'll regret later.

HOW TO GET OUT OF QUICKSAND

Getting caught in quicksand or mud is only worsened when you struggle to free yourself of the muck and mire. You can't win a frantic struggle in quicksand, so each movement must be slow and calculated. Imagine trying to get yourself out of the deep end of a pool without using your hands, instead employing a rolling movement across the water. The same is true in quicksand and mud: straight up and out is nearly impossible. Rather, the path to safety lies in keeping your body flat and rolling across the surface with your feet behind you, not dangling below. It's very similar to getting yourself out of a frozen lake when you have broken through the ice. Roll with your chest until you are on safe ground.

Yossi stumbled and crawled through the jungle, determined to make it to the beach, where he would either die or be rescued. Later that day, he came across a beach, though not the one he had been seeking. Nevertheless, it had a hut in the middle of it, in which Yossi collapsed. After an hour of rest, he explored the beach, and was shocked to find that he was back in

Curiplaya. The place was radically different than when Yossi had last rested there, though, as the floodwaters had washed away most of the huts. He spread his poncho out as a signal and set to the task of tending to his rotting feet, an agonizing task given that they were little more than festering, skinless flesh at this point.

Yossi lay in the hut, contemplating his fate. Death was certainly an option, but having survived nineteen days alone in the jungle, he began to realize that perhaps he could do more, particularly if he stayed put. Maybe, just maybe, he could survive an entire season until the San Jose residents returned to camp in Curiplaya.

He was roused from his plans by a distant drone. He did not get excited, though, as he was convinced he was hallucinating yet again. But when the drone grew louder, Yossi could ignore it no longer. He got up and staggered out of the hut. Getting out of a canoe on the beach were four figures. One of them was Kevin. And while Yossi may have hallucinated the young lady who accompanied him on the trip back to the beach, Kevin was 100-percent real.

After their separation at the Mal Paso San Pedro, Kevin had scoured the banks of the Tuichi for a couple of days looking for Yossi. With no sign of his friend, he floated down the river on a dried balsa log. He floated past Curiplaya and was on his way to San Jose when he spotted two men hunting in a tributary stream. They led him back to San Jose, where Kevin hoped to find Yossi. Nobody in San Jose had seen Yossi, so Kevin hired raftsmen to take him down the Tuichi to Rurrenabaque, where he again hoped to find his friend. People there told him Yossi had no chance of surviving the waterfall over the Mal Paso San Pedro, and even if he did, he would have starved in the jungle.

Undaunted, Kevin took a flight to La Paz, where he began to work the bureaucratic machinery of the Israeli embassy and Bolivian government. Precious days later, he finally convinced government officials to begin a plane search for Yossi. Every step of the way, officials assured Kevin there was little, if any, chance of finding Yossi alive. The plane search proved futile, but Kevin pressed on. He returned to Rurrenabaque, where he hired a local man, Tico, to boat up the Tuichi as far as the Mal Paso San Pedro in search of Yossi. The going was slow because of all the debris that now floated down the river, but Tico was a master navigator.

Day turned to evening, but there was still no sign of Yossi. Tico was disappointed, but he informed Kevin that they had to turn around at the next suitable beach and head back to Rurrenabaque. As the boat began to turn around, Kevin was astounded to see what seemed like a corpse emerge from a dilapidated hut: Yossi Ghinsberg.

YOSSI GHINSBERG

ELEMENTS OF SURVIVAL

Knowledge 5%
Luck 20%
Kit 15%
Will to Live 60%

Yossi was a true survivor. He was hampered on many fronts. He had almost no knowledge of the Amazon, or how to survive there. His kit was adequate and helped him on his journey to survival, but it was certainly lacking many critical elements. Luck was so-so, as it sometimes ran bad and sometimes good, though having Kevin stumble upon him on the beach was a near miracle. Yet Yossi did not let any of this get in the way of his intense and overwhelming will to live, the one factor that ultimately brought him back to safety—alive.

2

With the Waorani

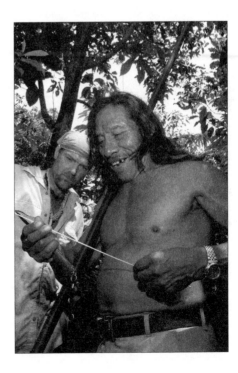

My introduction to jungles came through classic Tarzan movies. Those films may have been black and white, but in my imagination the jungle glowed in Technicolor: thick, green leaves drooping everywhere, steamy jungle vistas shrouded in gray fog, the echoes of multicolored birds ringing through the canopy high overhead—that's my version of paradise. This time, though, the jungle will be my reality. For the next seven days, I'm going to try to survive alone in the Amazon.

Having never really paid attention to high school geography (after all, they made us study iron ore extraction in Pittsburgh!), I've lived with two assumptions about jungles. One: you have to be wealthy to consider going to the jungle. Two: wherever they are, they are a lifetime away. It never occurred to me that so many vast, thick rainforest ecosystems could exist so close to my home in North America. The Amazon basin stretches from the northern part of South America to central Brazil in the south, with the Andes on the west and the Atlantic coast on the east. The Amazon River is the epicenter. I'm headed to the eastern Andes of Ecuador, the headwaters of the Amazon.

It's a six-hour taxi ride through the eastern Andes from Quito to the small, edge-of-the-jungle air base in Shell. Flying out of Shell is a risky venture. The only safety-conscious and experienced pilots are the missionaries, but they're not permitted to fly anyone who isn't associated with

their missions. Enter anthropologist and linguist Jim Yost. He lived with the natives in this area for ten years and is one of only half a dozen people in the outside world that can speak their language. He also has connections with the missionaries, so he helps me arrange a flight deep into the headwaters of the Amazon River, where I will be a guest of the Waorani.

The Waorani are considered one of the most violent peoples in the history of civilization. In former times, sixty percent of adult male deaths were homicides, mostly revenge killings. Most of the killings came at the end of a spear, often in the dead of night. The perpetrators will sneak up on a hut, burst through the thatched grass walls, and drive a spear into someone's chest as he sleeps. In the 1950s, this remote area of the Amazon became infamous when five missionaries were massacred by the Waorani.

What happened after the massacre makes for an even more incredible story. The wife and sister of one of the slain missionaries moved in with their relative's killers and brought them Christianity. The Waorani were profoundly moved, and the tribe embraced the concept of forgiveness. Since then, that concept has spread and the entire culture has begun to evolve from one of violence to one of understanding. As I contemplate my stay with this tribe, I realize it's still a relatively new development for them.

It takes only a few minutes in the air to leave what, to me, looks just like northern Ontario: large expanses of untrammeled bush broken up by roads, dwellings, and mines. But we are soon flying over a vast expanse of dark green jungle that stretches quite literally as far as the eye can see. Somewhere down there, I'll be left alone for a week.

Our destination is the Waorani village of Snake River. From the sky, I can make out a tiny grass airstrip in the middle of the dense forest. Jim Yost, photographer Laura Bombier, and I are about to enter a land lost in time.

The entire village comprises eight huts peppered over two acres of barely tamed rainforest encircled by a chain-link fence that was freed from an abandoned oil company camp and now serves as protection from jaguars. Most of the huts here were made with milled wood, courtesy of the Norwood sawmill shared by this and five other villages in the area. Eight families inhabit the eight buildings. The roofs are made of corrugated tin, also liberated from abandoned oil camps. The ground is a combination of hard-packed mud and rooster and dog droppings. Beyond the chain-link fence lie hundreds of miles of mosquito-filled, snake-slithering, jaguar-

prowling, spider-crawling, ant-infested, wasp-buzzing jungle heaven!

Waorani etiquette dictates that, after disembarking the plane, you wait on the edge of the village until you are invited to enter, even though the huts are a mere ninety yards from the airstrip. This tradition could see you standing there for many hours, if not all day, until some elder decides to give you the thumbs-up. Fortunately for us, they are excited to have visitors and to see their old friend Jim, whom they call Warika.

Six Waorani help us with our gear, and we walk across a small wet area where we are cautioned to watch for snakes. Over ninety percent of all adult Waorani have been bitten by snakes—deadly snakes. We look down often.

The only sanitation in the village is a lone outhouse situated right in the middle of the village, the only spot not protected by fences. Unbelievably, it actually has a flush toilet, courtesy of a hose tapped into a distant stream. In anticipation of our arrival, the villagers have built a traditional hut with a thatched roof. Once the mangy dogs and the rooster are kicked out, it becomes our home.

The first order of business is to hang our hammocks. Now, I can totally relate to the comfort and beauty of sleeping in my hammock at the cottage on a lazy weekend afternoon, but the thought of spending more than twenty nights curled up in one makes me wonder if I will get any sleep at all.

After settling in, Jim climbs into his hammock and waits. For what, I'm not really sure, but Laura and I do the same. Perhaps it is hammock practice time? The only activity for the next few hours—other than trying to get comfortable on a thin piece of nylon stretched between poles—is trying to relate to the three little girls who will become our constant companions during our stay in the village. They dare each other to inch closer to me to see if they can poke this odd-looking stranger from behind. They are all under age seven; two of them have never been out of the jungle.

There are 1,700 Waorani living in an area covering more than eight thousand square miles of thick jungle. Most of the villages are slowly becoming modernized. A few of them have electricity from diesel generators; some even have sanitation and running water. Each village is a hard one-to-four-day hike from the next.

But a stay in a fully equipped village doesn't make for a great survival story, so I've elected to go primitive and stay with a splinter group of a few

families that, believe it or not, long for the old days. No, they don't want a return to the violence and killings, but they do want to return to jungle ways, where days are spent hunting for monkeys with a blowgun or wading in the streams with fishnets in hand.

There is yet another splinter group that was somewhat less inviting. Years ago, a group of Waorani natives took off into the jungle, just over a day's paddle downstream. The Tagaedi, as they are now called, are one of nearly seventy tribes that live deep (much deeper than I currently am) in the Amazon. No one who has tried to contact them has ever come back alive. To make matters even more intimidating for me, only three weeks before our visit, some of the Waorani from another village went down and killed sixteen Tagaedi. Hostility and tension fill the already thick jungle air. I realize I am about to be alone for a week in a territory rife with retribution.

Our village is a much different story. We have a number of hosts, none of whom speak English. Badiana is a thirty-year-old woman with a wonderfully sweet disposition. Kinta and Ippa, both about fifty, are the main organizers of the village. Tomo and his wife, Anna, both over sixty, have come up from their own, even smaller, village farther downstream to be here for Jim. And then there is Duey. He is one of the Waorani who massacred the five missionaries by spear. I could be greatly intimidated, even afraid, but before my time here is finished, I will find it as gut-wrenching to leave these people as I would my own family.

As my guide, Tomo will become like a brother. His appearance is striking. His skin is like leather and his toes are splayed out wide from walking barefoot in the jungle his entire life. In fact, the Waorani only started wearing clothes because outsiders were uncomfortable with their nakedness and they had grown weary of the staring. Clothing in the jungle rots quickly, and not much will last beyond a few weeks. Nakedness wasn't simply an aesthetic choice, it was a practical matter. For the Waorani, to wear one lone string around the waist is to be considered dressed; the absence of the string is shameful nudity. Men tie the string to their foreskins to pull their penises up and out of the way when tromping through the jungle.

In the jungle, the night closes in quickly. There are no sunsets, no big skies. Some would find it claustrophobic, even creepy. Not me. For me, the night lies heavy, like a thick blanket, and the sounds are amplified, even ear-piercing. Over there, a frog croaks. Behind me, a night bird calls. Not

far off, a puma growls. Somewhere out there, probably within a stone's throw, a jaguar's large paws tramp the jungle floor.

Jim, Laura, and I are mellowing out as we lie in our hammocks, waiting for the Waorani evening meal to begin. Not many people visit the Waorani. Missionaries, anthropologists, and the odd magazine writer will go to the effort to come this deep into the heart of the Amazon. But we are different. The Waorani know I want to survive a week alone in their jungle, a desire that prompts ongoing jests about what a great meal I'll be for the jaguar. I tentatively join the laughter, until I am told that the Waorani will do anything to avoid being caught alone in the jungle at night.

Okay, so they consider us crazy. But we also have a woman in our group, something the Waorani find even more fascinating. Few females venture this far into the jungle. Badiana thinks Laura is absolutely beautiful and is so happy to have another woman to connect with, if only through hand signals.

Though we have brought our own food, Anna and Ippa are only too happy to feed us—constantly, it seems. Mostly it's manioc, a root much like potato, along with whatever is caught that day, usually some kind of fish or bird. But the treasured treat is manioc drink. First, the root is boiled and mashed by hand. Then the mash is chewed by female village elders before being spit back into the bowl. The saliva begins a process of fermentation, and the mixture is left to sit overnight. The next morning, it is mixed with hot water and ready to drink. You are expected to guzzle, not sip, your old-lady-chewed, slightly fermented drink, as sipping is considered an insult. It is also an insult to put down your food bowl once you have picked it up.

My concerns that it would be inconvenient for the Waorani to feed, house, and guide us are quickly put to rest when Jim explains that it is, in fact, their honor. They are thrilled that someone cares enough to want to learn and experience their traditional, and quickly disappearing, way of life. Jim himself is like a legend to them; some of the younger Waorani even come into the hut just to get a glimpse of the famous Warika. During the ten years that Jim and his wife, Kathy, spent living among the Waorani, he became an indispensable part of helping the Waorani achieve ownership of territory in the jungles of Ecuador. Tomo respects and cares for Jim greatly, but when Duey arrives later that evening, the love and friendship is even more evident.

Waorani don't have words for hello or goodbye, so Duey simply sheds tears as he hugs Jim in greeting. Duey has walked for a day and a half through thick jungle just to see Jim. It was Duey who organized the men and women of the tribe to come into our hut to sing for us this first evening. It is by far the crudest, most rudimentary form of music I have ever heard. There is only the faintest hint of form or melody, and no pitch or tuning at all for the rustic percussion instruments and flutes. Each song is a repetitive chanting of one or two lines of lyric. It is beautiful. I sit in the firelight as seven Waorani treat us to their traditional storytelling songs. I breathe deep and hold back tears. The honor is purely ours. In the middle of the night, I am awakened by Duey chanting and praying in a loud voice. Jim explains that this is a holdover from his days of existing as part of a more violent culture. You stayed awake in shifts and talked and sang so that your enemy knew you were awake and couldn't attack you by surprise.

The next day, after our breakfast of manioc, we wait patiently in the hut, hanging around, literally, in our hammocks while the rain falls. It rains nearly every day here, usually for many hours, and often as a downpour. Once the rain stops, the sun beats down through any small opening in the jungle canopy like a fiery hammer on your head. Before long, our hosts arrive; my training is about to begin. Kinta and Ippa wear traditional clothing on their upper bodies: leaves and feathers on their heads, woven plant fiber and decorations around their necks.

My first lesson is in the art of hunting by blowgun, a survival priority. If you can't hunt or fish, you can't survive. Village kids can point a two-yard-long blowgun heavenward and hit a hummingbird sixty yards away. I practice on coconuts, and Tomo cheers every time I hit my mark. Maybe I'll survive in the jungle after all!

Tomo has his own near-death story to tell. He once hit a monkey with a dart from his blowgun. As it fell, the monkey got caught on a branch. Tomo climbed seventy feet up the tree to knock the monkey down. High up in the jungle canopy, he grazed a small poisonous caterpillar. The toxic shock was so powerful that his whole body was jolted out of the tree and he fell to the ground. He was taken to the village hospital, where he remained for three weeks. His entire body turned completely black from the caterpillar toxin. Things were looking grim when an entomologist was found in Brazil who not only recognized the poisoning but had developed

an antidote. Tomo's life was saved, and he hadn't broken a single bone.

The Amazon is home to countless millions of poisonous snakes, spiders, frogs, ants, bees, wasps, fish, and caterpillars. Can I survive here? Many of the survival methods I teach in North America are backward in the jungle. In North America, for example, you never stand on or jump off a log for fear of breaking an ankle. In the jungle, however, you always stand on logs before you cross them, because most poisonous snakebites occur when you step over the log, oblivious to the snakes hiding on the underside. I also learn to tromp heavily, as the vibrations will often cause the snakes to slither out of your way.

My next tutorial involves net fishing in the small, muddy jungle streams. This time, the women take over as my teachers. As Anna shows me how to shove my net deep into the muddy water to corner the fish, Laura, who was busy trying to get some video footage, falls backward into the murky stream. When she surfaces, the first words out of my mouth are "Is the camera okay?" Everything we do, we do as a group, including laughing together.

It is the night before I am to set out on my week-long survival test. Tomorrow, I will be deposited in the heart of the jungle, alone. Before sleeping, I take my satellite phone out to the airstrip to call home. It is my only link to the outside world, and on this night I need to hear familiar voices. Instead, I hear a low growl from about sixty yards away in the pitch-black jungle. I make a beeline back to the hut. The growl belongs to a full-grown puma that has been hanging around the area.

Sleep proves difficult. I'm more anxious about this survival stay than any other, yet I'm also exhilarated; surviving in the Amazon jungle is my personal quest. Bug screening covers my hammock. This is good, given that our hut is filled with annoying, biting gnats. Also, the alternative—sleeping on the floor while thousands of army ants and the odd tarantula crawl over me—is worse. Before we embark in the morning, the elders ceremoniously paint my back and arms with ink made from plant dyes. I am immediately swarmed by bees. They, along with wasps and butterflies, will be my constant companions for the next seven days.

My greatest insect foe, though, is a huge, two-inch-long ant they called the *manyi* (or bullet) ant. It has a monster-sized set of chompers on the front end and a massive stinger on the rear. A sting from one of these

ants is said to feel the same as jamming a pair of red-hot pliers into your skin, twisting it hard, and holding it there. The pain doesn't diminish for at least five hours. The Waorani fear this bite more than snakebites, yet I'm amazed when one of the kids skillfully catches one for me using a small piece of grass twisted like a noose. In the days to come, I will step barefoot beside at least six of these devils.

I will also plunge my hands deep into muddy riverbanks in search of catfish, praying I don't instead get a handful of electric eel—or a freshwater stingray, the most feared creature of all. I will suspend disbelief and do a number of things that go against all my instincts. But this is jungle-style survival, and all bets are off. My crew, including paramedic Barry Clark, will wait for me back in the village, just in case.

On day six of my week alone in the jungle, I go for a short walk to relieve myself at the end of the day while the sun is setting. I look up to see a huge spotted jaguar not more than fifteen yards away. Concentrating on slowing my breathing and keeping the monster cat in sight, I slowly make my way back to my bush camp. I hadn't planned on following the jungle trail home until tomorrow, but this unexpected visitor is reason enough to cut this adventure short. I don't mind suffering for my art, but I'm not interested in getting eaten for it.

The sun is setting and darkness falling fast as I start to pick my way home. The trail is small and tangled, and I use the video camera's night-vision function to guide my way. I set a quick pace, constantly searching for the jaguar. The big cat stalks me all the way back to the village.

After what seems like an eternity, I come to the edge of the airstrip and hastily make my way into the fenced enclosure of the village. I've made it. Barely.

Later that night, as I lie exhausted and spent in a hammock that now feels like the ultimate in luxury, Jim wakes me up. "Listen," he says, and motions to the side of our hut. Clearly audible is the growl of the jaguar; he will continue to circle the village all night. The next day, Kinta hikes out to where I first saw the big cat and tells me that, by the size of the prints scattered all over the equipment I'd left behind, he is a 250-pound male.

Although *Survivorman* is now part of my past, people always ask what my favorite location was. Suffice it to say that I have never been so profoundly affected and full of awe as I was in the Amazon, the land of Waorani.

"I Will Not Die on This Mountain"

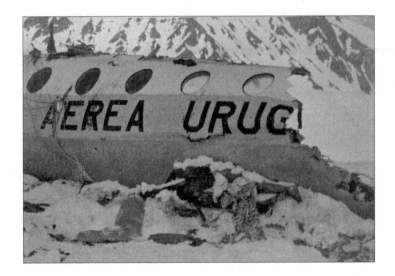

IN THE **PANTHEON** OF SURVIVAL STORIES, THERE ARE THOSE THAT STAND TALL AMONG THEIR PEERS AS TRULY EPIC, STORIES THAT ARE SPOKEN OF WITH AWE, EVEN AMONG THOSE WHO HAVE LIVED THROUGH THEIR OWN ORDEALS. THE STORY OF **NANDO PARRADO** AND THE FORTY-FOUR OTHER PEOPLE WHO BOARDED A CHARTER FLIGHT FROM **MONTEVIDEO**, URUGUAY, TO SANTIAGO, CHILE, ON OCTOBER 13, 1972, IS ONE OF THOSE. FOR MORE THAN TWO MONTHS, THEY ENDURED SOME OF THE MOST HORRIFIC CONDITIONS **IMAGINABLE** BEFORE TWO AMONG THEM MADE A FINAL, DESPERATE **TREK** INTO THE HEART OF THE ANDES TO TRY TO FIND HELP.

Along with some friends and family, Nando Parrado and his fellow members of the Old Christians Rugby Club were on their way to Santiago to play an exhibition match against a Chilean team. Spirits were high as the players, most in their early twenties, boarded the Fairchild twin-engine turboprop for the three-and-a-half-hour flight across the Andes. But when the pilots heard of bad weather in the mountains ahead, they decided to set down for the evening in the small town of Mendoza, just on the eastern edge of the great mountain range. The weather had not improved significantly the next day, and the pilots struggled to make a decision. Nando and his teammates, full of the piss and vinegar that so often defines young athletes, jeered the pilots for not daring to attempt the passage across the mountains. Eventually, the pilots acquiesced, and they took off shortly after 2 P.M. on October 14.

The flight was uneventful at the start. The boys laughed, played cards, and marveled at the vastness of the Andes below them. Here was a mountain range like few of them had ever conceived of, let alone seen. Given that some of the mountains in the range easily eclipsed the maximum cruising altitude of the Fairchild (22,500 feet), the pilots had charted a course through narrow Planchon Pass, where the ridges were low enough to allow passage of the craft.

Yet, as is often the case in these situations, the break in the weather that the pilots had hoped for never materialized, and the steward was soon asking the passengers to fasten their seat belts due to approaching turbulence. The Fairchild pitched and moaned in the ferocious wind, and at one point lost several hundred feet of altitude in a matter of seconds. When the cloud cover stubbornly refused to lift, the pilots were forced to rely on dead reckoning for navigation. Nando leaned forward to comfort his mother, Eugenia, and sister, Susy, who were accompanying him on the trip. Seconds later, Panchito Abal, one of Nando's best friends, pointed out the window. Through the sporadic break in the thick cloud they could see the dark walls of the mountains flying past, not more than fifty feet away. The engines whined as the plane tried desperately to climb. Seconds later, all hell broke loose.

The Fairchild careened off the mountain and the fuselage split into two pieces, with the tail section falling away. Everybody sitting behind Nando was lost immediately, including one of his best friends, Guido Magri. Miraculously, the front section of fuselage hit the snow at almost precisely the same angle as the slope itself, preventing it from disintegrating on impact. Instead, the severed plane careered down the icy mountainside like a runaway toboggan at speeds near 200 miles per hour.

The fuselage eventually slammed into a snow berm, partially crushing the nose of the craft and dooming the pilot and copilot. The force of the impact ripped all the remaining seats from their anchors and hurtled them to the front of the plane, killing several of those who had survived the initial impact. All told, thirteen people were already dead once the plane came to a fitful rest on the side of what is now known as Mount Seler.

Nando lay unconscious as the others began their survival ordeal. Gustavo Zerbino and Roberto Canessa, both medical students, took stock of the living. Amazingly, some of the players had suffered only minor scrapes and bruises, while others had far more gruesome injuries. Enrique Platero was impaled by a steel pipe during the crash; when Gustavo pulled out the pipe, a few inches of Enrique's intestine came with it. The calf muscle on one of Rafael Echavarren's legs had been almost completely torn off the bone and was dangling around the front of the leg.

Almost instinctively, Marcelo Perez del Castillo assumed his position as leader of the group and earned his C as team captain. He was brilliant

in the early moments after the crash, organizing the uninjured and setting them to work to help the others. This was the perfect response, because it was action—proactive action, which is vital to making it through any kind of survival ordeal. Action immediately dispels panic, which can be horribly contagious in grim situations. While you might almost expect panic to have occurred, it didn't. I believe Marcelo was instrumental in keeping this runaway emotion at bay, which in turn likely helped save lives. It gave people something to focus on other than the sheer terror of their circumstances.

Now came the first of many difficult decisions the survivors would have to make: who would get attention first and who would be left to possibly die. In other words, triage. Search and rescue teams receive extensive training on what kind of victim is most likely to survive an accident; these people receive attention first. Gustavo and Roberto did the same, working their way through the plane, determining which victims they would spend their energies on and which were too close to death to warrant aid. The dead were removed from the fuselage and moved outside; the injured were carried gently out to the snow while those fit enough for work set to the task of clearing the debris from the plane. Though they may not have realized it at the time, the decision to move the injured out into the snow was brilliant. The cold began to dull their pain. Anyone who has ever iced an injury knows that, once the pain of the cold eventually subsides, the pain of the injury does as well. This move certainly slowed the metabolic processes of many of the injured, thereby improving their chances of survival.

Marcelo proved his natural leadership—and survival—abilities in those frantic early hours in more ways than one. Having organized the healthy into work crews, he then set his mind to assessing the reality of rescue. Marcelo realized that, since the plane had crashed late in the afternoon, there was no way rescue crews would find them before the next day, at the earliest. With this in mind, he realized that his next step must be to ensure that he and the others survived the night perched on the side of the icy, windswept mountain.

To make the survivors as comfortable as possible, Marcelo and the others who were healthy cleared space inside the fuselage. He then assessed the structure of the plane itself, and took another brilliant proactive step. He realized that, while the fuselage would provide protection from the elements, it was full of holes, particularly a gaping one at the rear,

where the tail section had ripped off. He organized his friends to seal these holes, to prevent the frigid (below -20°F or -30°C) air from ripping through their flimsy shelter, and even to build a wall of snow at the far end of the plane. Were it not for this last bit of leadership, few would have lived to see the next day.

A long and brutal night ensued for the survivors, most of whom had never experienced any kind of cold, let alone the kind of bone-numbing temperatures found high in the Andes. As morning dawned, Marcelo was first on his feet, rousing the others to action. He coaxed the living to keep faith. He was convinced that rescue was no more than a day away, but he didn't let that get in the way of his survival instincts. He directed the others to gather up any food they could find scattered about the craft, and began to carefully ration it among the survivors. Meals became little more than a square of chocolate or smear of jam washed down with a mouthful of wine. This was not an easy decision, but it was certainly the right one. As difficult as it may be to steel yourself against the pains in your stomach, the practice of rationing is one that should never stop in a survival situation.

Coco Nicholich was put in charge of the cleanup crew—another important early decision by Marcelo. It not only ensured that people remained focused and occupied, but ensured a tidy survival site. The Cree people of northern Quebec, when living in the remote northern bush in winter, meticulously clean snow off their clothing before coming in from the cold. Every snowflake is removed from their outer clothing and brushed from their footwear. The alternative is to see the snow melt, and getting wet in temperatures that can sink to nearly -60°F (-50°C) is a dangerous thing. The rationale is really quite simple: a clean and organized survival site (or camp, in the case of the Cree) is an effective survival site. You don't waste time looking for things. You maximize usage of space. You are as comfortable as possible. Bottom line: it makes you feel better.

Coco also helped keep his friends' spirits buoyed by telling jokes and stories, a great way to boost morale.

While on a six-day adventure race, my team and I were beginning to hit a mental and physical wall in the middle of the night as we pushed through thick forest. It occurred to me that it was my turn to bolster our collective spirits, so I began to sing. I soon stopped, thinking that I might have been annoying my teammates, but they called out in unison for me

to continue. Whatever your party trick is, whatever skill you have, it may be employed to keep up the spirits of those caught in the ordeal with you.

Nando was among the most seriously injured in the crash. For three days he lay in a coma, the result of a head injury he suffered upon impact. Once he regained consciousness, though, it didn't take long for stark reality to slap him in the face. As he opened his eyes for the first time in more than seventy-two hours, he put a hand to his injured head and was sickened by the spongy feeling under his fingertips: he was pressing pieces of shattered skull into his brain. As he looked around the plane, Nando observed that, while he and his friends seemed able to cope well enough with their situation during the brightness of day, with darkness came misery. As the survivors lay there cold, alone, and forlorn at night, some wept with grief, others screamed in pain. I believe it was only the strength of Marcelo that kept the others from losing their minds in the grim early days of the ordeal.

The agony of nighttime survival, particularly in the cold, is difficult to appreciate. For Nando, his first night of consciousness was sheer hell, a feeling he captured in his 2006 book, *Miracle in the Andes*:

> Time itself seemed to have frozen solid. I lay on the cold floor of the fuselage, tormented by the icy gusts blowing through every gap and crack, shivering uncontrollably for what seemed like hours, *certain that dawn must be only moments away* [italics mine]. Then someone with an illuminated watch would announce the time and I would realize that only minutes had passed. I suffered through the long night breath by frozen breath, from one shivering heartbeat to the next, and *each moment was its own separate hell* [italics mine].

I can't claim to have ever experienced the terror that Nando and his friends did, but he magnificently describes many frozen nights I have spent trying to find sleep in the confines of a small survival shelter.

The survivors were also hampered by the thin air, something they had never experienced in the coastal city of Montevideo, which sits less than 150 feet above sea level. Even the strongest athlete struggles with thin mountain air. Imagine having your mouth taped around a straw and your nose pinched, then having to climb a set of stairs or jog. Most people eventually acclimatize to altitude, but it can take days, or even weeks. In the

Luckily, there are a few solutions to the problem of nighttime chills.

The first time I ever filmed myself in a survival situation, for a film now titled *Stranded*, an unexpected cold snap descended during my sixth night in the field. My shelter, which to that point had seemed comfortable and well built, turned into a wind tunnel. The only way I could contend with the cold was to force myself to go outside and do stride jumps and push-ups, which worked brilliantly. The exercise cost me valuable calories, but it warmed me enough to allow me to then doze off for twenty minutes, which seemed like an eternity at a time when sleep deprivation had already begun to take its toll on me.

On another occasion, I was perched on a mountaintop in British Columbia during a fierce rainstorm, and found myself trying to sleep under a huge boulder. It was critical to stay dry inside the shelter. I employed a yoga-like method, systematically flexing and relaxing my individual muscle groups from my toes to my neck, and back down again. I was amazed at how much of the chill could be dispelled using this Zen-like approach to warming. I paid special attention to my stomach and core muscles—pulling in my abdomen hard and strong—which helped create heat within my core, an important place to keep warm when hypothermia is a real risk. An additional, highly effective way to create inner heat is to breathe deep and long, and, on the exhale, make the sound of the ocean, the air passing through the back of your throat, which should be narrowed to create a smaller escape hole. Be sure to pull up on the stomach muscles through the whole breath.

meantime, you have to deal with the nausea and dizziness that accompany it. During a ninety-mile walk (uphill all the way) in the mountains of Peru, where the altitude was between fifteen thousand and seventeen thousand feet above sea level, the air was so thin that I frequently had to stop and inhale vigorously to catch my breath. No matter how hard or how fast I sucked in air, I never hyperventilated or got dizzy, because there was so

little oxygen in the air to begin with. Meanwhile a sixty-six-year-old Queros elder (a direct descendant of the Incan high priests) was happily scooting past me straight uphill. The Queros' lungs and hearts have been proven to be a half-size bigger than those of people who live at lower altitudes.

Once Nando regained his wits, the stark reality of their situation began to wash over him. His mother had been killed on impact; his beloved sister, Susy, was still alive, though badly injured. Nando made his way over to where Susy lay, and spent every possible moment holding her in his arms, touching her skin, talking to her. During these quiet moments with his sister, Nando was able to fully comprehend the true nature of his situation. The immediacy of danger was everywhere; he felt it deep in his bones.

This is a more important realization than you might think. It shows that, on some level, Nando understood that the danger was immediate. Such a realization will keep a survivor on alert, either for an answer or for protection. The other option is not as pretty: survival victims who remain oblivious to danger are more likely to place themselves in even more danger by remaining passive and allowing the forces of the dangerous predicament to overtake them, instead of preparing and steeling against them.

Nando's innate survival instinct should be considered legendary. Almost from the moment he regained consciousness, a voice in his head accompanied him, told him what to do to improve his chances of survival. When he first learned of his mother's death, Nando's instinct was to cry. Yet the voice told him not to cry, because to cry meant to waste precious salt. He recognized that he and his friends would only be able to survive if they could successfully react to the additional challenges and catastrophes that would soon be thrown their way. The only problem? None of them had any real outdoors or survival experience, and they really had no idea what was on its way.

Nevertheless, Nando and his friends were motivated, a crucial element in any survival situation. They were young, fit, and had everything to live for. Yet their motivation took several different forms. Marcelo's was rooted in his own dark belief that he was somehow to blame for the crash. After all, he had been the one who organized the friendly match and booked the charter flight. Nando was fueled more by love—for his mother who had died, the dying sister he held in his arms, and the father and sister he left at home. In those first few days, he vowed that he would not die on

that mountain, and repeated his mantra whenever things looked grim: "I will not die here. I will not die here."

Though there had not yet been any sign of rescue, their fourth afternoon on the mountain was punctuated by the sound of a small prop-driven plane flying over the crash site. The survivors screamed and waved; one among the group was sure he had seen the plane briefly dip its wings. Rescue, they now believed, was imminent, though nobody could be sure they had actually been seen.

Did the plane see us? This is a common refrain among lost victims who desperately want to believe that rescue is only a plane ride away. Unfortunately, it would have been very difficult to spot the wreckage of the Fairchild from high above. The plane itself was white, and the debris around it would have seemed like little more than specks in the snow. It's a tragically ironic twist that, simply due to the color of the plane, it could not be spotted while it rested out in the open—quite the opposite of trying to spot Yossi Ghinsberg deep in the thick, green jungle foliage. In any case, it is highly unlikely that a plane has spotted you unless it makes a very obvious display to the contrary. No rescue pilot worth his or her salt who spots the victims will simply fly by with a slight dip of the wings. They will circle and dip wings at least twice, or until they are assured that you have seen them, too.

So, while many of the survivors prayed for rescue, Nando and a few others took a more pragmatic view of the situation and realized being saved might not be an option. In the end, the plane never came back and never dropped supplies. Nando was again advised by the voice in his head that would prove to be a constant companion in the many long weeks to come. Prepare yourself for the long haul, it told him. This kind of phenomenon—such as hearing voices or being accompanied by an imaginary being—is a common occurrence among people at the edge of death in survival situations, and usually encourages them to make one final effort to survive. Yossi Ghinsberg, alone in the Amazon jungle, was on his last legs when a young lady appeared before him, apparently begging for help. Yossi vowed to protect her, and it led him to salvation. In Nando's case, the voice was always with him, almost from the moment he regained consciousness.

Yet Nando was certainly not alone in his will to survive on that snowy mountainside. Not long after the crash, Arturo Nogueira, whose legs had been shattered in the crash and who was confined to a makeshift

Extended exposure to the thin air found at high altitudes can lead to a potentially deadly malady called altitude sickness.

Altitude sickness begins as a series of nonspecific symptoms that can resemble anything from the flu to a hangover, which makes diagnosis particularly challenging. However, most cases are typically characterized by headaches, which can be accompanied by any number of other possible symptoms, including shortness of breath, rapid pulse, headaches, drowsiness/malaise, fatigue, insomnia, dizziness, loss of appetite, and swelling of the hands, feet, and face.

Adding to the confusion is the fact that people react differently to the stresses of high altitude. What seems perfectly bearable to one person can be excruciating to another. Yet few are immune to the most serious forms of altitude sickness: high-altitude pulmonary edema and high-altitude cerebral edema, both of which can prove fatal if untreated.

High-altitude climbers and mountaineers prevent altitude sickness by ascending slowly and methodically, thereby acclimatizing their bodies to the stresses altitude places on them.

hammock in the fuselage, spent hours poring over the flight charts recovered from the cockpit. Using those, as well as information gleaned from the copilot before he died, the survivors determined they had crossed the Andes and were now somewhere in the western foothills of the great range. They became fixated on one fact: Chile was to the west. And while that knowledge would ultimately lead to their salvation, the survivors ran the risk of becoming *too* rigid and stubborn in their beliefs. Chile may have been to the west, but their attempts to scale the mountain that stood between them and their destination—instead of following its natural course down—nearly killed them several times over.

This is where gaining knowledge is tricky. For while knowledge is indeed power, it still needs to be tempered with reality. There is no place

for stubbornness in a survival situation. There was no way of truly know-ing for sure that Chile lay to the west, so alternative answers should never have been counted out.

As their fifth day on the mountain dawned, Nando and his friends realized they would have to take matters into their own hands if they were going to stand a chance of surviving. Four of the fittest among them decided to head out on a reconnaissance mission to the top of the mountain, to see what the horizon held. Carlitos Paez, Roberto Canessa, Fito Strauch, and Numa Turcatti were also seeking the plane's wrecked tail section, which they believed held vital food and clothing, and batteries for the plane's radio. They were aided by Fito's stroke of sheer MacGyver genius: a few days earlier, he had fashioned snowshoes from the plane's seat cushions and used bits of cable or seat-belt webbing to attach them to the hikers' feet.

Yet despite their best efforts, the climbers were unable to attain the summit. The mountain was too high, the air too thin, and their experi-ence too little. They concluded they would have to find another way off the mountain.

Nando spent nearly all his time at his sister's side, holding her, whis-pering to her, encouraging her to fight to stay alive. But on the eighth day of their ordeal, Susy died in his arms. He spent the night hugging her now-lifeless body, desperately trying to maintain sanity in what seemed like an increasingly cold, cruel world. With his mother and sister now gone, depression became a real possibility for Nando. Unlike panic, which mani-fests itself as a sudden rush of debilitating emotion, depression is more insidious, but no less dangerous. Indeed, as time passes in a survival situ-ation, loneliness, boredom, and apathy begin to creep in. Depression is never far behind.

Yet Nando's instinct was strong. He didn't allow himself the luxury of tears or of sinking into depression over the loss of his friends, his mother, and his sister. Spurred on by the inner voice he often described as cold and unfeeling, Nando stayed in survival mode, suppressing more complex emotions and narrowing his focus to one thing: staying alive and return-ing to see his father and sister once again.

As driven as he was to survive, Nando was, on some level, convinced that it was only a matter of time before he died. At these moments, when

panic drew uncomfortably close, Nando experienced a feeling that washes over many people in similar situations: a manic urge to flee, which is the "flight" part of the fight-or-flight response. In these moments, it can feel like there is a giant monster chasing you, forcing you to pick up the pace, perhaps even to start to run. Run away from your fear. Run away from your pain. Run away from the situation you are in. This is when panic hits full bloom—and takes over.

As dangerous as panic may be, and as instantaneous as it usually is, it doesn't always happen right away. Panic can crop up later, long after you made your assessments and organized your situation into something survivable. This is why it is vitally important to never stop organizing your supplies, fixing your shelter, searching for food. Tasks such as these occupy the mind, and in a survival situation, an occupied mind is a good thing.

Nando certainly occupied his. With Susy gone, he became obsessed with the idea of affecting his own survival. He assumed all along that rescue would never arrive, so he began to run through various scenarios in his brain, all of which revolved around him setting out to find help. In making these considerations, Nando did the right thing and considered all the factors relevant to the decision: Did he have the strength to survive a trek in the mountains? How steep were the slopes? How cold was it at night? Was the footing stable? What path should he follow? What would happen if he fell? What lay to the west?

As part of his obsession with leaving, Nando began to visualize the journey in exacting detail: how he would claw his way up the mountain, what he would see from the top, what he would say when he met his rescuers, how his father would look, feel, and smell. Although often used in sports, visualization techniques are rarely mentioned in survival, but they're highly useful. I'm sure there are lots of naysayers out there, but I think there's a lot to be said for the idea that if you can visualize your objective, it will happen.

As the days went by without rescue, spirits began to drop. Some of the survivors began to sink into depression and became listless, apathetic. This certainly caused some tension between the remaining survivors, but if I had my choice, I'd take the tension of group survival over the loneliness of solo survival any day. Group survival can pose challenges. The danger of contagious panic is always present. There are more mouths to feed,

QUESTIONS TO ASK BEFORE MOVING ON

- How far away is safety?

- Which way does safety lie, and do you know how to get there?

- If not, do you run the risk of getting even more lost if you head in the wrong direction?

- Do you and your traveling partners have the strength to make it there? Are any of you too injured?

- Do you have enough supplies?

- Does anybody know where you are?

- Is there a chance rescuers may coming looking for you? How long before they start looking?

- Are you on a well-used trail that might have other people on it?

- Is it more dangerous where you are now or where you are going?

- Does your current location offer water, shelter, fire/fuel, and food?

- Are you with a vehicle or other large object that may be easily seen from the air?

and the many bodies that may require medical attention can be taxing on resources. But the advantages—the camaraderie, the various forms and sources of motivation, the effect of shared workloads—all outweigh such drawbacks as resentment and petty arguments.

For example, it was the ingenuity of one person that solved the problem of water for the entire group. Although the plane was lying on top of a snow-covered glacier, getting enough drinking water for the survivors was always a concern. At first, Nando and his friends simply ate snow, but after a few days at high altitude, their lips became so cracked and tender that it became a near-impossible task. So they turned to melting the snow in the sunshine, whether in wine bottles or on top of the silver fuselage.

Fito helped solve the water conundrum by fashioning a bowl and spout from a discarded piece of aluminum, filling it with snow and setting it out in the sunshine. The device melted snow so effectively that others quickly constructed similar ones, putting an end to the group's collective concerns about dehydration. This is the type of inventiveness I would have hoped for in their situation. There was a real sense of urgency when it came to water, and for good reason. Humans can go several weeks without food, but deny us water for a few days and death is imminent. Dehydration is a real risk in any survival situation, but it becomes even more acute in cold weather and at high altitudes, when it sets in more quickly. What's worse is that, while dehydration in a place like the desert is always on your mind, it may be overlooked in alpine environments.

But now there were other concerns with which to contend. As the last of the rations were doled out at the end of their first week on the mountain, starvation became a very real possibility. That night, as Nando lay freezing in the remains of the plane, trying to fall asleep, a grisly realization came to him. If he and his friends were going to survive long enough for rescue to arrive or for them to hike to safety, they would need food. And there was only one source of food available.

As you might imagine, the idea of eating the dead spurred days of lengthy moral debate among the survivors. Most of the players were Catholics; some were concerned that eating the flesh of another human would condemn them to eternal damnation. Others simply couldn't come to grips with the idea of cutting their friends into pieces. In the end, though, the stark reality of their situation left them no other choice. They gathered in a circle, and each pledged that, if he or she died, the others had permission to use their bodies as food.

Even the staunchest holdouts in the group quietly acquiesced. The most religious among them drew strength from the idea that they were drawing life from their friends' bodies in much the same way they drew spiritual strength from the body of Christ when they took Communion. Nando was far more pragmatic. His friends were gone, and the bodies now represented meat and sustenance, nothing more. The subject of eating the dead—necrophagy, as it's called—has stirred controversy for years. Yet, as far as I'm concerned, it was the right thing to do, a desperate measure in a desperate time. As the group concluded, their friends' souls were gone,

and their friends would want them to do everything they could to survive. In starkest terms, the dead bodies represented sustenance—meat and fat and bone, all good survival food. The notion of butchering and eating another human being goes well beyond the "plate fright" that I often talk about, where people balk at the idea of eating a creepy-crawly. And yet—like eating bugs and other slimy critters—it's something I think most people *would* do if starvation were the only alternative. Nando and his friends had no choice: eat the dead or die themselves. In the end, they made the only decision they could if they expected to survive the ordeal.

By the eleventh day on the mountain, little had changed for the survivors, other than the ready store of food the survivors now had on hand. That morning, eighteen-year-old Roy Harley managed to coax back to life an old transistor radio salvaged from the wreckage. The signal crackled and popped, but those crowded around the device heard a news report that, after ten days of searching, Chilean authorities had called off the search for the missing rugby team. The mountains were too dangerous, the report said, and there was no chance anyone would have survived more than a week in the frigid mountain air.

The news caused a huge mental and emotional shift among the survivors. Many of them threw their hands up in despair; rescue was the only thing keeping them sane. Others considered suicide. Nando was one of them, but those fearful thoughts were soon quelled by his inner voice, which again steeled him for the reality he would one day face: he would have to climb to the top of the mountains, and then venture off into the distance to find help. He frantically tried to begin his climb right then and there, but his friends talked him out of what would have been a very foolish decision.

It is said that information is power. That statement is never more true than in a survival situation, where information provides the power to make decisions. In this case the radio report finally gave them what they needed: knowledge that the search had been canceled. As difficult as it may be to believe, there is a strange sense of relief in receiving terrible news such as this. You may feel hopeless and discouraged for a while, but it is liberating to finally know what you need to do to set your own rescue plan in motion.

None in the group seemed worse affected by the news than Marcelo, who changed from fearless leader to somber and reserved victim almost

instantly. Marcelo had put all his eggs in one basket, the God basket, and thought that divine intervention would send rescue their way. With those hopes shattered, he didn't feel he had much to live for. Luckily, his feelings were not shared by all. As the reality set in, a few of the others made plans for another assault on the mountain. Three men—Gustavo, Numa, and Daniel Maspons—gathered up what little provisions and equipment they could muster and set off shortly thereafter. Among the gear they took were the fruits of their survival ingenuity: sunglasses they made by cutting tinted plastic sun visors from the cockpit and stringing them together with copper wire.

They didn't return that night, a night of frigid temperatures and howling winds. When dawn finally broke, the survivors at the crash site were heartened to see three specks high up on the mountain, moving slowly down the slopes above them. When they finally made it back to camp later that afternoon, they looked as if they had aged twenty years in one night. Gustavo, whose glasses had broken during the climb, was suffering from an intense case of snowblindness. As the climbers slowly warmed themselves, they shared the story of their harrowing night on the mountain.

They had climbed only halfway up as dusk approached, so they decided to find shelter and climb again the following day. They found a level place near a rocky outcrop, built a small rock wall to protect them from the incessant wind and huddled together to keep warm. This is a simple, yet effective way of staying warm in group situations, especially for the middle person. Better yet is to lie skin to skin with another person. It may be uncomfortable to do so with someone you might otherwise consider a stranger, but modesty can make for a lot of very cold nights; "cuddling" can spell the difference between life and death. It has come in handy for me on numerous occasions.

I was traveling with a friend on a very cold night, trying to make it to his backcountry cottage. We didn't make it, and decided to spend the night in a cabin we had recently passed. The cabin had no heat and no blankets, so we stripped to our underwear, crawled between two mattresses, and slept with our bodies back to back. This technique worked wonders for keeping us warm, much more so than if we had stayed in our clothes and avoided contact with one other. This experience, however survival oriented it might have been, doesn't come close to a hundred other nights I have

spent surviving outdoors in the cold winter air, and is a very far cry from what those men went through that night on the mountain.

The second attempt to summit the mountain yielded a bit more information than the first. They had not found the much-sought-after tail section of the plane, but did come across pieces of wreckage, some luggage, and the bodies of several people who had fallen out of the plane when it split apart, many of whom were still strapped to their seats. The one thing the search failed to yield, however, was an idea of which way civilization lay. They were still trapped and alone.

As the days passed, the survivors became more efficient at processing the dead into food. Grisly, yes, but this was yet another necessary step in their evolution as survivors. To make the meat more palatable, they cut it into small pieces and dried it in the sun. Sometimes they cooked it, on those rare occasions that they had a fire.

While the meat from their fallen friends certainly kept the survivors alive, Nando could not help feeling that he was slowly and inexorably losing his strength, which would ultimately hinder his attempts to seek help. This is a common issue among survivors: they don't try to affect their own rescue when they are strong and healthy, but end up doing it when they are physically compromised. Of course, there are times when sitting and waiting makes more sense than moving, such as when you're injured or in an otherwise dangerous situation. But in this case, the survivors became slightly weaker with each day they clung to the hope that they would be found. So if you have to move, do it when you are strong, healthy, and prepared. Leave markings, notes, and other signs to indicate where you have gone, in case someone happens upon your trail or camp.

By the last week of October, Nando and the twenty-six others who were still alive had been on the mountain for more than two weeks. As the days passed, the survivors became encouraged by Nando's insistence that he would climb the mountain and find rescue. Marcelo's spirits continued to sag, and Nando began to emerge as the group's leader. Now they had a plan and a purpose: they would eat the meat of the dead, regain their strength, wait for the weather to improve, plan a route, and find help. But first, all hell would break loose—again.

It was October 29, 1972, and the twenty-seven survivors had settled in for yet another frigid night in the fuselage. As they began to doze, the

powerful force of bad luck struck when a massive avalanche swept down the mountain, burying the remains of the plane under several feet of hard-packed snow. Nando was encased in what seemed like cement, and he waited for death to take him. In some way, it was a relief to finally face his end. There would be no more struggles, no more frozen nights. Then a hand shot through the snow and uncovered his face, and Nando was able to breathe again.

After a few frenzied moments of chaos, he was free to witness the macabre scene around him. Some people were lying motionless, others rising slowly from the snow like corpses from the grave. There were a few brief moments of silence, and then the details of the avalanche began to filter through. There was a distant roar on the mountain, which brought Roy Harley to his feet. Seconds later, a wave of snow plowed through the makeshift wall at the back of the fuselage, burying Roy to the hips and covering all those who had been asleep. Roy desperately started digging the others out. Those who were uncovered by Roy started digging for their friends, too. But they were too late for many. In total, eight died in the avalanche: Marcelo, Enrique Platero, Coco Nicholich, Daniel Maspons, Carlos Roque, Juan Carlos Menendez, Diego Storm, and Liliana Methol.

In the aftermath of the avalanche, Nando began to question his purpose. Why had he survived while others had died? Daniel and Liliana had been on either side of Nando, only inches away, as he lay down to sleep. Yet they were dead and he was still breathing. His luck was good and theirs was bad. They had chosen their sleeping spots, and those choices proved deadly.

The hours and days after the avalanche were a living hell, a nightmare of unimaginable proportions. Although there was a fresh air supply (courtesy of a hole Nando had poked through the snow with a piece of metal pipe), the plane was dank and dark, the air thick. The only source of water was the filthy snow that filled the plane, the same snow the nineteen survivors were crawling around on, sleeping on, and relieving themselves on.

Food was also a problem. Trapped as they were with no access to the bodies outside, the survivors had nothing to eat. They recognized that the avalanche victims were buried underneath them, but the closeness of the operation was too much to face. Until that point, bodies had

been butchered outside the fuselage, away from general view. If they were to resort to that same grisly option inside the snow-encased plane, however, it would be there for everyone to see. They swore they would rather starve than face the prospect of butchering the freshly dead.

With no other choice but to dig through the tons of snow that now surrounded them, the survivors took turns scraping and digging away at it. Eventually, they made their way to the surface through the cockpit, only to be met with a blizzard of such furious proportions that they had no choice but to stay inside the fuselage until it abated. In the meantime, they had ample opportunity to revisit their plans for escape. The prevailing feeling was that, although Chile certainly lay up over the mountain and to the west, they might have better luck hiking east, *down* the mountain and toward the broad, white valley that swept away into the distance. Their hope was that the valley would eventually turn toward the west and rescue. When someone mentioned that summer in the Andes arrived promptly on November 15, Nando threw down the gauntlet: he would leave on that day, with or without partners.

By the third day after the avalanche, hunger had become so acute that the survivors had no choice. Someone found a piece of glass and began slicing into one of the dead. The sound of the shard cutting flesh was revolting enough; eating the meat was almost impossible. Before the avalanche, the meat had been dried in the sun, weakening its taste and making the texture more palatable. Now the survivors were handed soft, greasy pieces of flesh, streaked with blood and gristle. Most of them choked it back with great difficulty; others could not bring themselves to do it at all.

It wasn't until November 1—four days later—that the blizzard finally stopped and the survivors emerged from the fuselage. It took an additional eight days of backbreaking work to clear the plane of the tons of snow that now filled it. At the same time, Nando and the other expeditionaries were preparing for their departure. Although they were encouraged by the gradual improvement in the weather, they were also disheartened that several among them continued to weaken. Arturo died early into the second week of November.

On November 15, Nando, Numa, Roberto, and Antonio "Tintin" Vizintin set out eastward down the mountain. They had walked for only an hour when a blizzard kicked up with a fury, sending them scrambling back

to the fuselage. The storm kept them there for two more days, when they started out again, this time without Numa, who had weakened considerably. The trio hiked for hours in fine weather and eventually came across the tail section of the plane, and the treasures it had held secret for more than a month: suitcases with fresh clothing, rum, chocolates, a camera with film, and the extra batteries for the plane's radio.

After what seemed like a luxurious night of sleep—the first when they were able to stretch out and roll around—the expeditionaries continued their eastward journey the next morning. The going was difficult in the bright sunshine, and progress was slow. They spent a long, cold night huddled together under a rocky outcrop, during which Nando was sure he would freeze to death. The next morning, they continued the hike, though Roberto and Nando were both beginning to doubt that the valley ever turned to the west. Their route, they determined, was only taking them deeper into the heart of the Andes. They decided to return to the Fairchild, where they would try to coax the radio back to life with the batteries from the tail, and call for rescue. Ultimately, they left the heavy batteries in the tail section, deciding instead that it would be easier to carry the radio down. When they finally made it back to the fuselage, they learned that Rafael Echavarren—whose calf muscle had been nearly torn off during the crash—had died.

In the days that followed, they worked furiously on the radio. Eventually, they got it to the point where it might work and hiked back to the tail section, where they had stashed the batteries. The device yielded nothing but static. Although his friends still held out hope for rescue, Nando was resolute: he was heading up over the mountain and to the west. The hike back to the fuselage was hampered by a raging blizzard. In the midst of the whiteout, Nando had to rescue Roy Harley, who had fallen and curled up in the snow, waiting for death to come. Somehow, they made it back to the Fairchild, utterly spent.

The survivors began to sink deeper into despair. Their food supply was running out, and the gruesomeness of the situation had assumed stark proportions. Where they once limited themselves to the most generalized pieces of flesh of their comrades, starvation had forced their hand. Now they had no choice but to broaden their diet to organs, hands and feet, brains—even the blood clots that formed in the large blood vessels of the

hearts. Even so, the bodies of the three women who had died—Nando's mother, Eugenia, his sister, Susy, and Liliana—all lay untouched under the snow. Even in desperate times, the survivors had stayed true to their promise not to touch those three bodies. They never would.

By the first week of December, Nando and his fellow expeditionaries had regained enough of their collective strength to once again begin preparing in earnest for their westward journey. As part of these preparations, they again trolled the depths of their human inventiveness to make the trip as comfortable as possible. The key innovation was a sleeping bag they sewed together from the quilted batts of insulation they had gathered from the tail section of the plane. They hoped it would keep them alive as they slept out in the open. The sleeping bag was ready by the first week of December, but Nando encountered resistance from the one person he counted on most to accompany him on the journey: Roberto. Roberto was still adamant that help was on its way, thanks to a radio report he had heard earlier, and wanted to give his rescuers a chance. Nando was unconvinced; he was set on leaving on December 12, and would go alone if need be. The wait was not without tragedy: Numa died on December 11.

Nando and his fellow expeditionaries needed no further sign. Slowly and inexorably, they were all dying. To wait for rescue was to wait for death. If anything, the crash site spoke to the now-barbaric nature of their existence: the once-pristine snow was soaked in blood, urine, and feces, was littered with bits of human bodies, and reeked of death.

On December 12, Nando, Tintin, and Roberto finally set out. Either they would find rescue or die doing so, but they would not come back. Nando already considered himself a dead man, so he saw no risk in trying to scale the mountain. Before leaving, Nando turned to Carlitos and told him, in a soft voice, to use his mother and Susy as food, if need be.

The climb up the mountain, which rose to a height of some fifteen thousand feet, was incredibly difficult. The expeditionaries had no idea of the technical challenges of mountain climbing, the negative effect that altitude was about have on their bodies, and were wearing little more than jeans and sneakers. Before the crash, few of them had ever seen snow before. I think this was one of those situations where ignorance was truly bliss. Had they really known what they were in for, they might not have set out at all.

The sun shone down mercilessly, softening the snow to the point that, with each step, the hikers sunk in to their hips. The air grew thinner, and Nando and his friends gasped for air. Still, fueled by the knowledge that they were the only hope for their friends who clung to life in the fuselage below, they forged on. After they had climbed some 2,500 feet, Nando was dismayed to find that they seemed no closer to the summit above. On the verge of desperation, he was once again calmed by the voice in his head, which told him to stop considering the mountain as a whole and instead cut the task into small, attainable pieces. He looked slightly ahead and chose one reachable landmark after another. This was a brilliant strategy, and can be used in any number of situations. When the task at hand seems too much—whether it's making a fire, building a shelter, or gathering food—break it down into its component parts. You'll not only be empowered by your successes, you'll find the job goes by much more quickly. As author Rick Canfield puts it, "You can drive across the country in the dark, and yet you can only see the first two hundred feet in front of you with your car headlights. So, it's all the way—two hundred feet at a time."

The trio settled in for their first night on the mountain in their makeshift sleeping bag. Although their collective warmth kept them from freezing to death at what was likely fourteen thousand feet of altitude, they suffered terribly through the night. When dawn finally arrived, they slid their stiff feet into their frozen shoes and set out once again. Although hard to imagine, the second day on that precipitous slope was even more difficult than the first. Nando's existence was reduced to a single purpose: put one foot in front of the other and climb. Guided by the voice, he narrowed his focus so that nothing else mattered. Roberto seemed ready to give up on several occasions—he thought he could see a road far to the east—but Nando refused to give in.

The third morning of their climb found them at the base of a near-vertical wall encased in snow and ice. With no choice but to climb, Nando used a stick from his pack to carve steps in the wall. Step by excruciating step, they inched their way up. Many hours later, they attained the summit. It was certainly not what any of them would have expected. The view that met their eyes was one of the most depressing things Nando could imagine. In every direction, there were nothing but snow-covered

mountains as far as the eye could see. They had been wrong all along. The plane had not crashed on the western edge of the Andes. They were right in the middle of them.

For a moment, despair got the better of Nando. He fell to the ground and cursed his fate before recovering his senses. Once again, with death knocking at his door, Nando chose to control his own destiny. Then and there, he and Roberto reaffirmed their pledge to one another: if they were going to die, they were going to do so on their feet, walking toward the sun to the west, not on their backs in the fuselage. They scanned the horizon for any sign of civilization, to no avail. Then Nando noticed two smaller peaks on the western horizon that were not capped with snow. A valley wound its way from the base of the mountain they now stood atop, in the general direction of the two peaks. It would take days, even weeks, to make it such a great distance, and by then their food would surely have run out. With no other choice, they decided that two would have a better chance of making it than three. Tintin would have to go back to the plane.

They rested for what remained of the afternoon in anticipation of the arduous trek that lay ahead. The next morning, Nando and Roberto bade farewell to Tintin. He headed down the mountain to the east, they to the west. Roberto was sure they were walking to their death. If the climb up the mountain had almost killed them, the descent was even worse. Though they didn't have to deal with the same kind of physical exertion, the footing was unsteady, and each step came with the risk of falling to their deaths. At one point, Nando lost his senses, sat on one of his seat-cushion snowshoes, and began to slide down the mountain, narrowly escaping serious injury. They made it down the mountain at around noon the next day, and looked down the valley they hoped would lead them to salvation.

For days, they trudged along the glaciated valley floor, picking their way across and around ice blocks, the rough edges of the windblown snow gnawing slowly at their feet. On the seventh day of their journey, December 18, the snow slowly began to yield and patches of loose rubble appeared at their feet. Later that day, Nando was roused from his almost-maniacal focus by the sound of water ahead. He rushed forward to see a jet of water shooting from an ice wall and down into the valley below, where it formed a fast-flowing stream. Nando and Roberto knew this was the birth of a river and wisely decided to follow it.

Soon, the snow released its grip completely on the ground underfoot, though the hiking was no less difficult. The weakening pair picked their way slowly around the boulders and rocks strewn across their path. The days wound into nights, and yet Roberto and Nando soldiered on. They grew weaker with each passing hour, and their shoes were beginning to come apart at the seams, but they were fueled by a fierce sense of purpose. The force of good luck was on their side, and their eighth day away from the fuselage dawned bright, sunny, and warm.

Later that afternoon, Roberto found the remains of a rusted soup can on the ground, their first sign of so-called civilization in more than two months. More followed: cow and horse dung, a tree stump that still bore ax marks. Later that afternoon, they spotted a small herd of cows a few hundred yards away. They camped that evening with hope rising in their hearts. As the ninth day of their journey dawned, Roberto found it increasingly difficult to move. With the prospect of rescue so tangible, however, they continued in the face of their weakening condition. With every bend in the well-worn path they now walked, Roberto expected to come across a peasant's hut. It never materialized. But as they reached the top of a broad plateau later in the day, they saw the stone walls of what they assumed to be a farmer's corral in a meadow. The only thing stopping them from reaching it was the river, which now raged with a fury before them.

The afternoon skies were darkening toward evening, when Nando heard Roberto shout from across the meadow. He had seen a man on horseback! Nando, whose eyes were not as good as Roberto's, could see nothing, but he let Roberto guide him to a spot on the slope where the dim outline of the rider became clear. They shouted and waved frantically. The man looked up and waved back! Though the river drowned out most of what he said, one word rang clear across the river: *mañana*—tomorrow. They were saved.

Nando woke before dawn the next day, their tenth since leaving the Fairchild, and saw the dim glow of a fire across the river, around which three men sat. Nando screamed and gestured, then saw one of the men scribble on a piece of paper, tie it to a stone, and throw it across the river. The note said a man was coming later and asked Nando and Roberto what they wanted. Nando's return note described who he was, where he came from, and the desperate situation of his comrades who were still perched

on the mountain. The peasant read the note, nodded, and made a hand gesture that told Nando and Roberto to wait. A few hours later, a man on horseback, Armando Serda, rode up on a mule. They were saved.

The hours and days that followed were a blur for Nando and Roberto. They were first taken to the peasants' huts, where they ate the prodigious amounts of food put in front of them, then slept the afternoon away like dead men. The police arrived the next morning, as did a horde of reporters. When the helicopters arrived, Nando pinpointed the exact location of the Fairchild on their flight chart. The officers were skeptical. There was no way these two near-skeletons could have walked more than seventy miles through the High Andes with little more than the clothes on their backs. Nando persisted. A short while later, the choppers were in the air, with Nando in tow. The helicopters pitched and bounced as they struggled to climb over the massive walls of Mount Seler. The engines whined dangerously as they pushed the chopper over the peak, only to have a massive updraft throw the helicopter backward. With no other choice, the pilot sought another route to the crash site.

The light was bad and the winds heavy, but the pilot and other crew members decided they would make one final push to the plane. They circled around Mount Seler (as Nando later named it, to honor his father), where Nando regained his perspective and guided them to the crash site. The chopper couldn't land because of the angle of the slope, but the rescue team hopped out. Daniel Fernandez and Alvaro Mangino jumped into one helicopter; Carlitos Paez, Pedro Algorta, Eduardo Strauch, and Roy Harley got into the other. Tintin and the rest would have to wait for the second trip, but by the afternoon all the survivors were together again, in a small town called Los Maitenes.

They were later flown to a military base near the town of San Fernando, where waiting ambulances took them to a nearby hospital. Each person was led to a small, clean room, where they peeled off their dirty clothes, showered, ate, and rested. Nando's reverie was disturbed by a commotion outside his room. He opened the door to see his sister Graciela and her husband making their way down the hallway. He held his sister and brother-in-law for a few beautiful minutes, then saw the bowed figure of his father, Seler, at the end of the hall. Nando gently broke the news of his mother and sister's death to his father, and felt him sag in his arms.

Later, they sat together in Nando's room, sharing what Nando called "the simple miracle of being together again."

To this day, mountain climbers have hailed the ten-day journey of Nando and Roberto as one of the greatest mountaineering feats of all time. In total, sixteen of the forty-five passengers who boarded the Fairchild lived to tell their tale.

NANDO PARRADO

ELEMENTS OF SURVIVAL

Knowledge 0%
Luck 20%
Kit 10%
Will to Live 70%

Talk about having the deck stacked against you. Nando had absolutely no survival knowledge whatsoever, and the wrecked plane offered little true survival gear, other than what he and his teammates could scrounge from the wreckage. What makes Nando legendary in the world of survival, however, is his unbending will to live. Like Yossi Ghinsberg, Nando refused to yield, refused to accept death as an option, and refused to acquiesce in the face of truly horrific circumstances.

4

Adventure Racing

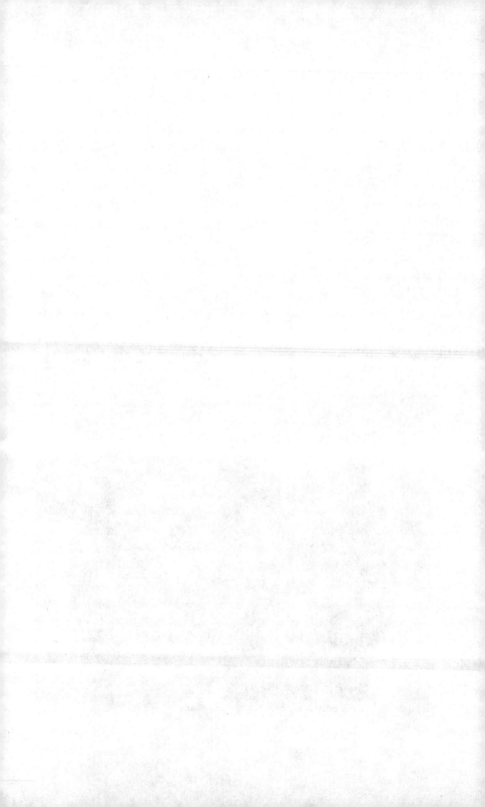

Somewhere deep in the forest between Timmins and Sudbury, Ontario, Derek McNeil, Tanya Martin, Doug Neudorf, and I sit huddled together on the cool, wet ground. We are in the middle of a virtually impenetrable wall of face-ripping, ankle-bruising, toe-bashing spruce and balsam forest. The mosquitoes are thick and relentless, but are a reprieve from the hordes of blackflies that attack during the day. It's 3 A.M. on June 1, hour forty of the inaugural National Adventure Racing Championship of Canada. To this point, we have stopped to rest for a total of ninety minutes during the first part of this six-day race.

"I just can't keep moving. I've got to sleep for a bit. I can't think straight," Derek proclaims. Tanya feels the same. Doug remains his usual stoic self, though inside he is wrestling with the demons of quitting. I've been feeling the sharp, stabbing pains of knee strain for hours. We all spoon together for warmth and try to get a half hour of sleep. We think we're close to the first transition area, where hot soup and friendly faces await. We don't know we're more than six hours of nonstop bush-slogging away.

This is an adventure race, the ultimate mental and physical challenge. I've been a huge fan of the sport ever since the days of *Eco-Challenge*, a multi-day adventure race produced by Mark Burnett (producer of *Survivor* and *The Apprentice*) for the Discovery Channel. So I jumped at the chance to be part of the first Canadian adventure race. A couple of months and a

lot of training, later, I found myself in the company of sixty-seven much younger and fitter athletes in a convoy of equipment-packed vehicles bound for the starting line somewhere outside of the northern Ontario mining community of Timmins, about 450 miles north of Toronto.

Adventure races can take many shapes and sizes. Some can be a short as eight hours, others are twelve-day endurance marathons. They take place all over the world and usually include a number of modes of travel as participants make their way from checkpoint to checkpoint. Bush-whacking, trail hiking, canoeing (my personal favorite), biking, rappeling, rock climbing, rafting, snowshoeing, and skiing could all be part of any given race. In many cases, teams don't have the opportunity to choose their routes until minutes before the race begins. The National Adventure Racing Championship of Canada is a 480-kilometer (nearly 300-mile) race that includes bushwhacking, biking, and canoeing. Each team comprises four people, a mix of men and women.

Earlier on, at the four-hour mark of climbing steep ridges and forcing our way through the thickest bush I have ever seen (and I've seen a lot of bush), we broke through to a babbling brook, where we refreshed ourselves and our water supply. Another team was close on our tail, so we went into stealth mode and let them pass. After all, this would be the only good water source for a while; if they happened to miss it, we'd have a slight advantage.

I love this strategic aspect of adventure racing. I've even heard of teams that have walked backward through the mud to throw off their fol-lowers. Derek and Tanya have been constantly reminding me and Doug, the two rookies, to drink and eat, to the point where they would become upset with us for having more energy drink left in our water bags than they did. I bent over and shoved my overheated face into the brook to guzzle as much as possible. We heard the sound of breaking twigs as the other team passed through the bush a hundred yards away.

In an adventure race, each team member typically has a predeter-mined role. The navigator, who has the strongest compass-reading skills, leads the way to the next checkpoint. If the navigator carries only the com-pass and not the map, the next person in line may keep the map hanging from their pack, constantly checking for reference points: a high ridge over there, a lake over here. The next two may simply trek along, keeping pace

with the leaders. The team captain is also responsible for bolstering team spirit, but there is no question that everyone on the team is responsible for boosting morale at one time or another. I may carry you through this leg, but you may need to carry me through the next. Our team was thrown together without much time to prepare, so Derek, Tanya, and I all navigate while Derek assumes the leadership role.

Another hour passes, and we finally hit an established trail. Morale is at an all-time high, and we even bump into another team. Everyone is happy and we all travel together, laughing, talking, and trying to keep pace with the ridiculously fit Olivier, who leads Team Endurance Junkies. We're called Team Survivorman.

Suddenly, the skies open up and dump a torrent of rain and hail on us, but it's welcomed with hoots and cheers on this otherwise scorching day. Then the trouble starts. I'm carrying the map, but I don't know the protocol of navigating during a race. As far as I can tell, Derek and Tanya are happy and Doug is keeping pace at the back, so we continue to follow Team Endurance Junkies as they make a number of turns at forks in the trail. Nobody has thought to check the map.

Eventually, they distance us, but we continue following in their foot-steps. But something is wrong: it's getting late and we've been traveling far too long not to be at a large lake just outside Checkpoint #1. Then we round a corner, and the trail crosses a big river—a very big river. The only problem is there's not a river like this anywhere on our route.

Frustration and arguments ensue. Where are we? Finally, Tanya notices the only possible feature like this on our map—we're *way* off course. So I learn adventure race rule #1: Never blindly follow another team; they could be wrong. We eventually make our way back to where we have to go, but not until we have traveled four hours and ten kilometers out of our way.

There are mandatory items that all adventure race participants must carry: compass, first aid kit, satellite phone, GPS, sleeping bag, emergency tarp, and tent, along with the necessary food and water. Lightweight energy drinks and food are a staple, but Derek's idea of packing some cold slices of pizza is an incredible morale booster.

As delicious as the pizza may be, it barely masks the frustration I feel from wearing cross-training running shoes instead of hiking boots.

Hiking boots offer much more protection, but are simply too heavy to be hauled around for three hundred miles when speed is of the essence. Running shoes may drain well and don't weigh on your feet, but they are constantly wet from trudging through swamps and creeks and offer your toes no protection from the constant banging against branches and rocks. Swollen, blistered feet are common at the end of every race. Clearly, someone needs to invent an adventure-racing shoe!

Hour thirteen. After our unfortunate detour, we are finally climbing a three-kilometer trail that rises two thousand feet to Checkpoint #1, Ishpatina Ridge, the highest point in Ontario. En route, Tanya's right shoulder barely grazes a leaning tree, but it's enough to dislodge a log ten inches in diameter, which drops five feet down, directly onto Doug's head. A serious injury out here would not only be devastating, but extremely dangerous as well. It would also be nearly impossible for us to carry him out of here on our own. Doug's okay, but he will be plagued by neck pain and headaches for the rest of the journey.

We're all exhausted, but there's still a long way to go. Doug swallows some Tylenol. My head is clear—I'm no stranger to sleep deprivation thanks to my experience as Survivorman—but my knees are showing signs of strain. A sharp pain shoots through the inside of my knee with every grunting step forward. Derek is feeling better after his struggle with stomach pain, but his feet feel like they're being sliced slowly with razors. For Tanya, the worst is yet to come.

Each race is peppered with a series of checkpoints, some manned and some unmanned. Some serve as transition areas where, if it is a supported race, you can meet up with your support crew and transfer from foot to canoe or canoe to bike. Transition areas are great because they have tents already set up, medical teams, hot food, and a change of clothes to help keep you moving.

For Team Survivorman, Checkpoint #2 is simply a campsite at the south end of a lake, where two volunteers watch over a fire and some tents. It is here that we learn, to our surprise, that we are not dead last! This means that somewhere out there, after twenty-two hours of nonstop racing, three other teams have not even made it as far as we have. I feel bad for them, but duty calls. We heat up some of our pizza over the fire, fill our water bags, and set off for sixteen more kilometers of bushwhacking,

comfortable in the knowledge that, even with our four-hour blunder, we're only a few hours behind the leaders. It's great news, but it won't last long.

We're forcing our way through even thicker bush when we realize the only way we're not going to get lost is to hold our bearing. Derek proves an excellent navigator through the Canadian wilderness, always landing us right on the shore of the remote lake we are trying to find. Yet as confident as we are in Derek's route-finding skills, we are nagged by the belief that "we must be there by now." So we orient the map, comfortable in the knowledge that the lake must be just around the next corner, only to find that we're just halfway there. All this, and darkness is falling yet again. We've been hoping for a trail. The map shows an old trail. There must be a trail soon. Where's the trail?!

There's a real art to map reading. In a race like this, a good navigator can make the difference between winning and not even finishing. Transferring compass bearings, noting ridgelines and lakes, taking into account magnetic declination, the age of the map. The map is old—is the trail still there? It may not be, but it may have been made into a big, beautiful road, and hitting it may save hours of bushwhacking.

Each member has a chance to shine during the race. Derek, a supremely fit cyclist, will push me up the hills on our bikes during the 100-kilometer (sixty-mile) biking section, pedaling with one hand on his handlebars and one hand on my back. My time to shine comes around the thirty-sixth hour of the first section of hiking, as we lie down on the ground for some rest. Doug is quiet, Tanya suffering silently, and Derek near hysterical trying to figure out where the trail is. After a thirty-minute nap in the middle of the night, Derek is adamant that we head off in the direction of his choosing. I know it's wrong, though, and insist we stick to the compass. I am, in the end, correct, and happy that I can make an important contribution to the team. My strength comes from my ability to handle sleep deprivation, something I have had so much experience with from my survival excursions.

Forty-five hours into the race, we've rested for a total of less than two hours. Tanya's physical condition takes a turn for the worse. For the last twelve hours or so, she's been suffering from horrible chafing and infection all through her inner thighs and pelvic area. That hasn't stopped her from stoically pushing forward, at times literally crawling through the

bush, her skin red and raw, the infection threatening to become internal. We know we are close—we have to be. But how much farther? The black-flies are ferocious. Tanya can't keep going, though she claims otherwise.

But nothing looks right at this point on the map. There shouldn't be a lake here. The creek looks wrong. What if we're wrong and we're way off course? It's 7:30 A.M., and for a brief moment Doug and I think it's 7:30 P.M. It starts to rain.

Race organizers keep search and rescue teams on standby twenty-four hours a day in case of emergencies. Adventure racing is a fantastic sport, but it's serious business and comes with a major set of inherent risks. No one wants to see an injury occur, let alone see a team get truly lost. I pull out our emergency satellite phone and make the call to race headquarters. They check our GPS coordinates: we're two hundred yards from the trail that leads to the next transition area. Head northeast and we're there.

Upon our arrival, Tanya is led into a waiting ambulance, doubled over in agony. Derek, Doug, and I collapse into our support tent, strip down, and dig into the food that's been provided to us. We're finished. If we want to continue as a three-person team, we have twenty-five minutes to make the cut-off time and jump into the canoes. But we don't have the energy to go on.

It's then that we learn that three other teams pulled out about sixteen kilometers back, at Checkpoint #2. Like us, three other teams are pulling out here at the transition area. Two men have been taken to hospital. One woman lost her bug net halfway through the race and is covered in black-fly bites from the top of her forehead to the base of her neck; her face is covered in blood.

The race leaders breezed through here twenty-two hours ago. They've likely already finished the canoeing section (the next part of the race) and are on to the biking leg. But they are not human, they are machines. Later, all of the best teams will describe this as the toughest trekking section they have ever endured in an adventure race.

I'm sure Derek would have liked to see us do better. Tanya is content with the lessons we have learned. Doug and I are supremely proud that we made it this far. Later, I will lose six of my toenails. "Ah yes, every race," Benoit Letourneau, captain of the eventual winners of the race, Team Simon River Sports, will laugh with me days later.

5

Survival at Sea

FOR SOME OF US, THE NOTION OF LIVING AS
FARMERS IN THE ENGLISH COUNTRYSIDE WITH
NO PHONE OR ELECTRICITY IS ADVENTURE ENOUGH.
IT WASN'T FOR THE **ROBERTSON FAMILY.**
AFTER THEIR YOUNG SON NEIL SUGGESTED ONE
MORNING THAT THEY BUY A BOAT AND SAIL AROUND
THE **WORLD,** THE FAMILY SPONTANEOUSLY
AGREED. TWO YEARS LATER, HAVING SOLD ALL THEIR
EARTHLY BELONGINGS, THEY HAD ENOUGH MONEY
TO MAKE THE **DREAM** A REALITY. THEY NEVER
ANTICIPATED THE **NIGHTMARE** THEIR
VOYAGE WOULD BECOME.

The Robertsons' home for the next seventeen months would be the *Lucette*, a forty-three-foot schooner purchased in Malta and sailed back to England by Dougal, the family patriarch, who ruled his house with an iron fist. After two months of acclimatizing to the boat in the English port town of Falmouth, the Robertsons set off on their circumnavigation of the world. It was January 27, 1971.

The voyage took them first to Spain, then Portugal, after which they spent some time in the Canary Islands, where they took on two young Americans hitching a lift across the Atlantic. From there, the journey continued to the Windward Islands of the West Indies, up through the Bahamas, and on into Miami, where they stayed for a while so the kids could catch up on schoolwork. During their time in Florida, Dougal and his wife, Linda (Lyn for short), bought a fiberglass dinghy in Fort Lauderdale. Lyn remarked on how the dinghy—named *Ednamair* after her two sisters, Edna and Mary— might save their lives one day. She couldn't have known just how prophetic her musings were.

They sailed to the island of Nassau, where the Robertsons' eldest daughter, Anne, decided to stay and pursue her own fate. Saddened, the family continued on to Jamaica, where eldest son Douglas celebrated his eighteenth birthday.

Next stop was the archipelago of the San Blas Islands, then Panama, where they picked up a new crew member: a twenty-two-year-old graduate student in economics and statistics. Robin Williams was cheerful and adventurous, and Dougal and Lyn hoped that his mathematical prowess would rub off on the children, especially the twelve-year-old twin boys, Neil and Sandy. Robin's plan was to stay with the family for the seven-thousand-mile voyage across the Pacific to New Zealand. He got more than he bargained for—much more.

The first stop in the Pacific was the Galapagos Islands. After an idyllic time spent island-hopping and reveling in what may still be the purest wildlife refuge on earth, the Robertsons set sail for the Marquesas Islands, a group of volcanic islands that forms part of French Polynesia, more than four thousand miles away. Two days out of the Galapagos, on June 15, 1972, disaster struck. Early that morning, while most of the family was in bed, sleeping or reading, the *Lucette* was struck by a blow of unthinkable proportions. Instantly, the sound of rushing water filled the cabin, as the cry of "Whales!" hurtled from the cockpit. Dougal rushed to the hole to find the blue Pacific pouring into the now-fragile craft. The desperate efforts he and Lyn made to stop the onslaught of water were futile. The *Lucette* was sinking—fast. It had been their home for the previous year and a half, but it wouldn't take long before the schooner was at the bottom of the Pacific.

There was little time to think. Dougal called, "Abandon ship!" and the others sprung to life. Life jackets were tied on, and a few odd tools were grabbed during the mayhem. The ropes holding the dinghy to the mainmast and foremast were cut and an inflatable life raft was sent into the water. With the *Lucette* rapidly disappearing into the shark-inhabited waters of the Pacific, the Robertsons had no choice but to make for their two small boats. The dinghy was half full of water, so they began to swim to the life raft, now fully inflated. The last thing Dougal did before abandoning the *Lucette* was toss a bag of onions, a bag of oranges, and a bag of lemons into the water. He also grabbed a vegetable knife and threw it into the dinghy.

With everyone safe in the raft, Dougal swam for the dinghy, where he gathered up as many oranges and lemons as he could reach and tossed them back to the life raft. The *Lucette*'s water containers had either floated

away or sunk, as had a box of flares. He swam back to the life raft, grabbing a floating tin of gasoline on the way. As he swam toward the rubber craft that now held everything precious to him in the world, he caught one last glimpse of the *Lucette* as the tops of her sails disappeared into the ocean.

The Robertsons and Robin were all on board, shaken but very much alive. And while they all made it, their folly was that they didn't have a pre-set plan (an ultra-efficient way of jumping into action without thinking) of what to do if something went wrong. It is surprising that they didn't have a survival kit at the ready that they could grab in emergency situations. Luck-ily, though, they had the raft, which was stocked with its own survival kit.

As the shock of their new reality washed over them, the details of what had just happened started to become clear. Douglas, who had been on watch at the time of the accident, saw a pod of about twenty killer whales (orcas) approach the *Lucette* at top speed. Three of them rammed the ship's six-thousand-pound lead keel, shattering the elm strakes of the keel on impact.

I was once on a boat during a *Survivorman* shoot in the high Arc-tic, when we came across nineteen orcas as they chased a few hundred narwhal, which, in turn, were chasing arctic char. In similar fashion to the Robertsons' experience, three orcas broke off from the pod and sped straight for the side of our twenty-foot steel boat. They came within inches of ramming our craft, but suddenly dove, made a sharp right turn, and resurfaced in front of the boat. It was terrifying, yet exhilarating, and for-tunately, I didn't meet the same fate the Robertsons did that day in 1971.

In those early moments after the disaster, Dougal wrestled with an emotion that affects so many people in survival situations: guilt. *He* had sold all their belongings and brought the family on this voyage. *He* had failed to anticipate this type of disaster. *He* was ultimately responsible for their well-being.

Yet like many who had come before him, Dougal channeled his guilt into motivation to survive. He began almost immediately, first by tak-ing stock of their minimal supplies, beginning with the raft's survival kit, which was encased in a three-foot-long plastic cylinder. The survival kit contained the following:

vitamin-fortified bread and glucose for 10 people for 2 days
water (18 pints)
flares (8)
bailer (1)
fish hooks (2 large and 2 small)
spinner and trace (1), along with 25-pound test fishing line
patent knife
signal mirror
flashlight
first aid kit
sea anchors (2)
instruction book
bellows
paddles (3)

They also had the bag of onions, a one-pound tin of cookies, a jar containing about half a pound of candies, ten oranges, and six lemons. There were six people—four adults and the twins—in the middle of a rarely traveled section of the Pacific. Things were looking grim, indeed.

I understand the fear they must have been experiencing. It's one thing to go without food, but the prospect of dehydration must have risen to the front of their collective consciousness very quickly. That's why it must have been very difficult to sit and watch one of the *Lucette*'s water containers float away on the sea. But these were shark-inhabited waters, and a pod of killer whales had just sunk their forty-three-foot boat. It would have taken a real act of heroism to jump into the water and retrieve the container. Nobody did.

Lyn and Dougal immediately set to the task at hand: surviving. Whether they knew it or not, they jumped to activity with the most important first step in any survival situation: assessment. Lyn wanted to know, brutally and exactly, what their chance of survival was and how they might get back to safety. But first, she provided all the motivation she and Dougal would need in the many weeks to come. She put her hand in Dougal's and said quietly, "We must get these boys to land. If we do nothing else with our lives, we must get them to land."

According to *Essentials of Sea Survival* by Frank Golden and Michael Tipton, in addition to the standard kit that comes with a life raft, you should have

buoyant smoke signals (2)
extra anti-seasickness pills
extra first aid kit
heliograph (signaling mirror)
parachute flares (2)

radar reflector
red handheld flares (3)
second (spare) sea anchor
sunscreen and lip salve
thermal protective aids

Also consider adding these items:

antiseptic cream or petroleum
 jelly (small container)
balaclava with waterproof outer
 shell
batteries
book on survival
Cyalume sticks
diary (logbook) and pencils
flashlight, waterproof with
 attachment clip
fracture straps (2)
garden-pool repair kit (with
 adhesives that can be
 applied to wet surfaces)
gloves, warm and waterproof
GPS unit

handheld VHF transceiver,
 waterproof
hard candy (several packages)
matches, waterproof
multi-tool or Swiss Army–style
 knife
nylon string
personal location beacon
plastic bags (medium-sized)
 and ties
plastic food wrap (1 small roll)
plastic garbage bags (1 small
 roll)
safety pins (1 package)
scissors, blunt-ended, heavy-duty
SPOT personal tracker

The grab bag should be waterproof and buoyant, with a handle that is easy to grab with cold hands. There should be some means of securing it to your body, such as a lanyard, should you need both hands to do something else. It should be stowed safely in a place where you can easily get it at the last minute before abandoning a sinking vessel. Check it regularly to make sure that items are not deteriorating, expiry dates have not passed, and things like batteries are still fresh.

SEA SURVIVAL KIT (CONTINUED)

If time permits, try to salvage the following useful items from the sinking boat and load them onto the raft. Bulky items that are buoyant may be floated alongside the raft and attached to it.

camera (with flash)

empty boxes

fenders

fishing equipment or a spear gun (take care to avoid puncturing the raft!)

knife and sharpening tool

portable bilge pump (easier to use and more effective than a bailer)

seat cushions (to preserve body heat)

sunglasses

towels and spare clothing

Tupperware-style food containers, filled with carbohydrate-rich foodstuffs: chocolate, condensed milk, cookies, dried fruit, fruit juices, hard candy, jams or jellies, sugar, etc.

additional items from the medical kit: antibiotics, antiseptic solution, clear adhesive tape (for wound suturing), eye drops, inflatable splints, skin creams (including Sudocrem and Flamazine for burns), spare bandages and dressings

The bottom line: anything you take could prove useful, so take as much as you can, depending on how much time and space you have.

Lyn was very brave (and smart) in asking Dougal for the truth about their situation. It would have been far easier to sugarcoat reality, especially with children on board and the pain of losing the *Lucette* so acute, but there is no room for fantasy in a survival situation. The truth should almost always be told. The only exception would perhaps be when you are dealing with an extremely panicky person who is on the verge of losing control.

Dougal considered the situation as thoroughly and realistically as his seafaring mind would allow. They were more than two hundred miles downwind and down current from the Galapagos. Rowing back was impossible, even if the two strongest took to the dinghy to seek help while the others stayed behind in the raft. The Marquesas lay thousands of miles in

the other direction; reaching them would be a physical and navigational impossibility, especially since all their navigational tools had gone down with the *Lucette*. The coast of Central America, more than a thousand miles to the northeast and on the other side of the Doldrums (also known as the "equatorial calms"), a low-pressure area around the equator renowned for its calm winds, seemed equally unreachable.

Of course, the other option was to stay put and wait for rescue, an important consideration in any survival situation. Yet Dougal knew that it could be as long as five weeks before a search was even initiated. Even then, the chance of being found—a virtual speck in thousands of miles of open ocean—was slim. The chance of being rescued by a passing vessel was equally remote, as the closest shipping routes lay hundreds of miles away. Rain was scarce and wouldn't come to the region with any kind of regularity for another six months. Their hope of survival beyond ten days was faint, at best.

With the faces of his wife and children staring eagerly back at him for insight, Dougal's decision became clear. Their only hope of rescue would be to sail with the trade winds to the Doldrums, four hundred miles north. Not only did the closest possible shipping route lie in that direction, but if they were going to harvest sufficient rainwater to keep alive, they first had to reach a place where rain might actually fall. The Doldrums were the closest possibility. The only question was: Did they have enough water to keep themselves alive until they reached the Doldrums? And even if they made it to the Doldrums alive, their journey was just beginning. Once there, they would have to float or paddle back to the coast of Central America.

Dougal must certainly have been dismayed by the stark reality of their situation, but he never gave anyone false hope. He never deluded Lyn or the children with silly thoughts of something that wasn't possible. Instead, he kept it real, assessed, and made a firm—and intelligent—decision.

Rather than becoming disheartened by their slim chances of survival, the Robertsons rose to the occasion. They now knew their task, had a goal. They would wait at the scene of the accident for twenty-four hours to see if any wreckage from the *Lucette* surfaced. After that, their destination lay to the north. Dougal was invigorated and felt the hopelessness lift from his shoulders. His reaction is a testament to the power of decisiveness in a

survival situation. With the decision made, they now had a purpose, a common goal. The Robertsons and Robin settled in for whatever this ordeal would throw at them next.

The first task was to deal with the mound of debris in the center of the life raft. In addition to the raft's survival kit, there was a huge sail and two hundred feet of fishing line that Douglas had pulled from the *Lucette* as she sank, as well as three gallons of gasoline, two oars, and two empty boxes. Lyn had also managed to rescue her sewing basket, which proved to be a treasure trove of useful devices. They were delighted to find that it not only contained the usual stores of needles and thread, but also two scalpel blades, four knitting needles, a blanket pin and hat pin, three plastic bags, a ball of string, buttons, tinfoil, a shoehorn, two small plastic cups, two plastic boxes, two small envelopes of dried yeast, a one-foot piece of copper wire, rubber bands, a bottle of aspirin, a pencil, and a pen. They also had a half pint of varnish, a West Indies pilotage book, and Dougal's watch.

They set to work right away, stripping a wire from the sail and using it to attach the raft to the dinghy. Robin and Neil got seasick and started vomiting as the little raft pitched and bobbed in the rolling seas of the Pacific. It was an alarming start to their adventure. Each time they vomited, they lost precious fluids, which would be difficult to replace in the weeks to come. Luckily, the first aid kit came with antinausea pills.

While stowing and organizing all their gear, the Robertsons found an instruction book in one of the side pockets of the life raft. Unfortunately, it offered little in the way of useful information on how to survive in the middle of the ocean. Instead, it contained lots of fairly useless information on morale and leadership. Dougal thought the best part of the pamphlet was its last two words: GOOD LUCK!!

The rationing began that first evening, as each person was afforded a biscuit and a sip of water, one-sixth of an orange, and a hard candy. Lyn, who was a very spiritual person, drew comfort in those darkening hours by praying and singing religious hymns. Ever the pragmatist and atheist, Dougal spent the quiet time by trying to pinpoint their location. It was difficult to concentrate, though, as they were surprised to find that their raft had become a bit of an attraction for the many sea creatures that called those waters home. Throughout the night, dorados—also known as dolphin fish or mahi mahi—bumped the underside of the raft continuously.

Little can be done to stop seasickness once it hits, but you may be able to prevent it, at least for a while. These tips may come in handy:

Try to look at the horizon as much as possible.

Shift your body with the waves so that you stay upright most of the time (impossible on a raft).

Use acupressure points (on the pulse-taking side of the wrist, for example).

Get in the water for a swim, if it's safe to do so.

Sea turtles also bit at the bottom of the raft, though never hard enough to penetrate its thick double skin.

They took turns keeping watch in two-hour shifts throughout the night, a ritual they brought with them from the *Lucette*. The person on watch not only helped keep the raft pointing into the heavy swells of the ocean, but also served as lookout for ships in the distance.

As day two of their ordeal dawned, the Robertsons were surprised to find that the pressure in the raft's flotation chambers had dropped dramatically during the night, largely due to cooling of the air. When they found that the bellows would not sufficiently pump up the chambers, they resorted to cutting the rubber tube from the bellows and blowing up the raft by themselves. After a few minutes of blowing, the raft was back to normal. It was an action they would repeat continuously until they finally had to abandon the sinking raft.

Dougal spent most of the morning bailing out the *Ednamair* and rigging a sail to the dinghy. The plan was to set the dinghy out front, acting as a tugboat and towing the raft during the trip north to the Doldrums. Later that afternoon, they set off, and it was now that Dougal began to realize just how fortunate he and his family had been to even have the raft, which now stood between them and a watery death.

As it turns out, the raft had been a gift from Captain Siggi Thosteinsson, a friend who had become dismayed at the sad state of the Robertsons' raft in Miami and gave them one of the two he was carrying at the time.

It was a bulky but comprehensive craft—fully enclosed, like a floating dome tent. It even had a double canopy roof, which prevented the Robertsons from becoming dehydrated in the blazing South Pacific sun.

Why did the Robertsons, who were clearly knowledgeable and well-prepared sailors, ignore such a vital element of survival by not having one of their own to begin with? I have no idea, but they're certainly not the first, and won't be the last, to make that mistake. It sounds crazy, but so many sailors do not pay attention to their rafts. Most don't check and repack their rafts regularly. Unbelievably, some don't even take one!

When I spent a week surviving in a raft in the waters off Belize, I started with two rafts, which I purchased from two different sailboats. The first raft sank in just a few minutes. Luckily, I was only ten feet from shore when I found this out. The second, which I ended up spending four days in, leaked constantly, just like the Robertsons'. I hate to think how long they would have lasted had they been stuck in their original raft.

In that second day on the raft, the Robertsons and Robin spent some time writing farewell notes to the friends and family members they would leave behind should they not make it to safety. The ever-ingenious Lyn had cut small pieces of sailcloth to serve as paper. When finished, the letters were secured in waterproof wrapping and stowed in one of the raft's pockets.

Although I understand why they did it, I can't help but feel that this kind of action—focusing on death rather than the task at hand—is the wrong one to take. Dougal noted that they thought it a better idea to do it sooner, when they were strong and fit and the prospects for survival good, rather than later, when they might not have had the mental, emotional, or physical strength to face the truth. But I still say it's the wrong mentality altogether, much too sad and forlorn for a time when you're trying to be upbeat and positive. For me, the goodbye note is the last thing that should be done in a survival situation, and only when it is very apparent that you are doomed. Frankly, I'm surprised the Robertsons did this at all, because until then they had been so proactive.

It is not surprising, given the morose task they had just set to, that Lyn told Dougal that if Neil—who had clearly suffered the most during those early days and was not looking at all well—died, she would go with him. Ever the pragmatist, Dougal said she'd be much more useful alive than dead.

Sleeping on the raft was a cramped and uncomfortable affair. Even with one person on watch, the five bodies were wrapped around and on top of one another. Seawater seeped through the floor of the craft and collected in pools under them. It makes me wonder why they didn't have one or two people sleep in the nine-foot dinghy to make more room. In addition, their bodies would fare much better than they did sitting in salt water all day and night. I imagine it was because the floor of the dinghy was hard and uncomfortable, but they would find that out soon enough, anyway.

The next morning—day three—the Robertsons awoke to find an eight-inch flying fish had launched itself into the dinghy overnight, a gift from the sea and an early indication of the kind of luck these castaways would experience. After Dougal cleaned the fish, Lyn again demonstrated her resourcefulness by marinating, and therefore effectively cooking, the fish in a squeeze of lemon juice. This is a great way of preserving fish if you have no way to cook it. You can even do it in your home in an urban disaster situation.

TREATING FISH WITH LEMON JUICE

Chefs know this trick already. Simply submerging raw fish in pure lemon juice for a short period of time actually "cooks" the fish. It does not preserve the fish as long as drying does, but makes it palatable and will increase the length of time before it begins to rot.

The clouds thickened as day three advanced, and soon a shower passed overhead. Luckily, the canopy roof of the raft was equipped with a water catchment area, along with a rubber hose that led down into the main compartment of the raft. By pulling down on the hose, a depression was formed in the roof, where water could be collected.

But the stuff the Robertsons collected bore slim resemblance to drinking water. It started out as bright yellow, and saltier than the sea itself. Soon, the water was running clearer through the tube, though it was hardly refreshing. They managed to collect half a pint of yellowish, rubbery-tasting stuff before the shower passed. It wasn't much, but it was a start, and an important lesson in survival.

Catching rain off any kind of roof is generally considered a great way to collect water. And it is. But what is often overlooked is that the first part of the rainfall really only serves to wash the roof. So if you're on land and have a tin roof overhead, that first bit of stuff running down is probably full of animal feces—mice, squirrels, bats, and birds. If, as in the case of the Robertsons, it's the roof of a life raft, then you'll be ingesting bits of chemical paint, latex, rubber, and so forth. It's something raft companies would do well to consider when constructing rain catchment areas on their boats.

Even with this newfound "bounty" from the sky, the family wisely continued to stingily ration its water. Rather than drink a larger amount only once during the day, they partook of very small sips throughout their waking hours. It was a smart move. In the end, you're putting the same amount of water into your body, but the Robertsons' method gives you something to look forward to, even if it's just a sip of rubbery gunk.

Yet, unlike in most group survival situations, the Robertsons were not rigid or mechanical about the amount each person got to drink. Instead, they employed a "ration by trust" system whereby each person took what they felt was the right amount. That said, I'm sure Dougal kept an eye on things, and it's unlikely that anybody exceeded their rightful amount while he was just a few feet away. This method is truly unique among survival stories, and the only time I've ever heard of such a thing. But I'm not sure where I stand on this strategy. I can see it being a great morale booster, since it shows the group's collective faith in one another. But there's also great risk, if someone loses perspective and finishes the entire group's stores in a moment of weakness.

By day four, Dougal had decided that he would try his hand at fishing. Indeed, the only way they were going to survive was by taking advantage of the bounty of sea creatures that swam in the waters around the raft, even if another flying fish had offered itself to the dinghy overnight. A few initial casts seemed to catch the attention of the dorado, so Dougal cast the spinner and lure well out ahead of them. He was shocked to see the spinner arc gracefully through the air, land in the water, then disappear below the surface. Apparently, he had not tied it on correctly, and their only spinner and lure had sunk into the depths of the Pacific. It was a foolish mistake, and Dougal cursed himself mightily for the error of his ways.

This mistake helps illustrate that you must always be cautious and

meticulous in any survival situation. You can't rush things. You have to think *everything* through. In general, Dougal was a fastidious man, a characteristic no doubt honed during his years on the farm and their year and a half on the *Lucette*. He was particularly precise when it came to navigation. He spent hours poring over his charts, estimating how long they would be at sea, their chance of rescue, and the possible route they might take.

Where I think he fell short, though, is in failing to tell the others about a couple of tiny islands that lay between them and the mainland. Dougal realized the only way they would hit the islands was by sheer luck, not navigation, and he didn't want to get anyone's hopes up. But even though the chances of stumbling upon these islands might have been ridiculously slim, the others deserved to know about the possibility. If you believe in the power of positive thinking, or even visualizing, having everyone hope for the islands might have created enough positive energy to actually lead the raft to one.

As the days went on, the group entertained itself as best it could, with games like Twenty Questions and I Spy. The raft was losing air more rapidly than ever, and they had to dedicate more time to blowing it up. Food was scarce, and they were clearly losing weight, though the occasional gift of the flying fish helped bolster their meager food stores.

On day six, they received a far more generous gift from the sea. The family awoke to a tremendous noise coming from the *Ednamair*, and when they pulled the dinghy over, they were amazed to see a thirty-five-pound dorado flapping in the bottom. The fish would frequently leap out of the water in pursuit of flying fish; this one apparently miscalculated its flight path. It was a stroke of sheer luck, but when you're floating on a life raft in the middle of the South Pacific, luck may well be the most important of the four additive elements necessary for survival.

Worried that the madly flopping fish would propel itself back into the sea, Dougal leapt into the dinghy, grabbed the fish, and rammed a knife into its head, sawing furiously. When he had decapitated it, he cut the tail off for good measure.

After Dougal had cleaned and gutted the fish, the Robertsons enjoyed more food than they had had in one sitting since the sinking of the *Lucette*. They ate fish flavored with lemon juice and onion, along with a concoction of dorado liver and heart and small pieces of yet another flying fish that

had landed in the dinghy overnight. When they had eaten their fill, Lyn was wise enough to split open the dorado vertebrae. They found the spinal cavity to be full of fresh, nutritious water.

It's amazing that, after what otherwise would be considered a very small meal—the Robertsons were diligent about rationing—most felt quite full. In fact, Dougal was surprised that he was not crippled by hunger pains. I don't find it all that surprising, though. Too often, those of us in Western society figure we are starving if we go about three hours without food. True hunger pain takes much longer to kick in, especially when the adrenaline of a survival experience is involved. I don't really get hunger problems until day four of my survival experiences, and sometimes not even for a week.

Encouraged by the bounty of the dorado, Dougal continued his fishing attempts. He started with the large hooks, baiting them with the heads of the flying fish or guts from the dorado. But Dougal was thinking too big by going after dorado from the get-go. He would have been much better off fashioning a very tiny hook and catching the numerous small fish that also swam around the raft rather than trying so hard for big ones. Small fish are not only easier to catch, they're much safer, too. Large fish are powerful creatures, and many unsuspecting fisherman have been injured by their wildly flapping bodies. Their sharp teeth can rip a hole in a rubber raft. Catching, cleaning, and eating small fish would kill much more time, which not only offers a psychological benefit, but would give the kids the chance to try, too. Going for the big fish is not really survival thinking, it's recreational thinking.

The seventh day on the raft was a momentous one, in several ways. The day began with an outburst of rain. Soon, the water running down the pipe from the catchment area on the roof was clear, and everyone drank until they were bursting. They also filled up as many spare jars, cans, and plastic bags as they could. With such an increase in their water supply, spirits were high.

They soared to even greater heights later that day, when Douglas cried out that he had seen a ship. Everyone crowded to the door of the raft, and sure enough, a huge cargo vessel was approaching on a course that Dougal estimated would bring them within three miles of one another. Although three miles is a long way to see a flare during the day, they were

encouraged that gray skies would help their cause. Dougal climbed into the dinghy and set off one of the rocket flares. Thankfully, it fired, cutting a long, pink arc in the sky. They were about to be rescued! When the ship didn't change its course in the direction of the raft, Dougal lit a hand flare, waving it high over his head until the heat made it unbearable. Still, the ship did not alter course. He struck another hand flare and waved it frantically, to no avail.

With the eager faces of his family and Robin glancing back and forth from Dougal to the ship, he struggled to make a decision. Realizing that such a chance might never come again, he knew what he had to do. He would use their last rocket flare and one more hand flare, which he did. Still the ship did not turn. They had not been seen.

I don't disagree with Dougal using most of their flares. Indeed, it might have been weeks—or months—before they were seen again by a passing ship. What surprises me is that they didn't seem to have planned for what they would do in that event. In desperation, Lyn urged Dougal to set fire to the sail in a last-ditch effort to be seen. It was an irrational, and potentially disastrous, suggestion. Sure, it *might have* increased their chance of being rescued, but given the lack of response to the five flares they set off, chances were still slim. And without a sail, getting to the Doldrums alive would have been nearly impossible.

In those desperate moments as the ship sailed away, something snapped in Dougal. But it wasn't what you might think. With the prospect of rescue looking less and less like a reality—when would they have another chance like that?—Dougal did not sink into depression or self-pity. Quite the opposite. With all hope seemingly lost, Dougal decided that he would no longer think of rescue as a viable outcome. From now on, their survival was their own responsibility. They would make it to safety under their own power and by the strength of their collective ingenuity. Dougal vowed not to use the words *rescue* or *help* anymore, a surprisingly common occurrence in survival situations, particularly when it becomes obvious that the rescue you have hoped for is not going to come. The same thing happened to Nando Parrado and some of the more steel-hearted of his teammates after their plane crashed high in the Andes and they learned via transistor radio that the search had been called off.

It is, without a doubt, this kind of thinking that will enable someone

to survive. As Dougal so rightly said, it was no longer a question of *if* they made it to land, but *when*.

Later that afternoon, they were disturbed by an unusually hard bump on the bottom of the raft. They had become accustomed to the many sharks filling the waters around them, but this felt different. When they looked out over the side, they were amazed to see the scaly head of a sea turtle looking back at them. The old Dougal Robertson might have let the beast swim away, but with his newfound mantra of survival at all costs still ringing in his ears, Dougal leapt to the dinghy and pulled the eighty-pound turtle aboard by its flippers, careful to avoid its sharp beak, which was now snapping wildly.

Slaughtering and butchering the turtle would be no easy trick, but Dougal used his combined experiences as a sailor and farmer and set to the task. He set his feet on each of the front flippers, held the beak in his left hand, and plunged the knife deep into the turtle's neck, quickly killing it.

SKIN AFFLICTIONS WHEN ADRIFT AT SEA

Anybody who has spent time in the bottom of a water-filled boat under the burning sun knows all too well that there is nothing romantic about drifting helplessly across the open sea. From sunburn to boils, there are several ways your skin can turn on you in these situations.

Sunburn is the most obvious risk. Dougal and his family were fortunate enough to be covered by canopies, which minimized their exposure to the sun. Others haven't been so lucky. As we all know, prolonged and extensive sunburns increase the risk of skin cancer.

The risk of sunburn on the open sea is magnified even further by the fact that salt water drains away skin's natural moisture, making it more susceptible to dryness and cracking. Constant contact with salt water also chafes the skin and makes it prone to the formation of boils, those tender, red, pus-filled lumps that make the simple act of sitting a painful undertaking.

Unfortunately, they had not learned yet that the blood of the turtle, which was spilled during the quick killing, was an extremely valuable food source.

The next days found them happy and motivated. They had food drying in strips all over the boats, water was plentiful for the moment, and they were driven by their collective will to live. Their mantra—"Survival!"—was repeated often, as a daily watchword. Their focus was clear and intense.

While Dougal played the role of hunter, Lyn's days were full to overflowing as she tended to everyone's well-being in one way or another. She worked hard to keep the twins, Neil and Sandy, active and moving to the extent that she could on the cramped raft. Her daily exercise regimen was a stroke of genius, but it should have extended to all the people on the raft, not just the twins. When you're in cramped quarters and have little room to move, you need to do anything you can to prevent your muscles from atrophying. One of my favorite ways of doing this is by employing the yoga-like method I described in Chapter 3 (see "Curing the Nighttime Chills, page 50). Not only does it help generate heat in cold, cramped places, but it keeps the muscles active, too.

Lyn's involvement did not end with exercise. She also looked after everyone's skin, which was becoming peppered with various boils and sores, the result of exposure to the sun as well as the constant sitting in salt water. She also took care every day to dry out the bedsheets, which became soaked each night as water seeped into the raft. They didn't stay dry for long, but it was comforting for everyone to at least lie down on something dry.

Lyn's attention to the small details was brilliant. She not only occupied her time—and that of the others—with a series of small tasks, but her meticulous devotion to tidiness likely kept everyone as healthy as possible. Hygiene and cleanliness are often overlooked in survival situations, but they are important considerations, especially in the long term. Yet the one thing Lyn could not reconcile was the weakening condition of the twins, especially Neil, who had been so seasick when they first boarded the raft. She and Dougal discussed it at length, and finally decided that as long as they could harvest food from the sea, the raft's emergency rations would be kept as supplemental rations for the twins only.

As a parent of two children, I certainly understand why they put the rations aside exclusively for the twins, but don't necessarily agree with it.

Their primary rationale was that the kids' digestive systems might not be able to handle raw food, but the brutal fact is that if Lyn and Dougal didn't survive, the chances of the rest of them surviving was greatly diminished. It seems they were doting on the twelve-year-olds quite a bit. In fact, the twins were quite capable of pitching in and helping out. But Lyn would have none of that. She focused on them constantly, often denying herself to give them more. She gave them "little dinners"—a bit of extra food beyond what the adults were eating. She even went so far as to pretend to drink her share of water when the jar was passed around, but only pressed the glass to her lips so there would be more for the twins. While seemingly noble, these were risky and unproductive steps to take. You can't help anyone if you yourself are incapacitated. The caregiver must keep himself or herself as strong as, if not stronger than, those they are looking after. In a survival situation, selflessness can be stupidity.

I don't mean to seem heartless here. I've never been in a survival situation with my kids, so don't really know how I would react. And I recognize that children are weaker than adults, with less maturity and less resolve. If babying the twins gave Lyn and Dougal a focus that also helped keep themselves strong, it may have been the right thing to do. But the pampering seemed a bit much and possibly counterproductive to the survival of all. These were twelve-year-olds, not helpless toddlers.

The hours and days passed, yet the Robertsons were doing surprisingly well. They had food and water, and nobody had fallen ill. Yet the ordeal was beginning to take a gradual toll on their physical frames. The skin eruptions and boils that made sitting and sleeping so difficult were worsening. This was primarily due to the salt water, which was now leaking into the raft with alarming regularity. The life raft had sprung quite a few small leaks, and it looked as though the dinghy might soon become their home at sea. Dougal worried about whether the *Ednamair* was big enough to hold them all without capsizing on the ocean swells.

With so much time on his hands, Dougal obsessed over the idea of catching fish. I have been in many situations where a problem at hand has been solved by someone "obsessing" over it, as was the case when the plane crash victims needed a better water supply in the Andes mountains tragedy. In the right circumstances, obsessing can be useful; in this case, the waters were literally teeming with fish, yet the Robertsons could find

no way of getting them out of the sea and into the boat. Dougal's next idea was to impale them as they swam by, so he began carving a fish spear from an extra paddle handle.

This kind of innovation is a testimony to the Robertsons' collective ingenuity and resilience. They were great at fixing problems when they arose. But the family—and Dougal in particular—never seemed to devote much energy to anticipating what might lie around the corner. Time and again, Dougal simply accepted the first solution to a problem that presented itself, apparently without taking the time to ask himself what else might go wrong and how he might deal with *that*. In reality, he would have been wise to look for two to three solutions to each problem.

For example, near the end of their second week adrift, Dougal tugged on the rope that secured the raft to the dinghy and found that it came slack in his hand. The pin that held the rope to the dinghy had worked itself loose with time, and nobody had bothered to check it. I would guess that Dougal assumed the rope was safe enough, but he really should have devised a backup method of securing the dinghy to the raft. He's lucky they didn't come apart in rough water, or they would have lost the dinghy completely and come to a very different end.

Similarly, they seemed content to use the roof of the raft as their primary method of collecting rain. Given the infrequency of rain and the critical importance of water to their survival, they would have been wise to use the extra sailcloth as a secondary catch. Again, though, they had one answer to a problem, and it was good enough. The Robertsons didn't investigate other possibilities, even if it would have meant more water for them. Had I been in their situation, I would have at least considered the possibility of a solar still, a device that makes seawater drinkable and could have made their lives a heck of a lot easier.

Although the days were long and monotonous, there was the occasional spate of excitement. One morning, Dougal entertained the idea of catching a dorado by hand, and held his hand just under the surface of the water, hoping to grab one by the tail as it swam by. When the raft shuddered from a collision with what seemed like a particularly large fish, he slid his hand into the water, waiting. He was surprised to find the fish swimming perfectly between his arm and the raft, and he instantly hauled it out of the water. To his surprise, he held in his arms a five-foot mako

USING A BOX SOLAR STILL

The basic premise of a solar still is that the sun's rays are used to evaporate the water, leaving the solid matter (the salt) behind.

Many solar stills are built by digging a hole in the ground, but you can also construct what's called a box solar still, which uses any kind of rigid structure to hold its components. Into the box goes a container of salt water (if the box is plastic and doesn't have any holes in it, you can pour the seawater directly into the box). Place a small container such as a cup or jar in the middle of the box, then cover the box with plastic sheeting.

Weigh down the sheeting with an object such as a rock. The weight should form a small depression in the middle of the plastic sheet, directly over the container, that will catch the pure water. Make sure the plastic sheeting is sealed as tightly as possible around the perimeter of the box.

Place the still in a spot where it will be exposed to as much direct sunlight as possible. As the sun beats down on the box, the salt water will evaporate, leaving the salt behind. The pure evaporated water will condense on the plastic sheeting, run down to the point formed by the weight, and drip into the container. It's not the most efficient way to collect fresh water, but it's better than nothing.

One of the only people ever known to successfully drink salt water was Dr. Alain Bombard, a French biologist who sailed a small boat across the Atlantic in the 1950s. Bombard claims to have survived the trip by fishing, harvesting surface plankton, and drinking a limited amount of seawater for long periods. His claims were contested by some scientists, who believed Bombard had been secretly provided supplies during his voyage.

Of course, the alternative is to drink seawater, a practice overwhelmingly regarded as incompatible with life. Seawater is usually about three times saltier than blood, which makes it impossible to be safely metabolized by the human body. When you drink salt water, water flows out of your cells as your body tries to dilute the salt and cleanse the body. So the cells become more dehydrated, not less. If the process continues, it can result in seizures, unconsciousness, brain damage, and, ultimately, death.

shark, which could sink the fragile craft with one slash of its razor-sharp teeth. Dougal hurriedly threw the shark back into the water, relieved that it hadn't done any damage.

Day fourteen came with another gift from the sea. A second turtle bumped into the raft, and soon it was struggling in the bottom of the dinghy. Dougal was about to execute it when he heard Lyn tell him to save the blood for drinking. He gathered some in a plastic cup, set it to his lips, and was surprised that it was not salty at all. They passed the cup around, happy to have something—anything—to drink in the blazing South Pacific heat as their stores of water again reached dangerously low levels. It was a brilliant, lifesaving move on Lyn's part, especially after the blood of the first turtle had been wasted.

Good luck came to them again, just as the situation was getting desperate. Day fifteen dawned cloudy and threatening, and soon rain was falling from the sky in copious amounts. They not only filled all their containers, but drank their fill of the glorious gift from the sky. It was yet another in a litany of smart moves by the Robertsons. In situations where dehydration is a real risk, it's not enough to fill your containers. It's as important—if not more so—to drink as much as you possibly can in that moment.

The bad weather was not all good news for the Robertsons. In the rough waters, the dinghy broke away from the raft and began drifting into the distance. When Dougal caught sight of the boat, it was already sixty yards away. Paying little heed to the danger posed by sharks, Dougal—who knew that losing the *Ednamair* meant losing a chance at survival—jumped in the water and started swimming for his life—literally.

Under normal circumstances, the Robertsons stayed out of the water at all costs, a wise decision. But these were not normal circumstances, and Dougal made the right choice. He could see two sharks circling below him as he swam, but they never attacked. I've had similar experiences. During my time in the water with a variety of sharks, I've found that they won't lunge at you right away, but will take a few minutes to assess and make sure they want to mess with you. I have even jumped right into large schools of sharks after they have been baited in, and they still leave me alone. Sharks are not the bloodthirsty attacking machines that documentary television shows might have you believe. Another good strategy I've employed is to always keep them in my sight, since sharks don't usually

attack their prey head on. So, if you can get in the water wearing goggles and face the predator, you stand a good chance of not being attacked.

In the end, Dougal made it to the raft unharmed, then paddled it back, where it was reattached to the dinghy. He collapsed in the raft, ashen and drained from the monumental effort. It was one of those dire moments that are defined by adrenalin-driven superhuman effort, and Dougal was up to the task.

DEALING WITH SHARKS

If your survival situation finds you in a body of salt water, don't create a lot of turbulence by thrashing around—sharks are attracted to this type of behavior. Never enter the water if you are actively bleeding, as a shark can detect even the smallest amount of blood in the water. Finally, do not throw entrails or garbage into the water, as this, too, may attract sharks. Look behind any cruise ship that throws its food refuse overboard, and you will see hundreds of sharks in the ship's wake.

If you do have an encounter with a shark, your only option is to defend yourself—not an encouraging place to be. A shark's most sensitive place is its nose; try to direct your blows there, if possible. Remember that sharks like to attack from behind, so try to face the shark at all times. Keep your back against a coral reef, or wreckage if there is any. Go back to back with your dive buddy and put any object you have between yourself and the shark, like your underwater video camera. Oh . . . and get out of the water!

Although their water stores were again in reasonable shape, they decided to conserve as much as possible, this time without wasting a drop. With that in mind, they realized that the bottom of the dinghy had caught lots of rainwater, which was now mixed with turtle blood. Rather than drink what would otherwise be unpalatable, Lyn brilliantly suggested that the only other way to introduce the much-needed liquid to their bodies was with an enema. Now they needed some way to administer it. It wasn't long before a device was rigged up with two pieces of rubber tubing and

a plastic-bag funnel. Everyone (except Robin, who demurred) received one to two pints of water, much more than they would have been able to drink, given the shrunken state of their stomachs.

By day seventeen, the condition of the raft had worsened to the point where they could no longer put off the inevitable: they had to move to the dinghy. The walls of the raft had been eroded on the inside from the wear and tear of their bodies, and on the outside from the constant contact with salt water. It was leaking constantly and barely holding air; full-time effort was required to bail out the ever-increasing infiltration of seawater and keep the air chambers inflated. Thinking like true survivors, though, they did not simply set the raft adrift and wave a fond farewell. To the contrary, they used much of the raft to modify the dinghy. But not before casting aside much of what they now deemed superfluous, since the dinghy was much smaller than the raft. Dougal reluctantly threw away the two turtle shells he had meticulously cleaned, because they took up too much precious space. I wonder if he might have been able to find a way to strap the turtle shells to the side of the dinghy. They seem like little boats in their own right, and might have helped shed water and increase the dinghy's buoyancy. Of course, they might have failed miserably in this regard, but in survival you should consider every option before tossing anything aside.

Yet for all the salvage of the raft and modifications to the dinghy, there was still quite a bit of raft material left when all was said and done. Rather than somehow finding a way to hold on to that valuable material, which could have been stripped into lashings or used as friction protection inside the dinghy, Dougal cast it away and let it sink—a foolish decision. Again, I don't think the eldest Robertson was thinking of Plan B. He had one idea in his head, and that was it. There was no other way to go, no other scenario to anticipate—dangerous thinking in a survival situation.

Despite their fear that the dinghy would prove mercilessly uncomfortable, the group was happy to find quite the opposite, which comes as no surprise to me. The dinghy was smaller, yes, but it was also dry (so their boils could heal) and didn't require constant inflating to stay afloat. The dinghy's buoyancy was certainly helped by the flotation collar they made from the raft's flotation chambers, but they would have been wise to have checked the comfort of the dinghy well before this third week at sea.

They weren't on the *Ednamair* long before they caught their third turtle. Butchering it in the cramped quarters of the dinghy was tricky, but they managed without incident. With a new store of food on hand, they were able to discard some of the rotting meat from the previous turtle, which they threw to the storm petrels that kept them constant company. I can't say I agree with the idea of casting food aside—no matter how bad it may be—but I also understand the need for a little bit of levity and fun in a survival situation. You can call it a psychological payoff that may be worth the food sacrifice. It also helped that the Robertsons seemed to have a fairly good supply of food on hand, despite the fact that they were floating in the middle of the ocean.

Dougal and his son Douglas were the only two who knew how to pilot the dinghy, so they were forced to take turns at the back of the craft, operating the steering oar. I know Dougal was a control freak—an alarming trait that manifested itself again and again—but this was going too far. He had Robin (a twenty-two-year-old man) and Lyn (his ultra-capable wife) on board, too, not to mention the twelve-year-old twins. It's ridiculous that Dougal didn't take the time to teach everyone how to steer the dinghy. What if Dougal and Douglas fell ill or died—a very real possibility given the circumstances? But again, Dougal accepted the answer at hand and failed to explore the matter any further. He and Douglas could steer, so why bother teaching anyone else? His need to be in control, along with his one-track mind, was a potentially deadly combination. At one point, Dougal actually forbade eighteen-year-old Douglas from cleaning a fish for fear he might waste some of the meat. This may have been a possibility, but the benefits of everyone knowing how to perform such vital tasks far outweighed the risks of losing a bit of meat.

As the Robertsons neared the end of their third week at sea, their clothes had disintegrated to virtually nothing. It wasn't really a problem on warm, sunny days, as they could seek shelter under the canopy salvaged from the raft. When it rained, though, their near-nudity became much more acute, and they shivered under what sparse rain gear they had. And the rains did come with more frequency as they neared the Doldrums. The rainwater wasn't easy to collect—they had to hold the catchment material high over their heads with aching limbs, and the rockered bottom of the dinghy was the cause of more than one accidental spill—but they managed.

whether it's your shelter, animal traps, or the ropes holding a float to your boat. There is no room for complacency during a survival ordeal. But the Robertsons made more good decisions than bad ones, and they also had a fair bit of luck on their side, which often outweighed what foolish mistakes they might have made along the way.

Bad weather was scarce. In fact, in the many weeks they spent on the boat, it seems like they really only had to contend with one wicked thunderstorm that required that everyone play a part to keep the dinghy afloat. It seemed to be one of the few times the twins actually helped out with a chore or job, this time by bailing. I find it unforgivable that they were still being babied, to the point where Lyn even feared that they might fall asleep and drown in the few inches of water that occasionally filled the bottom of the raft.

The rain may have provided ample water, but the drawback was its effect on the food they left out to dry. Rather than become the jerky they had hoped for, it was now covered with a foul-tasting, slimy film. Dougal, worried that they would become ill by eating it, threw the turtle meat overboard. It's a good idea to prevent sickness in a survival situation (the last thing you want to have to contend with is diarrhea or vomiting), but it would have been better to anticipate the spoiling of the meat and eat it before it got to that point.

As the calendar progressed, the Robertsons seemed to reach a comfortable state of equilibrium with the sea. Their great ingenuity saw them regularly employ new modifications that made their lives easier. Lyn had the brilliant idea of leaving the turtle fat out in the sun to render. Soon they had jars filled with beautiful turtle oil, which she not only administered as enemas to keep their intestinal tracts working, but also rubbed on their various skin lesions, which soon began to heal. For his part, Dougal was still driven by the idea of harvesting dorado from the sea, and he created numerous variations on a fishing spear. None proved fruitful, until day thirty-two, when Dougal finally realized that, instead of spearing the fish from above, he could fashion a gaff hook, snag dorado from their soft underbellies, and toss them into the boat.

It was a fantastic idea, and one that finally proved effective. Eventually, Dougal became an expert at gaffing. This is a recurring theme in survival: when you try some type of activity over and over again, you will, in time,

Turtles continued to present themselves to the family, so food was not a problem, at least for the moment. Yet the wetter weather made it more difficult to dry and store the turtle meat, and mold had begun to form on some of it. With this in mind, the Robertsons would have been wise to harvest any kind of food they could get their hands on, just in case things went wrong. They didn't, however. On one day, a young blue-footed booby landed on Douglas's shoulder. Dougal considered grabbing it, but was dissuaded by the notion that sea birds were salty, stringy, and full of sea lice. It was foolish; there is no room for pickiness in survival. The Robertsons would have been wise to listen to young Neil, who cried out, "Pluck it! I'll eat it!"

Their narrow-minded pickiness showed itself again when Dougal caught a suckerfish. Rather than butchering and eating it, they threw it back after deciding it wouldn't taste good. In a survival situation, *any* food is worth eating, as long as it's not poisonous. They also could have gathered food by constructing a strainer, dragging it behind the boat, and collecting plankton as they sailed along. And even though they had enough food to keep them alive, the Robertsons, like so many others in long-term survival situations, obsessed over food, despite the fact that they were far from starving. They entertained themselves almost daily by setting up a café they called Dougal's Kitchen and planning the meals they would serve there. With raw turtle and fish as their staples, the thoughts of food such as minced beef pasties, lamb stew, roasted rabbit, and coddled-egg-and-cheese pasties were enchanting.

As their third week began, the Robertsons were beginning to feel li they could stay at sea indefinitely, as long as none of them got sick. Ra was falling regularly, turtles continued to present themselves, and flyi fish occasionally flew into the boat. If anything, it seemed like the Robe sons' greatest sources of risk were their own mistakes. One squally mo ing, as they passed around a jar of water, the boat tipped dangerousl the bright yellow float that helped keep the *Ednamair* above water br away. It would take Douglas, the strongest oarsman on the craft, ne an hour of desperate rowing to catch the runaway float. Again, they failed to set up a strict, military-style regimen of checking things over it came back to bite them. Survival is work, first and foremost, and y got to employ a regular work schedule to check on the things around

become expert at it. Dougal's newfound fishing expertise was a boon for the Robertsons' diet as well as their water intake, as rain had not fallen for many days and their supply was again getting desperately low.

The Robertsons certainly were motivated to collect as much food and water as possible: their plan was not to float to safety, but rather to paddle to it. Dougal estimated that, once they had floated past the Doldrums, they would need another couple of weeks of paddling to get them to the coast of Central America. They would need all the food they could get to keep the rowers fit and strong.

Day thirty-five came with cloudy, rainy weather, a welcome change from the hot sun that had been beating down upon them almost mercilessly for days. Here, for the first time in more than a month, they realized they could use their extra piece of sailcloth to collect water instead of the rubbery yellow catchment material of the raft. As the rain intensified, they were happy to see that the sail held the water long enough for it to be transferred to jars and plastic bags. It was a valuable insight, but one it shouldn't have taken a month to figure out.

Though they had a fair supply of food on board the *Ednamair*, it did not stop them from becoming excited when yet another turtle bumped against the underside of the boat. Dougal called to switch places with Robin, who was in the front of the dinghy, but after more than a month at sea, Robin seemed to feel he was up to the task of pulling the turtle into the craft. He reached over the side of the boat, grabbed the turtle by its flippers, and felt it slide from his grasp. He was not strong enough to get it into the boat.

Dougal lost control. He slapped Robin in the face, then cursed and scolded him severely for what he called Robin's stupidity. Yet if anyone was acting foolishly and stupidly in this situation, it was Dougal. He was the one with the knowledge, but he refused to share it, just as he refused to teach the others how to steer the boat. Robin was larger than anyone else on the dinghy, and easily should have been as strong as Dougal. Teaching Robin (and Douglas, for that matter) how to catch turtles would have ensured the family's survival had something happened to Dougal.

Day thirty-seven brought a discussion of the trip ahead. They now had an ample supply of food for the grueling paddle to the coast. The only thing left to do was fill up the new water bag they had fashioned out of the

flotation collar that had once been wrapped around the bow of the boat. It had sprung so many holes that it was useless for its original purpose, but would hold as much as seven gallons of water in its new incarnation. The bag was almost full; paddling could not be far off. Dougal estimated they were approximately 350 miles away, a distance they could cover in a little more than two weeks.

Rains that evening brought the bag a little closer to full, and Dougal again set to the task of gaffing more dorado. He stuck the hook into the underbelly of a twenty-five-pounder, but as he tried to toss the fish into the boat, he was shocked to feel the lines snap and the gaff go limp in his hands. His last hook had snapped off, and there was little else he'd be able to do to catch fish. Yet, as disappointment began to wash over Dougal, he looked up and saw that the tiny *Ednamair* was laden with a rich store of dried meat. Even if they caught no more turtles, there was likely enough food to get them to the coast alive.

They would never find out. Late in the day, as twilight was beginning to settle across the horizon and they engaged in yet another lively discussion of Dougal's Kitchen, Dougal's expression went blank. "A ship," he said. They all remembered the disappointment of their previous encounter with a ship, so when he stepped up on the center thwart with a flare in his hand, everyone held their breath. He lit the flare and waved it high over his head as long as he could bear the burning sensation in his fingers. When he could stand the pain no longer, he threw the flare as high and far as he could into the sea. He grabbed another flare and did the same. Was the ship altering course? Frantically, he reached for their last flare, their last chance at salvation, and pulled the striker. Nothing happened. The flare was a dud.

He screamed for the flashlight, so that he could send a distress signal in Morse code across the evening sky. He didn't need to. The ship had changed course and was heading their way. They were saved!

When the *Toka Maru II*—a Japanese fishing trawler—pulled alongside the *Ednamair*, Dougal, his wife and children, and Robin felt a feeling of elation like they had never felt before. Soon they and the dinghy were on board the ship. They were weak and unable to walk because of all the time they had spent in the cramped quarters of the raft and dinghy, but were otherwise fine.

Over the course of the next four days, the kindly crew of the *Toka Maru II* treated the Robertsons like royalty. They ate, bathed, and slept the days away until they arrived back in Panama. Ten days later, Robin flew back to England.

The Robertson family chose to make the return trip, ironically enough, by ship.

THE ROBERTSONS

ELEMENTS OF SURVIVAL

Knowledge 10%
Luck 45%
Kit 20%
Will to Live 25%

Almost an even split across the board. Dougal and his family had a nice mix of everything you need to get through a survival situation. They certainly had knowledge, though it was largely limited to Dougal's seamanship and Lyn's medical knowledge; their sea survival skills were fairly minimal. Luck was a huge factor in their survival, whether it was gifts of food from the sea, water from the sky, or the rescue ship that stumbled across their path. Dougal had no emergency survival kit of his own, but the one on the life raft was a huge boon to the family's survival. Finally, he and his family had an intense will to live, as illustrated by their decision not to rely on rescue for their salvation, but to paddle themselves to safety, if need be.

6

Surviving Sharks (Part One)

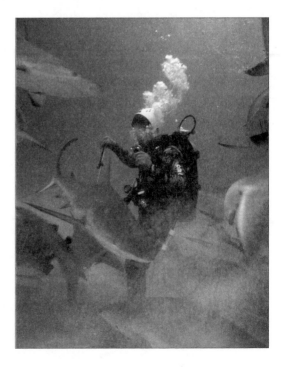

Sixty feet below the surface of the warm Caribbean Sea, sediment from an old shipwreck is stirred up and visibility is reduced to a foot in front of my face. Particles swirl around my oxygen tank and regulator, blotting out the view through my dive mask. In the meantime, I'm being bumped and jostled by huge beings covered in skin with the feel of rubbery sandpaper, their mouths filled with razor-sharp teeth. One tries to go between my legs, another hits my shoulder with the force of a hockey check.

Less than twenty-four hours ago, I received my dive certification. Most people get their certification and complete at least ten open-water dives to gain experience before they start pushing the limits. Yet there I was, on my first dive ever, trying to stay balanced on the deck of a Caribbean shipwreck. I just hoped I was breathing correctly.

I struggle to hold my body in a comfortable position, a proposition made much more difficult by the heavy cage full of dead fish I hold in one hand and the spear in the other. I'm attempting to feed the twenty-five reef sharks circling around me, all ravenous for a taste.

Ten feet away swim two cameramen who capture it all on film. Idiotic, you say? Probably. But for some reason, TV producers are obsessed with ratings, and they seem to think that my role as Survivorman makes me a suitable candidate for this kind of thing.

To be fair, I *did* grow up a huge fan of Jacques Cousteau. So, after forty-five years of snorkeling experience, when the chance came to dive with sharks, I jumped in headfirst.

When I was asked to host the twenty-fifth anniversary of Shark Week for the Discovery Channel, I may have played it cool on the phone, but I was jumping for joy. Sometimes, the chance for the thrill of a lifetime has to be accepted without questioning the repercussions. The opportunity may not return.

Coast of Florida

I grew up wanting to be like Tarzan. I watched those Johnny Weissmuller movies religiously every Saturday morning. But our shark wrangler, Manny Puig, actually thinks he *is* Tarzan. Hell, he might actually be! "I'm going to get you to catch a ride on a great hammerhead shark's dorsal fin, Les!" Manny proclaims. "I'm in!" I call back.

Three hours later, Manny and I float in the gulf waters off the coast of Florida, me in my trunks and Manny in his Speedo. Manny scrapes a knife against the side of a dead fish (the sound is supposed to attract hammerhead sharks); I'm trying not to swallow salt water through my snorkel. Suddenly, producer Scott Gurney screams, "Get Les out of the water—*now!*"

I pretend not to hear, and dunk my head under the water to get ready for the ride. The hammerhead is about ten feet below me, doing side-to-side chomps on the bait; the sound is remarkably audible under the water. Without warning, Manny grabs my forearm and slams my hand down onto the shark's surprisingly rough dorsal fin. I'm not ready, and haven't yet taken a full breath of air, so off I go on a seven-foot-long shark ride of naturalist, shark-loving bliss. The hammerhead comes back a few more times, and I free dive down to caress him on a few of his passes until he swims away.

But Manny isn't through with me yet. Next, he wants me to hand-feed a lemon shark. Don't let the name fool you: lemon sharks can be very aggressive and are big enough to rip a man to pieces. "They can be really nasty, these lemons," he cautioned. "Without warning, they just get pissed at you, turn around, and snap your hand off."

Nevertheless, I'm soon floating in six feet of murky water with two-foot visibility, with Manny again scraping dead fish. This is just eerie, because I can't see a thing. There will be no warning. The big lemon shark will just appear out of nowhere and cruise past my very bare feet, all while I'm holding bait in my hand and scraping it with a knife.

Four hours into the test, I dangle the fish below my body, trying not to think about the cramps developing in my arm. Finally, a big lemon rises from the depths, lifts its head, and rips the dead fish from my hand.

Mission complete.

Bahamas

Dive shop owner Stuart Cove and I kneel beside one another, forty-five feet underwater on the deck of a rotting shipwreck. The twenty-five Caribbean reef sharks circling us, some as long as nine feet, come within inches of us to take a hunk of fish off our spears.

As the pieces start to get smaller, my confidence increases, so I figure I'll just use my hands. Big mistake. I'm waving a juicy morsel of tuna in the water when a shark suddenly turns more quickly than I expect and takes the bait—and my hand!—in its mouth.

The shark chomps down on me. I'm surprised by the feeling, which is very similar to the bite of a large dog. It's a good thing I'm wearing protective chain-mail gloves, because otherwise I'd be typing this manuscript with only one hand.

The shark's teeth cut down to my knuckle, but, thanks to the chain mail, not through. I thrash and pull my hand out while delivering a left jab to the shark's side to push it away. As it turns, it takes the cameraman's arm in its mouth; fortunately, he too is wearing chain-mail gloves.

When we surface, my air has run out due to the excitement. But that doesn't stop me from yelling, "That had to be the coolest thing I have ever done!"

7

Sought Solitude, Found Death

FEW FIGURES HAVE CAPTURED THE WORLD'S
COLLECTIVE IMAGINATION AS POWERFULLY AS
CHRIS McCANDLESS HAS. BRILLIANT,
ATHLETIC, AND STRICKEN WITH ONE OF THE
MOST ACUTE CASES OF **WANDERLUST**
EVER DOCUMENTED IN THE POPULAR MEDIA,
McCANDLESS'S **NOMADIC** DAYS WERE MADE
FAMOUS BY THE PUBLICATION OF JON KRAKAUER'S
ARTICLE IN *Outside* MAGAZINE, BY KRAKAUER'S
SUBSEQUENT BOOK, ***INTO THE WILD***, AND
BY SEAN PENN'S FILM OF THE SAME NAME. YET AS
POWERFUL AS THE McCANDLESS STORY MAY BE, THE
FACT IS THAT CHRIS DIDN'T HAVE TO **DIE.**

He was young, strong, supremely confident, and fed up with modern society. So Chris McCandless set out on a journey, one where he would not only shed the layers of conformity that had been heaped on his shoulders by the outside world but also discover who he truly was. For nearly two years, Chris McCandless lived that dream, traipsing along the fringes of society. Then he decided to head into the Alaskan wilderness. It was the last place he'd ever call home.

And while it's difficult to find fault with a young idealist seeking an existential experience through wilderness living, the fact is that McCandless was woefully unprepared for what faced him when he set off into the Alaskan bush in April 1992. As soon as he took his first step on that untamed soil, he was writing the prologue to his own death sentence. But Chris McCandless didn't have to die.

McCandless's idealistic and romantic view of the world's wild places was, at least in part, born of the authors he adored, people like Jack London and Henry David Thoreau. They seemed to forge in him a certain philosophical arrogance that made him dislike society and yearn for a place where he wouldn't have to compromise his ideals.

But idealism and arrogance are dangerous partners to bring into the cold Alaskan wilderness. Nobody romanticizes how painful it is to get

frostbite or how awful it is to go without food for days on end, but these are the realities of most survival situations, and they seemed lost on Chris.

Although he certainly started marching to the beat of his own drummer much earlier in his life, the road to his eventual death began shortly after he graduated from Emory University in June 1990. Without a word of notice to friends or family, he loaded what few belongings he had into his old Datsun and started driving west. His goal, apparently, was to leave behind the trappings and structure of modern-day society. Here was a young man who wanted nothing to do with schedules or responsibilities, meetings or deadlines, or the encumbrances of material possessions. He got exactly what he wanted—and, unfortunately, much more.

Shortly after his journey began, McCandless shed his legal name and started calling himself Alexander Supertramp. He traveled across the country throughout that summer and fall, living, essentially, like a super tramp. He hitched rides with strangers, hopped trains, and occasionally fell in with other vagabonds he met on the road. He took the odd job, though he alternated these forays back into the structure of modern-day society with periods where he lived with little money or human contact.

And as romantic as Chris's days on the road may seem, it's important to remember that absolutely none of this would have prepared him for what awaited him in the Alaskan wilderness, regardless of what Krakauer might have intimated. In fact, McCandless didn't experience anything close to hardcore or true wilderness living until, on an impulse, he bought an aluminum canoe near the California–Arizona border and decided to paddle four hundred miles down the Colorado River to the Gulf of California, where the river finishes its journey in Mexico.

As with everything he did as a super tramp, McCandless didn't prepare at all for this significant undertaking. In some ways, he had every right to be arrogant. He was very smart, a natural salesman, great with people, and a terrific athlete. And he was certainly successful at surviving on the fringes of society. But this skill set, upon which his arrogance rested, means little in the wild, whether it's Alaska or the Colorado River.

And although McCandless survived more than two months in the canoe, he certainly had his share of mishaps. He got lost almost every time he had to do some route-finding, and was continually bailed out of trouble by accommodating Mexicans. He may have proved he could survive on

minimal amounts of food, as he subsisted on little more than five pounds of rice, but surviving on minimal amounts of food is not the greatest challenge of wilderness survival. And he would not run across too many helpful people out in the middle of the Alaskan wilderness.

In early 1991, McCandless eventually found his way back across the border from Mexico and into the United States. He had been on the road for more than six months and showed little sign of losing his love of the new life he had created. He spent most of that year wandering around the southwestern U.S., following much the same pattern he had established in 1990: work a little, slum a little.

As 1992 began, McCandless decided to fulfill one of his life's dreams and head to Alaska. His first stop was South Dakota, where he stayed with a friend and earned some money. Then, in mid-April, he started hitchhiking northwest. McCandless reached Fairbanks, Alaska, about ten days later.

The most dangerous thing about McCandless at this point in his travels is that he had convinced himself that he could actually survive in Alaska with minimal supplies. After all, he had made it through the previous year and a half, including his river journey. Why should Alaska be any different? Well, Alaska *is* different—much different.

McCandless had defined himself through his charisma, and usually had other people around to help him out, to feed him, put him up, or drive him somewhere. So yes, he was terrific at surviving, as long as he was working on the fringes of society and interacting with other people. He used his charm, not his survival skills, to get him through those situations.

Well, guess what: charm counts for absolutely nothing in the wilderness. You can't charm a fish onto your hook or wood to burst into flames. Your personality is not going to shelter you from the cold and wind. And there's a big difference between finding a place to sleep at a truck stop and surviving in the bush. McCandless's survival skills were all based on having the trappings of society—those same trappings that he loathed so much—at his fingertips.

In recounting the McCandless story, I can't help but feel that the ultimate cause of his downfall was his arrogance. He didn't have to go completely unprepared into one of the earth's harshest climates, but he did. Why? Because he was sure he was clever enough and fit enough to survive. And yes, he likely planned on staying there for only a few months, and yes,

summer was approaching. But those are very poor reasons to ignore the fact that surviving in the wilderness—let alone the Alaskan wilderness—is brutally hard work.

I understand that there was a part of Chris that didn't want to know what he was getting into, so it would all be new—novel and pure. But it would not have been a slight to his idealism to have taken the proper food and supplies with him. In fact, it probably would have helped him, because it would have given him a little more free time to expound upon the beauty and vastness of the natural world around him.

Most people don't have the luxury of planning for their survival situations. They happen, you're thrown in, and that's that. But McCandless had, in fact, been dreaming about an "Alaskan odyssey" for years. And yet, he scoffed at the opportunity to plan. That's not admirable, idealistic, or even cool, it's foolhardy.

When I go out into unfamiliar wilderness, no matter where and no matter how experienced I may be, I always make it a point to spend time with someone local who knows the area and can teach me relevant skills. Doing this does not remove the romantic appeal of the wilderness.

DAY PACK SUPPLIES

Hiking through the bush with a minimal pack is always liberating. But a few basic items can make a huge difference. I would keep the pack itself to a medium size to avoid back strain. Along with the supplies listed on the next page, I would bring a lightweight "bike 'n' hike" tent; a sleeping bag rated to 10 degrees below freezing; a lightweight Therm-a-Rest (self-inflating air mattress); a full change of clothing; a headlamp with spare batteries; a small digital camera; writing paper and pen, or a small musical instrument like a harmonica (depending on how you like to express yourself creatively); a small cook set with lightweight cutlery, cup, and plate; a small folding saw and/or hatchet; signal flares; and as much high-energy travel food as I can realistically carry. For a gun, my good friend and expert arctic survival guide Wes Werbowy recommends a Remington 870 with a short barrel and slugs or SSG shells for bears.

As well as a belt knife, you should carry these items somewhere on your person:

- bandana
- compass
- cup (metal, collapsible, for boiling water)
- emergency LED flashlight (small)
- lighter (my preference is a butane lighter that works like a little blowtorch)
- magnesium flint striker
- multi-tool or Swiss Army–style knife (with a small saw blade)
- orange garbage bags (1–2, large)
- painkillers (a few)
- parachute cord or similar rope (approximately 25 feet, ¼-inch thick)
- solar or "space" blanket (small)
- strike-anywhere matches in waterproof case (with striker, just in case)
- whistle
- Ziploc bag

Although this may sound like a fairly weighty list, you can carry a couple of the items—the whistle and the magnesium flint striker, for example—on a piece of rope or parachute cord around your neck. And when the other items are spread out among your various pockets (wearing clothes with lots of pockets is helpful!), you hardly notice them at all. They simply exist as part of you and should present no problem. And if you become separated from your pack, the items you carry in your pockets can make a world of difference. In Chris's case, it might have been a better idea to pull a small toboggan behind him rather than carry a pack on his back.

McCandless seemed to think it sufficient to take into the bush whatever he had learned in hippie camps, trailer parks, and truck stops.

So, what did McCandless take with him? Jim Gallien, the last person to see McCandless alive, said his half-full pack seemed to weigh only twenty-five or thirty pounds, ridiculously light for someone planning a several-month excursion into a land still blanketed under at least a foot of

snow. In it was a woefully inadequate collection of items: a ten-pound bag of rice (his only food!), a .22-caliber rifle and ammunition (a poor choice), and some camping equipment. The heaviest part of McCandless's bag? The nine or ten books he toted along.

Included in his personal library were pop novels written by people like Michael Crichton and Louis L'Amour. Okay, I understand taking something to read. But take one or two books at the most, and make sure one of them is a survival guide. I can't pass judgment on whether or not to take novels on such a journey, except to say that I would not do it. I would prefer to live the dream rather than have a fictional escape to it.

The only book McCandless carried that was even remotely related to surviving was a plant identification book. He must have thought this guide, as comprehensive as it might have been, would help him locate food when hunting was marginal. But it makes little sense for someone to head into the wilderness with only a plant book and no firsthand instruction. Identifying plants with only a book is very difficult and has gotten loads of people into trouble. McCandless did forage successfully for berries and other wild edibles, but for all we know, he might have walked right over any number of other wonderfully edible plants. Ultimately, the book failed him, because it's no substitute for hands-on information. In short, you should never be certain that you can identify a new plant unless someone has taught you personally. Plants may look different depending on the location or season, and even the most comprehensive guides don't have the room to go into such detail. McCandless's own journal pointed to his shortcomings in this area: a few late entries point to his suspicion that he's poisoned himself by eating the seeds of the wild potato plant.

Now on the trail, McCandless likely hiked for a couple of days before stumbling upon the rusting, abandoned bus that would became his home—and eventually, his tomb. The bus, which had been skidded into the bush for use as a hunting shelter, was equipped with rough bedding and a wood-burning stove. Not more than twenty-five miles from the nearest town, Healy, and just outside the boundaries of Denali National Park, he set up camp.

McCandless's chance encounter with the bus illustrates that, no matter how far off the beaten track you may go, there's always a pretty good chance you'll find something useful. When I was in the Amazon jungle

with the Waorani people, I was amazed to find that their village was surrounded by a chain-link fence. Where did they get that when they're in the middle of the jungle, half-naked, and hunting with blow guns? They had simply found an abandoned mine some distance away and taken it all from there, carrying it through miles of thick jungle.

Apparently happy in his new home, McCandless scrawled what Krakauer called his "declaration of independence" on a sheet of plywood filling one of the bus's broken windows:

Two years he walks the earth. No phone, no pool, no pets, no cigarettes. Ultimate freedom. An extremist. An aesthetic voyager whose home is the road. Escaped from Atlanta. Thou shalt not return, 'cause "the West is the best." And now after two rambling years comes the final and greatest adventure. The climactic battle to kill the false being within and victoriously conclude the spiritual pilgrimage. Ten days and nights of freight trains and hitchhiking bring him to the Great White North. No longer to be poisoned by civilization he flees, and walks alone upon the land to become lost in the wild.

Alexander Supertramp
May 1992

Chris was clearly seeking some type of higher experience, but any survival expert—and most Alaskans, for that matter—will tell you that the Alaskan bush is not the place to find it. You want that higher experience? Go spend six months in a monastery or live with a Tibetan monk for a while. Don't use the wilderness as your temple, because there aren't any monks who will bring you water and food. And if you don't have what you need, you may very well perish.

But even though McCandless craved a pure experience, he seemed to have no problem compromising his ideals and using the bus as his camp. I suspect it's because he got sick of sleeping outside and being cold, tired, and eaten by mosquitoes, which were likely already out in full force. The bus represented comfort and security, and I give him credit for recognizing that. I would have done the same thing. When you're cold and hungry, even the purity of the experience has its limits.

That's the thing about survival: you have to be open to the notion of compromising your ideals if it will help keep you alive. I learned this during the year I lived in the wilderness of northern Ontario with my wife at the time. It didn't take long for us to realize that you need a community of people to survive in a primitive survival situation. That's why tribes develop. In a tribe, each person has a specific job he or she is responsible for. The sum of all these jobs is enough to keep the individual members alive.

And while we managed to survive our year in the bush, it was at least in part because we weren't arrogant enough to think we could do it alone. We kept our lifelines open, and made use of them whenever we needed to. When Sue miscarried, we went to town. When we both got giardia, we went to town. And every time we met people in the bush, they practically poured food on us when they heard what we were doing. So the difference between my experience and Chris's is that I knew enough to maintain ties to civilization, whether it was for supplies, rescue, or medical assistance. We would've perished if we were just out there with nothing. But Chris was different. He willfully severed his link to the outside community, and paid the ultimate price.

To his credit, McCandless managed to live for almost four months, primarily by hunting the most abundant critters available in most survival situations: small game and birds. This is not to say he had an easy go of it. To the contrary, his journal makes many references to his lack of food, near disasters, and general weakness. But by the time the snow began to melt (about a month into his trip), he was able to gather more wild edibles and had greater success hunting birds and small game. Things seemed to be going fairly well—so well, in fact, that on June 9 he shot and killed a moose, providing enough meat to keep him fed for an entire year. Anybody who knows anything about survival and hears this part of the McCandless story simply shakes their head. *The man shot a moose and nevertheless starved to death in the bush? How can that happen?*

Unfortunately, McCandless based his butchering and preservation of the moose more on conversational advice than on hands-on experience. This again epitomizes his idealistic approach in the face of common sense. If you're not a hunter, and you go out and manage to kill a big animal, you're going to mangle the thing if you haven't prepared yourself. Consider the Robertsons, who took a few kills to figure out they could keep and

I've never had the good fortune of killing an animal as large as a moose in a survival situation. Had I found myself in that position, though, I would have made that animal the focus of my days—until the job was done. The gift of a large animal is the gift of life, for the animal represents more than just food. Clothing and bedding can also be obtained from the hide. Most aboriginal cultures believe that the animal has given its energy up to you. For that, you should thank the animal and use every possible part of it.

Before butchering and preservation even begin, the first thing you have to do is decide where the butchering will take place. For the aboriginal peoples of North America (before contact with Europeans), taking a big animal meant moving camp to where the animal was killed and preserving it on the spot. This was usually more expedient than trying to haul the animal to camp. I'm not sure how far away from his camp Chris shot his moose, but I hope he didn't waste too much precious time dragging it back.

To begin the process, I would start by trying to collect as much of the moose's blood as possible for drinking. All you need is a receptacle; watch for the flow of blood near the throat and internal organs. Blood also collects in the body cavity, but not necessarily the throat—it leaves the throat as the heart is still beating.

The next step is gutting the animal. During the process, eat the liver raw and suck the gel out of the eyeballs. Don't throw out the lower intestines. Once you've squeezed the fecal matter out of them, they make great bait for small game, fish, and birds. Even the contents of the stomach can be eaten in a survival situation.

For a man in Chris's situation—likely hungry and losing weight—the next step is to feast until you have regained energy. An adult Alaskan moose can easily weigh 1,200 pounds, so there's little danger of diminishing your supply. I'd start by boiling and eating all those parts of the moose that spoil quickly—organs, tongue, and brains—but there's no reason not to have a nice roast dinner or two. As always, you want to drink any broth left over after boiling; it contains important nutrients and fat.

With the energy from the first feast still coursing through my veins, I'd then set about skinning the animal (while it's still warm—it's much easier to remove the hide immediately after killing it). Since tanning a moose hide is a time-consuming and complex task, most people are not going to do this in a survival situation. But the hide can still prove useful. Scrape as much fat as possible off the skin (save it or make a broth out of it too; you'll use it later) and stretch it out with the fleshy side exposed to the sun and wind.

When dry, the moose hide will resemble a big, hairy piece of cardboard. It will be good for insulation. Don't kid yourself into thinking you are going to actually tan the hide. It is a tough and labor-intensive activity that takes a lot of skill and years of experience to master.

The next step is preserving the meat, a task possibly complicated by mosquitoes and blackflies. But you've got to deal with them, as maddening as their incessant buzzing and biting will be. Without a bug shirt or bug spray, I would wrap myself up with any other material on hand.

Now to the real task at hand: the meat. The first thing to know is that you shouldn't concern yourself with flies and maggots, which will invariably appear on the meat during the preservation process. This doesn't mean the meat is spoiled; in fact, you can eat the maggots along with the meat. To preserve the meat, start by building a drying rack from the materials in the area. Then cut the meat into thin, bacon-like strips and drape them over the rack's cross-poles. A small, smoky fire in the middle will speed up the drying process and keep the bugs down. Will the drying meat attract other animals, such as bears and wolves? Probably. But in most cases, the animals will wander into camp, see a human, and take off.

During my year in the northern Ontario bush, I once cooked a pot of bear stew outside for an entire day. Ironically, the smell attracted a huge black bear into camp. But as soon as I set foot outside the cabin, the bear took off like a shot. Mind you, I was completely naked, as I had been giving myself a sponge bath. I never saw the bear again.

PRESERVING A MOOSE (CONTINUED)

With the meat drying on racks (and a couple of roasts in my belly), I would next turn my attention to the bones. Cracking the bones reveals the delicious and nutritious marrow inside. At a minimum, Chris could have boiled the bones into stew. You can even pound the bones into bone flour, an excellent source of calcium.

Finally, we're left with the fat. Fat is difficult to preserve, so eating it—either by frying or adding to soup—is certainly an option. But given the amount of excess fat a moose yields, the only way to save the fat is by rendering it. To do so, fry the fat until it liquefies. Then let the liquid fat cool and harden (don't forget to eat the leftover crispies), at which point it becomes like a brick of soap. In this state, the fat will last a very long time.

drink the turtle blood or render the fat. Without the appropriate skill, the meat will rot before you can use it. I imagine he worked diligently to preserve the moose—the guy certainly didn't lack a work ethic. But he simply couldn't compensate for his lack of knowledge. Rather than slice the meat into thin, bacon-like strips and let it air-dry in the sun, Chris tried to smoke the meat in large pieces. This prevented the sun and wind from working their magic. Most of the meat rotted.

Despite having most of the moose rot and go to waste, McCandless made it through another month in the bush, apparently without major physical setback, though surely he must have been challenged psychologically at the loss of the moose meat. By the time July rolled around, Chris apparently had had enough of his wilderness adventure, and decided to walk the thirty miles back to the highway and civilization. This is where his second huge setback came into play.

Chris walked for two days (covering about fifteen miles) to the spot where he had crossed the Teklanika River back in April, only to find it running high and fast, a completely different animal than what he had crossed before. Although nobody will ever know how deep the river was when he tried to cross the second time, it would have been a difficult task no matter what. A fully grown man can be knocked down by as little as six inches of rushing water; once you to get in waist deep, or thigh deep, there's no chance of walking across safely. McCandless's only hope

of getting across would have been to try swimming in the near-freezing temperatures, or find another place to ford the river.

Despite the fact that he might actually have had a map with him (there is some debate on this point), Chris didn't realize that there was a hand-operated tram across the Teklanika, less than a mile downstream from where he tried to cross. The National Park Service also maintained an emergency cabin some six miles south of the bus. Even without knowing about the tram, he still could have opted to explore the banks of the river, hoping to find a way across.

And while people have faulted him for not finding the downstream tram, the truth is that finding something in the bush is a lot more difficult than it seems. You could stumble upon a set of railroad tracks, turn right, and hit a town in half a mile. Or you can turn left and walk two hundred miles without seeing any other sign of civilization. So the fact that the tram was only a little ways downstream was just a fluke. If I had been in that situation, I would have walked upstream. Whenever I've come to a river I needed to cross, I have found that walking upstream has often brought me to a shallow, braided section I could cross; downstream is where more feeder streams come in, and the river gains momentum and seems to get bigger. But Chris chose to go neither upstream nor downstream.

He was probably also hampered by the fact that he was exhausted and scared. And in that situation, the bus represented warmth, safety, and comfort. So he turned back. I don't agree with this decision, but I understand it. This is a fairly common problem among people in survival situations: they fail to effect their own rescue when they have the energy and supplies to do so, instead waiting until they're scared and desperate. Had Chris set out with four or five days' worth of food and a full belly, and in good physical condition, he might have arrived at the river and thought to himself, "I'm strong enough and I've got supplies, so I'm going to walk upstream for a few miles and see what I can see." Either way, turning back proved to be the biggest mistake he could make.

Once back at the bus, McCandless again set about trying to survive, primarily by hunting small game and foraging for wild edibles. By his own account, he was quite successful, though his condition gradually worsened. What ultimately killed Chris McCandless has been the subject of considerable debate. Whether it was toxic seeds, moldy seeds, or starvation, the

point is that he didn't have to die, because I think what truly killed him was his arrogance. Even once he got back to the bus, there were steps he could have taken to ensure his survival, but didn't.

The first thing Chris missed was lighting a signal fire. From what I've read about him, he probably thought he was idealistically and spiritually above doing that. Or maybe he was too arrogant to think he needed to do it. Maybe he just didn't think of it. I feel the opposite: if I had to set fire to something to save my life, I would do it. In fact, while writing this, news came out of a man who, while lost in the wilderness, effected his own survival by burning down an electric utility pole. The repairmen came out to fix the pole and found someone in need of rescuing instead. At some point, McCandless should have recognized that he was going to die if someone didn't rescue him. So he should have said, "I'm really sorry, Alaska, but something's going to have to burn if I'm going to live." A fire, particularly a big one, would certainly have attracted the authorities, especially if there was no lightning storm that might have started it. There's the risk that too large a fire might have put Chris's life at even greater risk than it already was, but he had very few alternatives at that point. The safest thing would have been to find a small island in the middle of a creek, or at a braided part of the river, and set fire to it. This might have attracted attention, and might have somewhat protected against the fire getting out of control. Of course, nothing is ever black and white when you're in a survival situation, but his life was on the line. If it comes down to doing something illegal that could save my life, I'll take my chances with the law. As the saying goes, it's better to be tried by twelve than carried by six.

Chris died on August 18; he was twenty-four years old. Before dying, he ripped a page from Louis L'Amour's memoir, *Education of a Wandering Man*, which contains an excerpt from a Robinson Jeffers poem entitled "Wise Men in Their Bad Hours." On the other side of the page, McCandless added, "I have had a happy life and thank the Lord. Goodbye and may God bless all!"

As sad as Chris's death may be, I believe that for a couple of months, before his situation became desperate, he got to live the life he had sought. He was able to live a pure, simple existence, surrounded by the glory of the outdoors. The sad thing is that he didn't have to die, and I don't think he wanted to.

Compare McCandless's experience with someone like Henry David Thoreau, who was clearly one of Chris's heroes. Thoreau is heralded as one of the great voices of simple wilderness living, and yet he walked to town regularly! If anything, Thoreau proved that you don't have to live like an ascetic to have the pure experience that Chris sought. In fact, I would argue that Thoreau's approach enhanced the experience.

This is the big difference between Chris and me. For all the surviving I've done, I've never done it to be noble, or because I had something to prove or was thumbing my nose at society. I go into the bush because of my love for all things wild and free, for nature, and not to escape society. I go there to receive the positive energy flow that is unrestrained by the building of modern society. With every trip I've ever made into the wilderness, I've always taken the very realistic view that I may blow it, so my eyes and ears are wide open. And for every survival situation I've been in, I first went off and trained with a local expert, because there are so many things that can go wrong. I think Chris felt he didn't need anyone else's help. That attitude ultimately killed him.

Bus 142 still sits in the exact spot that it did when Chris McCandless called it home. They say you can still see the bones of the moose scattered around the bus, Chris's jeans folded on a shelf inside. It is, by all accounts, a beautiful place to have called home—for a time.

CHRIS McCANDLESS

ELEMENTS OF SURVIVAL

Knowledge 20%
Luck 20%
Kit 10%
Will to Live 50%

Chris McCandless is difficult to grade, since he died in the Alaskan wilderness. He fell flattest when it came to kit, since he willingly walked into the bush with virtually nothing. He had some knowledge, though most of it was anecdotal. Luck was shaky at best, especially in light of the theories that point to local plants as hastening his death. In the end, though, it was Chris's will to live that saw him survive for as long as he did. In the end, even his very strong will wasn't enough.

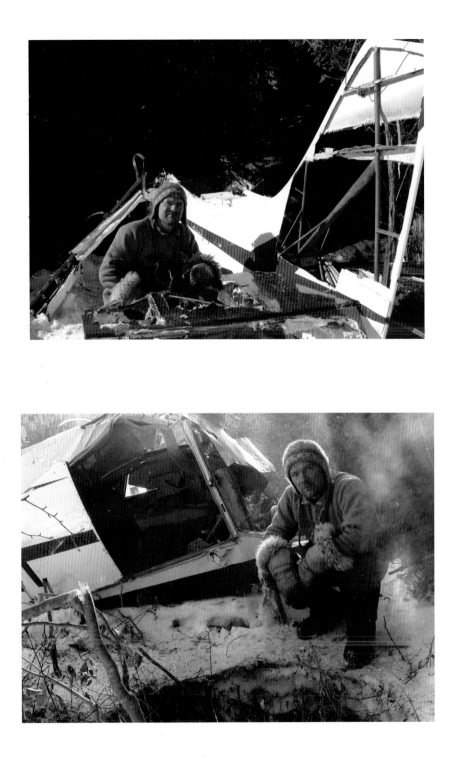

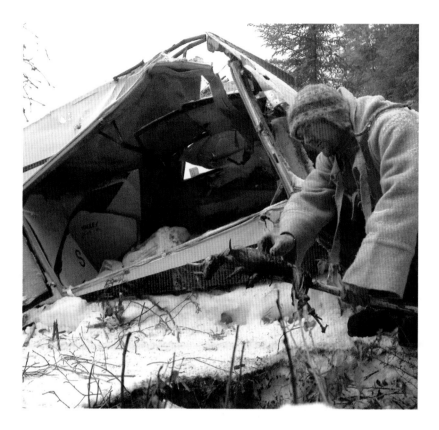

One of the first *Survivorman* film expeditions I ever did was based upon being stranded with a downed airplane. While the scenario was a bit morbid, the point was clear: the things salvaged from the aircraft could save a life. I used some of the plane's wires to make a snare, in which I caught a rabbit. I roasted it over the fire you see here, which I started using the battery, some wires, and a tiny bit of gasoline from the airplane.

Surviving beneath the waves is another world altogether. I learned a lot from shooting films with sharks, and though I received a few scars from some small bites, I wouldn't trade the experience for anything. Sharks are big, powerful, and beautiful creatures. It's just that if they take a "test nibble" to see if you are food, you can lose an arm in the deal.

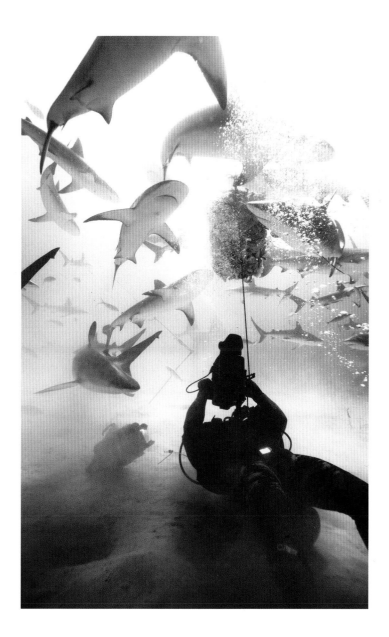

I am always asked which is harder: surviving in the extreme heat or the extreme cold. Even after coming close to succumbing to heat stroke and possibly dying in the Kalahari Desert, I still feel that the cold is the toughest. In the heat, at least you can sit under some shade and wait out the day. In the cold, you have no choice—you must keep moving and effecting your survival, so it takes much more out of you.

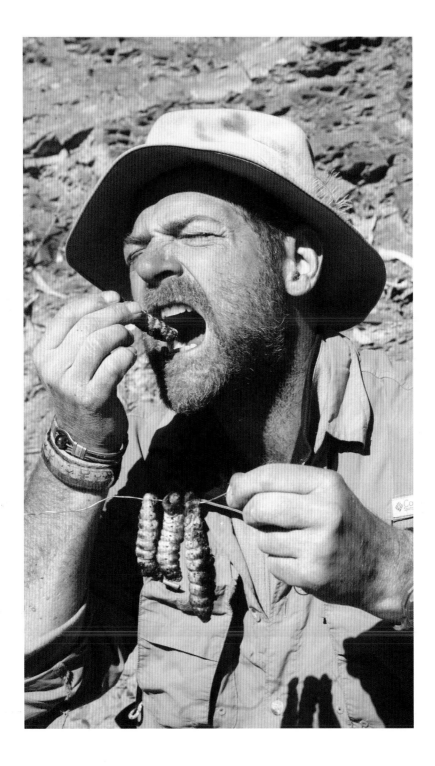

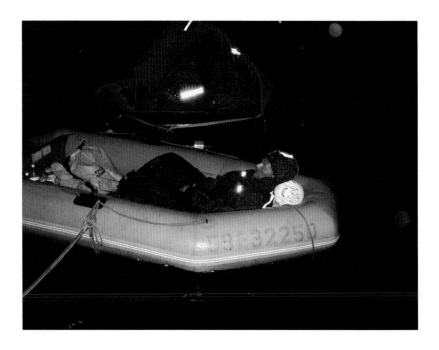

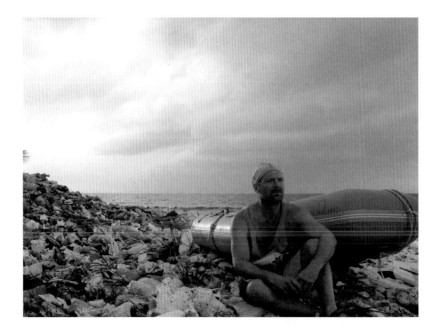

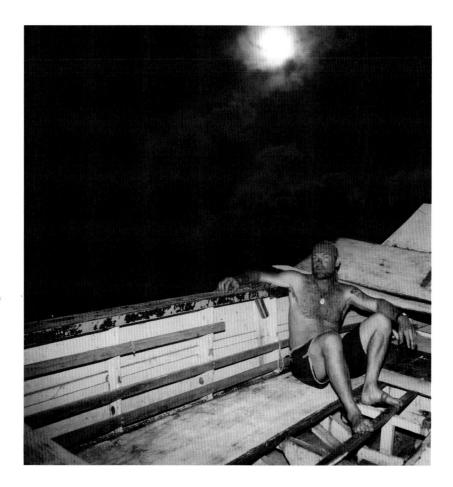

While filming for *Survivorman*, I spent four days in a raft floating on the ocean. It's the one survival challenge I hope to never face again. I had to be rescued when a massive storm came in, or I would have been blown to Honduras and likely never seen again.

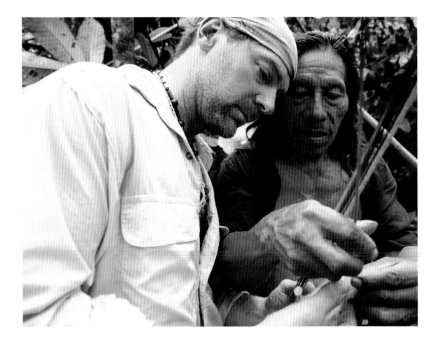

Of all of the places I have survived in—deserts, the High Arctic, oceans, forests, and mountains—it is always the jungle where I feel most at home. Perhaps it was the incredible experience of learning from the Waorani in the Amazon, or maybe it was just all those Tarzan movies I watched as a kid. Snakes, ants, spiders, jaguars and all, I still relax when I step foot in the world's jungles.

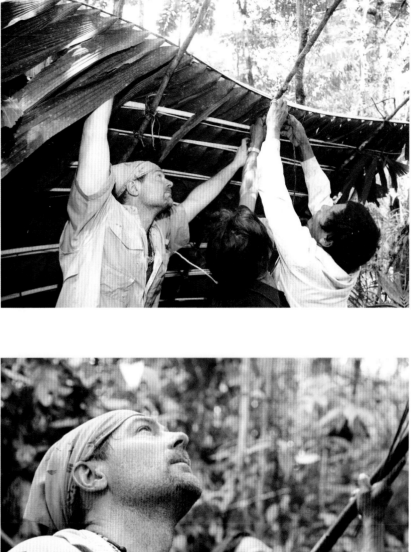

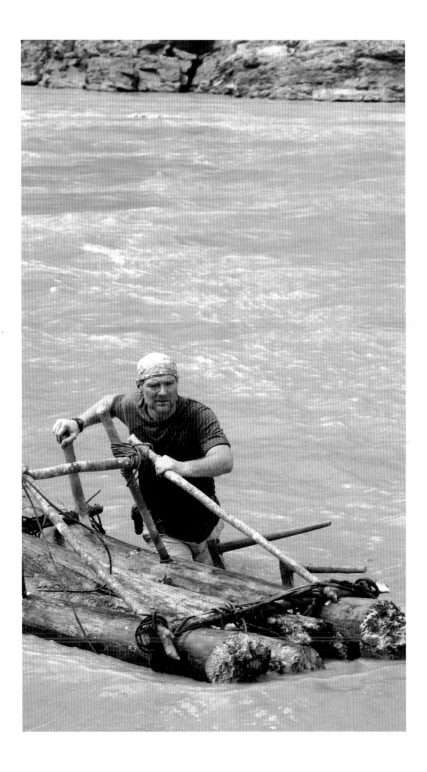

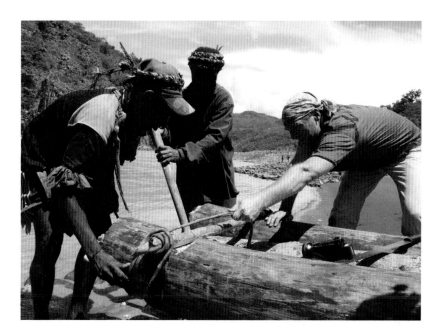

The concept of building a raft and floating down a jungle river sounds very romantic and adventurous, but it is nothing like that in reality. Here, in New Guinea, I build with the Hewa so that we can bypass some thick jungle and make our way downstream. The building of the raft is hot and difficult work, but it's rewarded by easier traveling than on foot.

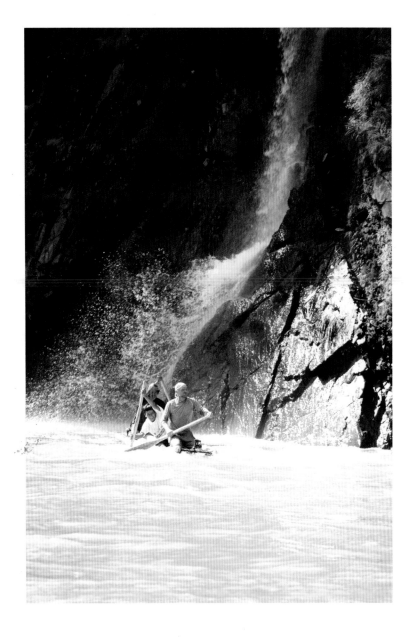

In the Season of Love

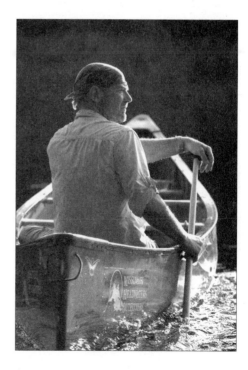

The aluminum canoe I have borrowed from a nearby lodge squawks as I drag it over the rocks. I am making my way across the shoreline of a remote, fog-enshrouded lake in Algonquin Provincial Park, a jewel of a place about 150 miles north of Toronto. The day is going to be easy for me. I am at the peak of my guiding and survival instructor days: fit, tanned, confident. My mission? To boldly go off the beaten path, deep into the Algonquin forest, where I will find a good spot to teach survival to my students. I have already decided on the place by softly dragging my fingertip over a topographical map and stopping, index finger tapping, on what seemed like the ideal location. We wilderness adventurers are funny that way. We can stare at a map for hours on end in a kind of dreamy, euphoric state. It's kind of like, well, map porn.

So off I paddle into the morning mist, alone and unafraid. "This won't take more than six or seven hours," I tell myself. "A few hours of paddling and a few hours of bushwhacking." I'm right, and the spot is perfect: not much more than a mile into the bush, far from canoe routes and hiking trails.

If the trip in to my perfect place has gone entirely as planned, the trip out will prove to be anything but. I am tramping leisurely through the bush to my canoe when I look up to see a beautiful female (cow) moose standing majestically in a boggy area not fifty feet away. What a sight she is, grazing quietly in the shallow water, seemingly unaffected by my presence.

This is when things start to go wrong. I begin to think it would be a good idea to test my moose-calling abilities on this unexpected audience. I'm smart enough to know not to try a bull-moose call. The last thing I want to do is entice any bulls in the area to come in for a challenge, especially because it's rutting season—or, as I like to call it, the season of love. During this time, the bull moose may well be the most dangerous animal in North America. Bull moose have been known to use their antlers like can openers to open up large trucks. So I'll only be trying out my female call on this day.

Carefully, I cup my hands over my mouth and send forth a long, semi-vibrating groan that trails off into the quiet of the forest around me. The cow looks up at me for a bit, then returns to her eating. I try again. This time, I elicit no response at all. I guess my moose call needs more work after all! I stand there, enjoying the day and watching her eat for a few more moments before turning to walk away.

With one leg still in the air during my first step, my world becomes a slow-motion vision as I first hear and then see a thousand pounds of fully antlered bull moose crashing out of the forest—and headed straight toward me, its eyes red and bulging in anger, nostrils flared and snorting, massive hooves pounding through the tall grass and water. I search my store of wilderness knowledge for options and decide upon the best course of action: I run. I run for all I'm worth.

I'm less than a hundred yards into the chase when I grasp the severity of the situation. The bull moose is chasing me into the forest, away from my canoe. That's when I again turn to my survival and wilderness knowledge and quickly scramble up a tree and hold on for dear life. The bull moose stays near the bottom of the tree, grunting and snorting all the while, digging furiously at the ground with his powerful hooves, and trampling small trees as if they are blades of dried grass.

As I cling to the tree, trembling, sweating profusely, my heart pounding through my chest, it occurs to me that, aside from the obvious one, I have made some very classic mistakes:

- I have told no one of my plans. When I left, no one knew where I was going. Even my wife isn't expecting me back for three days!
- I have gone as far as possible from normal travel routes.
- I have few, if any, survival supplies with me.

As if that isn't enough, darkness is beginning to descend upon the boreal forest. I realize I can't stay in the tree all night, so Plan B is becoming a real necessity. After only a few minutes (which seem like hours), and as soon as the bull moose ventures just a little bit away, I make a break for it. Just like in a cartoon, my feet are spinning before I even hit the ground, and the chase is on again!

This time, though, I carve my escape path in a wide arc, trying desperately to make it back to the shore of the lake, if not my canoe. The angry bull stays behind me the whole way, until I finally reach the shore. I slip into the water and immediately try to hide myself as best as I can. I sink my fully clothed self as deep as I can into the cold September water, with only my head sticking out, and make as little noise as possible. The trick works! Once I fall completely silent, he can't locate me.

As bad luck would have it, the moose is still waiting firmly between me and my canoe. So I inch my way along the shoreline in the opposite direction, my head just peeking out above the water, toward the part of the lake that is a canoe route. A few hundred yards later, the moose still hasn't spotted me, so I climb onto a rocky shoreline at a park campsite.

An hour passes. Finally, with night falling, a couple in a canoe paddle by. I must be quite a sight: soaking wet, no tent or gear, blabbering on about a moose. To their credit, they don't come close to me for about fifteen minutes, after which I am able to convince them I'm really not a raving lunatic. The couple then paddle me back into the bull-moose zone, where my canoe is still hidden in the trees. Years later, I won't be quite sure, but my memory will have me dashing into the trees and picking up the canoe with one hand, throwing it in the water, and jumping in to paddle back out to safety, all in the span of about three seconds.

I have been stalked by a jaguar in the Amazon jungle at night, sniffed by a lynx, bitten by a nine-foot reef shark (three times), and trailed by a pack of wolves. I've had to sneak around temperamental elephants in the Sri Lankan jungle, built a thorn shelter to protect against lions in Africa, and slept in the scorpion-infested desert. But nothing compares to the fear and heart-pounding awe of being chased by an angry bull moose in his season of love.

Survival Not Far from Home

IT WAS LATE DECEMBER 1992. JAMES STOLPA HAD JUST LEARNED OF HIS GRANDMOTHER'S DEATH, AND HE AND HIS WIFE, JENNIFER, DECIDED TO DRIVE THE MORE THAN EIGHT HUNDRED MILES FROM THEIR HOME IN CASTRO CITY, CALIFORNIA, TO ATTEND HER FUNERAL IN POCATELLO, IDAHO. UNDER NORMAL CONDITIONS IT WOULD JUST BE AN AVERAGE DRIVE, BUT THESE WERE FAR FROM NORMAL CONDITIONS. . .

After several years of drought, the winter of 1992 had come with a fury to the west coast. Persistent wind, rain, and snow had battered the area, wreaked havoc on holiday travel, caused power outages for thousands of residents, and was predicted to continue for the foreseeable future. Common sense likely told Jim and Jennifer Stolpa that the best decision was to stay home and offer their condolences from afar. Yet twenty-one-year-old Jim was driven, a dedicated family man. He knew how much his attendance at the funeral would mean to his mother. So, despite official warnings against travel, the couple, along with their five-month-old son, Clayton, decided to drive through the Sierra Nevada Mountains and make it to Pocatello in time for the funeral. It was the first wrong decision they would make in a series of mistakes that ended in catastrophe.

Jim was likely under a significant amount of stress, having just learned of the death of his grandmother. The sort of single-mindedness he displayed in deciding to press on has been the cause of many survival situations because when people have one overriding thought on their mind, they ignore voices of reason. Driving a 1988 Dodge Dakota pickup stocked with little more than tire chains and a couple of sleeping bags, they set out on Tuesday, December 29.

Later that morning, Jim and Jennifer found out that Interstate 80 over Donner Pass was closed due to heavy snow and would not reopen until the

following day, at the earliest. With time now of the essence, they had two choices: turn around and head back to Castro City, or find some other way to race through the mountains, through northern Nevada, and into Idaho.

A stop at a convenience store and a look at a road map yielded the possibility of an alternate route, so they made a fateful decision: they would bypass Donner Pass and continue to Pocatello, this time taking unmaintained secondary roads. During winter storms, all travelers—especially those traveling through the mountains—should stick to primary highways, as these are the first to be plowed and searched should people go missing.

At this point, Jim and Jennifer could easily have turned around. They didn't. They could have called Jim's mother and stepfather and informed them of the change in plans. They didn't. Jim would later lament that his biggest mistake was not informing people of their route change. He was wrong. It was a huge error not to inform people of the less-traveled route they were now taking, but they were already too far down the path of impending tragedy by that time. In fact, their biggest mistake was their "get there at any cost" attitude and attempting the trip at all.

If anything, the Stolpas were guilty of survival skill ignorance. I think they were convinced they could take on the elements with their truck and win. It's a mistake many people make, especially in the winter. The truth is, the weather is always bigger than us *and* our vehicles. The problem is, we never realize that until it's too late.

As bad weather began to descend, Jim and Jenn had an important realization: they would stand a much better chance in winter driving conditions with their tire chains. Unfortunately, this is where their preparation ended. They had no survival supplies other than some junk food they'd bought at a convenience store and their sleeping bags. Frankly, this is ridiculous. If you know you're in for trouble, either avoid it or prepare for it, fully and completely.

They stopped at a local service station to have the tire chains installed, reconfirmed their route through the mountains, and moved on. But what made them think that, if the main highways were closed, a less-traveled one would be passable? They put all their eggs in one basket by convincing themselves that the blizzard only existed where the main highways were closed. It was a winter-weather version of "the grass is greener on the other side."

- Expect the unexpected! Carry a winter driving survival kit.

- Always check local weather forecasts and information on road conditions.

- Make sure your car is in proper working condition, especially brakes, windshield wipers, and defroster/heater. Also check that headlamps, turn signals, and taillights are unobstructed by snow and ice.

- Check antifreeze levels and make sure your windshield wiper fluid has antifreeze in it. Add gas-line antifreeze to the fuel tank when refueling in extremely cold weather.

- Check your tires. Are they properly inflated? Are the treads in good condition? If you may be traveling through snow, you should have, at a minimum, all-season radials. Snow tires are recommended.

- Carry tire chains if you don't have winter snow tires. It doesn't do any good if you can't get them on or off your vehicle, though, so make sure you know how to use them and have the proper tools.

- Always keep your gas tank at least half full.

- When clearing off your car, do the whole thing, not just a little peephole in the windshield. Make sure every glass surface is clear and transparent; your side-view mirrors and all lights should be brushed and cleared as well.

- Keep extra windshield wiper fluid in your trunk.

- Check engine oil, especially before long trips. Cars use more oil in the winter. Use winter weight oil (5W-30).

By the time the Stolpas crossed from California into Nevada, some ten miles east of the town of Cedarville, Jim thought the worst of the driving was behind them. So he went out and removed the chains from the tires so they could make better time. I can't blame them for this decision;

most of us would do the same. But the next question is, why wouldn't he put them back on once the snow hit again?

And it did, with a vengeance. A full-blown blizzard was soon raging. Mounds of snow stretched across the road. After they passed the ghost town of Vya, Nevada, Highway 299 turned to gravel and became Washoe County Road 8A, a seldom-used track that cut through the high desert and rugged mountains of northwestern Nevada. Jim should have quickly realized that the tire chains were vital to their safety. Yet he never managed to put them back on the truck. It may be that they were too tight, Jim too inexperienced in their use, or the weather too bad. Whatever the case, the chains never made it back onto the tires, where they belonged.

Visibility was near zero. The drifts across the road became bigger and more frequent. Still the family forged ahead. Soon after dark, though, they got stuck in deep snow and were unable to get themselves out. The Stolpas were stuck, a blizzard was raging outside, and night had fallen.

With light gone and the truck stuck in deep snow, the Stolpas decided to spend the night in their vehicle. At this point, digging the truck out of the snow was an option, far easier than it would be the following morning, after the blizzard had raged all night. I imagine the couple was exhausted from their journey, though, so sleeping a little and waiting for light to break was the right decision. It was not a comfortable night, though. The wind howled and drove sub-zero air through every nook and cranny of the truck. Luckily, they had lots of gas and could occasionally start the vehicle to generate heat. They were also convinced someone would drive by in the morning.

As the dawn of morning turned to full-blown daylight, the Stolpas were horrified to find that they were in the middle of what seemed to be vast wilderness. Indeed, the Stolpas had stumbled into the Sheldon National Wildlife Refuge, more than half a million acres of rugged wilderness. The refuge is closed in the winter. Not surprisingly, there was no sign of other travelers on the deserted mountain road.

With virtually no tools, Jim and Jennifer tried to dig the truck out of the deep snow by hand, a brutal task at the best of times. Jim finally decided to try to attach the chains to the tires, to no avail. He realized he would have more luck by jacking up each wheel, but there was no jack to be found in their ill-equipped vehicle. They laid the chains out in the snow

to gain some traction, but the truck only moved a few feet before becoming stuck yet again. Had he carried a shovel, Jim could have dug out the truck, then rammed the vehicle's floor mats, some towels, clothes, or blankets under the tires to give the truck some traction in the snow. They were not that prepared. They might even have been able to use rocks, gravel, branches, or tree limbs to gain a foothold under the tires. They didn't.

So the Stolpas made another fateful decision: they would stay with the vehicle in the hopes that help would find them. But it was an ill-advised decision, particularly in light of the meager supplies they carried. They had enough fuel, blankets, and sleeping bags to keep themselves warm in the short term, but their food was limited to some baby food, cookies, a fruitcake, a bag of corn chips, and a jar of prenatal vitamins. Unbelievably, Jenn would not eat the fruitcake because she didn't like it. It was a shortsighted and foolish position; there is no room for pickiness in a survival situation. I'm sure her feelings would have changed as real hunger set in, but she didn't have the chance, because Jim had already finished it. It was a selfish move on his part; he should have saved half the cake for his wife in hopes that she would eventually accept it.

The first day passed, and amazingly, it seems the Stolpas did little to try to attract rescue or improve their situation, which, in light of the circumstances, completely perplexes me. Even worse, they didn't seem (or at least made no mention in subsequent interviews) to take the time to realistically assess their situation. Assessment is an extremely important part of any survival emergency, and the Stolpas seemed to ignore it completely, at least for the first few days of their ordeal.

Once they realized they were not going to be rescued by another driver, the Stolpas could have gone into full-blown survival mode and scoured the truck for anything and everything they could use to their benefit. Their first task should have been to try to attract attention to themselves, which they never did. Had I been in that situation, I would have used the truck's spare tire to make a smoky fire, which may increase your chances of being seen.

Start by siphoning gas from the truck's gas tank, a tricky proposition at the best of times. You need a long, thin hose about the diameter of a thick pen. Put one end of the hose down into the gas tank and suck on the tube until the gas begins to flow out the top end of the tube. There is a real

A car survival kit is a must in every vehicle, but is even more important if you live in or travel through areas of remote wilderness or extreme weather, where the risk of ending up in a survival situation is much greater. It may seem like a bit of overkill, because nobody ever expects to be caught in an emergency. We all think it can't happen to us, but it can.

You don't have to spend a lot of money on an expensive kit to equip your car for a survival situation. Bring the following:

- **a way to be spotted (flares, flashlight, lightsticks) and extra batteries**
- **a way to get warm (lighter and strike-anywhere matches in waterproof case)**
- **a way to keep warm (blankets, extra clothes, sleeping bag, survival candles)**
- **bandana**
- **belt knife with strong blade**
- **cell phone**
- **compass**
- **cook set, cook stove, and fuel**
- **cup (metal, collapsible, for boiling water)**
- **drinking water (enough for every person in the vehicle)**
- **food (including energy bars)**
- **jumper cables**
- **local road maps**
- **multi-tool or Swiss Army–style knife (with small saw blade)**
- **orange garbage bags (1–2, large, for signaling)**
- **painkillers (a few)**
- **parachute cord or similar rope (approximately 25 feet, ¼-inch thick)**
- **shovel (collapsible or folding)**
- **tarp**
- **tire chains**
- **toilet paper**
- **tools, such as ax, hatchet, pliers, screwdriver, and/or wrench**
- **whistle**
- **Ziploc bags**

danger of swallowing gas here, so suck without inhaling, using only the suction power of your mouth cavity. Most "old-timers" know how to do it and can tell you that they have tasted a lot of gas in their day. Once the gas flows freely out the top end of the tube (and you've stopped choking from the dribbles of gas in your mouth), you have created a suction flow. The gas will drain out of the tank and into your receptacle.

Lay the tire down flat, then pour gasoline into the inside trough of the tire. If you've got a lighter or matches, great. Light the gasoline and watch the tire burn. Take note that this also is dangerous, depending on how much gas you have in the tire. And remember that it's the fumes that ignite, not the liquid itself. So even a spark near the fumes will cause the gas to "explode" into flame.

If you're not lucky enough to have matches or a lighter, then it's a spark you need. Simply remove the battery from the car and attach jumper cables to its positive and negative terminals. The cables now have power running through them; tapping the free ends of the cables will create sparks. Send some sparks toward the gas on the tire—aiming for the fumes, not the liquid. Eventually, the gas will ignite in a large bang, so be ready for it and keep everyone back a few paces for safety.

Don't stop here, though. The bigger the fire, the greater your chances it will be seen. Grab any trees, brush, or bushes you can find and add them to the fire. Young trees create more smoke than old, dry ones.

Jim and Jenn were hampered by the fact that neither one of them took a leadership role. I realize it can be difficult when it's a husband and wife and there's an infant in the mix as well, but even in a group as small as two people, one person has to take over and lead, make the tough decisions. Somebody needs to consider the big picture—assess and plan. In this case, I think it should have been Jim, who had military training and was actually working in the army at the time. But he didn't, at least not at the beginning.

As their first full day alone turned to darkness, the Stolpas knew they would be spending another frigid night in the truck. Finally, Jim and Jennifer's survival instincts kicked in. They discussed the possibility of walking to seek help, began to ration what little food they had left, and even discussed aspects of the survival training Jim had in boot camp. With little baby formula left, Jennifer tried to nurse Clayton, whom she had been

weaning off breastfeeding. They ran the engine intermittently through the night for heat, using the truck's headlights during these times to flash SOS in Morse code. The storm still raged outside, blanketing the ground around them in a deep cover of snow.

In situations like this, the common thinking is to stay with the vehicle. Often, this is the best choice. But this was a classic case where staying put was not the best thing to do. The Stolpas determined from their road map that they were in the wildlife refuge. Given this information, they should have figured it was likely that very few people would pass their way in *good* weather, let alone in the wake of a winter storm.

Had he made this assessment, Jim likely would have realized that heading back the way they came, for help on the very first day—when they still had food and enough fuel in the truck to keep Jennifer and Clayton nourished and warm—was the right thing to do. Like so many other people, though, Jim rigidly followed the heavily preached mantra of staying put. He wasn't the first, and certainly won't be the last, person to make this mistake. People will stubbornly stay put like good soldiers, even when circumstances clearly dictate otherwise. This is why assessment is so important in survival situations.

Day two came and went, as did day three. As the fourth morning in the truck dawned, Jim and Jennifer's food ran out, despite the rationing. Jim realized they could not rely on waiting anymore, especially since the truck was getting dangerously low on fuel. To review: four days—*four days!*—with virtually no food and making no attempt to get out. It would seem the Stolpas were crippled by a stubborn "wait for someone else to rescue us" notion. Even if the weather was terrible, they still waited too long to affect their own survival. At a minimum, they should have tried harder to signal for help.

Jim's original plan was to go by himself, leaving Jennifer and Clay in the truck. But Jenn would have none of it. They were a family and would travel together. They decided to walk east toward Highway 140, which they determined to be some twenty miles away. It was now Saturday, January 2.

The most serious issue was that they were attempting a trek based on the unknown. They would head across land twenty miles instead of heading fifty miles back in the direction they knew. I wasn't there, but I think I know what my decision would've been: to head back along the

path I knew. It is the only sure bet in a dangerous situation. Taking the risk, in their state, was not a good choice. Better to follow the adage "go with what you know."

Before they set out, they wrote extensively in Jenn's diary, detailing their ordeal to that point and their plan to walk to safety. Like the Robertsons before them, they even wrote rudimentary wills, another action I find difficult to believe. Consider some of the other great stories of survival I've chosen for this book: Yossi Ghinsberg, Nando Parrado, Douglas Mawson. These people didn't spend time writing wills and obsessing about dying. They dedicated their mental energies to thoughts of living, surviving, reaching safety. Even Chris McCandless waited until he knew he was going to die before he wrote his own epitaph. By comparison, Jim and Jennifer seemed to have little, if any, survival instinct, and at this point at least, they displayed a weak will to live.

As they got ready to head out, their lack of preparation once again reared its ugly head. They had very few warm clothes with them, an unforgivable oversight given that they were driving into a winter storm. But to their credit, they made do with what little they had. Jim had no long underwear, so he donned a pair of his wife's stockings instead. They pulled on as many pairs of socks as they could find and wrapped their feet in plastic bags before putting on their sneakers. Jim and Jennifer realized their feet would suffer dearly on the walk through the snow, but did nothing more to protect themselves, when the truck offered a host of resources that could have eased their future suffering.

It's not easy to systematically destroy your vehicle, but once they decided to head out on their own, there was no reason to keep the truck in one piece. To protect their feet in this situation, they could have dismantled the truck's seats. When cut to size and shape, the foam cushions make well-insulated snowshoes. Seat covers can be used to cover the snowshoes, and seat-belt webbing is perfect for securing the shoes to your feet. These would not only have kept their feet warm, but would have facilitated walking over the deep snow they were about to encounter.

Yet the bounty of a truck doesn't stop there. Wiring proves a useful substitute for twine, to tie things. Hubcaps can be used as eating or drinking vessels, or even for digging. And side or rearview mirrors are great signaling devices.

In situations such as these, layering clothing is another important survival strategy. Wearing just one heavy item of clothing will invariably promote sweating, which is the last thing you want to have happen in cold-weather conditions, since the moisture on your skin will cause you to cool off quickly. Someone once said, "You sweat, you die." You're much better off to wear several layers of lighter clothing; this way, you can easily peel off layers as your level of effort increases, preventing sweat.

When it came to Clayton, the Stolpas had to be a bit more creative. They bundled the infant in all his clothes, stuffed him inside two sleeping bags, then zipped him into Jim's garment bag, which Jim pulled behind him like a sled.

From what I can tell, the Stolpas didn't melt any water to bring along with them on their journey, which would have been very easy, given that they were generating lots of heat with the truck. Figuring out what to use as a container would have been more challenging, but possible.

Jim's last action before heading out was to leave left a note on the truck's dashboard:

To Our Potential Rescuers
If we are already dead don't mind the rest of this letter. But if we are nowhere to be found we have started walking to 140 as it appears the closest place to find help.
Sincerely, The Stolpa Family
P.S. Our final destination is Denio.
P.P.S. We are carrying with us a 5-month-old baby. HELP!!

So much is missing from this note. How many were in the family? Did they have food? Supplies? Was anyone injured? How old were they? Who should be called? In short, this note is woefully inadequate and offers little helpful information for potential rescuers.

In most cases, leaving the truck might have been a calculated risk. But it wasn't in this instance, since the Stolpas apparently made no calculations regarding their situation. They sat and waited when they should have been taking proactive measures to ensure their survival. They only made a move when it seemed they had no other choice. Jim would later say that saving his child was the driving force behind leaving the truck and

seeking rescue. Thank goodness *something* finally welled up inside them to elicit a response!

The going was tough from the outset. The snow was waist deep in places, but the day was clear and bright, and at least they could see where they were going. They hiked for hours and their feet began to get very cold, but eventually they came to a fork in the road and a sign that read HELL CREEK. There was no such place on their map, so they took a chance and chose what they thought was the right path. They continued to trudge through the snow, pushing eastward. Little did they know they were now walking along an off-road trail and were headed deeper into the wilderness—away from safety.

With no water on hand, the Stolpas' only choice was to eat snow. Most survival experts will say this is the wrong thing to do, as it reduces body temperature and consumes precious calories during warming, but I disagree. I believe that, given the vital role that water plays in survival, it's okay to eat snow if it's early in the day and you're working hard. There is little chance that the occasional mouthful of snow is going to cool you when you're trudging through knee-high snow. Sure, it's better to drink water. But given the alternative—dehydration—I'll take my chances eating snow. The Inuit people of Canada eat snow all the time, and they know a thing or two about surviving in the cold. You have to be careful about doing it late in the day, though, when you're tired and the weather begins to turn colder. Your defenses start shutting down as evening sets in, and eating snow can do more harm than good.

The day was growing late, but Jim wisely kept Jennifer moving. From looking at their road map, Jim was convinced that the road they were seeking could not be far off. Using this as their motivation, Jim and Jennifer pressed on, up one last hill. The road, they thought, would either be right below or, at a minimum, visible from the top. Exhausted and freezing, the Stolpas finally crested the hill that stood between them and their expected salvation. But when they reached the top, they were shocked to see nothing but more snow-covered hills stretching in every direction toward the horizon. They had been hiking for more than twelve hours—in the wrong direction.

The direness of their situation was worsened when they realized that Clayton had not made a sound for quite some time. It took a while

to muster the courage, but Jim finally opened the suit bag to find the baby safe and sound. It's almost inconceivable to me that they didn't open the bag immediately to check on their child, yet the scare seemed to harden them to the grim reality of their situation and increase their collective will to live. I wonder how well they would have fared had they not had Clayton with them.

BABY CLAYTON TAKES CARE OF HIMSELF

Babies like Clayton cannot shiver to keep themselves warm, so the body uses other mechanisms to generate heat and survive in cold conditions. As a baby's body cools, it diverts blood from its extremities to its vital organs. Special cells convert what's known as brown fat directly into heat. In essence, babies enter a state of suspended animation. Of course, they can only stay this way for so long, but it was enough for Clayton. While Jim and Jennifer were freezing, he was nice and warm.

With no other choice, the Stolpas decided to head back to the truck. They fought for every step; it wasn't long before darkness began to fall and the weather again took a turn for the worse. They knew they were not going to make it back to the vehicle that night, and decided to rest for a while. But where? In the fading light they saw nothing but snow-clad hills. So they sought shelter under some brush in the lee of a hill, threw a sleeping bag over their bodies, and rested as best they could against the onslaught of cold that came with night.

A much better option would have been for the Stolpas to anticipate their needs beforehand and actively seek out a place to spend the night. That way, they could have fashioned a shelter, maybe even made a fire to keep themselves warm. The truck's hubcap likely would have proven useful in helping them dig themselves a nice shelter in the snow. But they were still *reacting* to the situation instead of taking proactive measures, and it cost them dearly.

When morning dawned, they were encouraged to find that the wind and snow had stopped, but another obstacle now stood between them and rescue. When Jennifer tried to stand up, she fell immediately to the

ground. She knew with every ounce of her being that the only way to survive was to walk, yet her body would not cooperate. Then, not far away, Jim spotted a shallow cave tucked into the base of a hill. It wasn't much, but all three Stolpas fit comfortably inside, and it afforded a bit of protection from the elements. After the hell of the previous evening, the cave seemed downright luxurious.

Decision time. Jennifer did not have the strength to continue, but they knew their chance of being rescued from the cave was even slimmer than it had been back at the truck. Jim finally realized what he had to do. He had to make his way, alone, back to the truck, then head in the other direction—west—toward Cedarville, the last populated town they had passed while driving. Coming to grips with the fact that you've gone the wrong way and must retrace your steps is humbling and often demoralizing. It may help to know that you are trying to better your situation. Accepting that you've made a huge mistake is one of the toughest survival mentalities to have to deal with.

Before heading out, Jim faced reality with his wife. Cedarville was fifty miles from the truck. If he was lucky, help would find its way back to the cave in three days. It was a frighteningly long time, but Jim knew that staying in the cave meant eventual death for the family. He had no choice. He left their few remaining scraps of food with Jenn and Clayton, along with the sleeping bags and blankets, and headed out again into the snow. The last thing he did before setting out at around 9 A.M. was to tie a colorful sweatshirt to a small tree outside the cave to mark the location. It was a smart move.

Finally, after all those days alone, the Stolpas made a good decision. Jenn obviously didn't have the strength to continue on foot, and exposing Clayton to the elements would have been very risky. So it made complete sense to leave them sheltered. Nevertheless, it was still a decision based on their own pathetic situation, brought about only by their inability to be proactive. This is what I find most difficult about the Stolpas' ordeal. It seems as if almost everything they did was a reaction to the consequences of their own poor decision making: deciding to undertake the trip at all, deciding not to have Jim go out for help on the first day, deciding to stay in the truck for so long, deciding to head out into the unknown instead of back toward the known.

Jim was desperate, but motivated by his now-overwhelming desire to save Jenn and little Clay. Finally, it seemed his will to live was kicking into overdrive. It was almost as if Jim and Jenn functioned better independently, since they made horrible decisions when they were together. From them on, Jim turned into what he would later describe as a walking machine.

Like so many survivors, Jim sang songs as he walked, both to keep himself company and keep his pace. Although the temperatures were dangerously low and Jim's hands and feet were freezing, he could have helped his situation by wiggling them as he moved, which would have increased blood flow.

Jim fought to stay awake as he trudged through the snow, knowing that if he fell asleep, he might never wake again. For many survivors, having a nap in the bright sunshine of the day often seems like a good idea, until you consider that this is the time when rescuers are most likely out looking for you. Sleeping will also cause your core temperature to drop, increasing the risk of hypothermia. Jim hiked all day and eventually found his way back to the truck that night. Unfortunately, the battery was dead and he was not able to start the engine. But the truck provided at least some shelter for Jim to get a bit of sleep.

As the seventh day of their survival ordeal dawned, Jim set out again, this time to the west, back down the fateful road they had driven on a week ago. He was more than fifty miles from the nearest town, had no food or water, was woefully underdressed for the weather, and had hardly rested for days. Yet the thoughts of his infant child and wife dying out in the desert motivated him to push on at any cost.

Incredibly, Jim stumbled along County Road 8A for almost twenty-four consecutive hours, frozen and cold, but fueled by the knowledge that he was the only hope for his wife and child. He would later say that one of the most difficult things he had to face during this time was loneliness and isolation, two very dangerous emotions during a survival situation, because they can bring on more negative thoughts, which may ultimately lead to depression. And when people feel depressed, they start to give up. Their focus shifts from improving their situation to convincing themselves there is nothing to be done. But it doesn't have to be this way. Defeating this misery rests squarely on your ability to be proactive and do something, anything, to better your situation.

By the time Wednesday morning, January 6, rolled around, Jim was near the end. His strength was sapped and frostbite had taken hold of his hands and feet. He had even started to hallucinate the sound of Jennifer's voice around him. Then, sometime shortly before noon, when all hope seemed lost, he looked up and saw what he thought was another illusion. A truck in the distance!

David Peterson, a supervisor with the Washoe County Road Department, first thought Jim was a cow out of pasture, but soon realized his dire predicament. Jim was covered in snow, his hands and feet were frozen, and he was ravenously hungry and dehydrated. But after walking some sixty miles though the snowbound desert, Jim had made it—alive. The only thing left to do was rescue Jenn and Clayton from the cave.

PREVENTING FROSTBITE

As Jim and Jennifer would learn the hard way, trudging through the snow with improper clothing is an invitation for frostbite, the process by which human tissue freezes after prolonged exposure to extreme cold. No part of your body is more vulnerable to frostbite than your extremities: hands, feet, and face.

Turn-of-the-century explorers treated frostbite by rubbing the affected area with snow, a strategy we now know to cause more harm than good. A much better approach is to immerse the affected area in cool water, a very painful—but necessary—process.

Don't ever thaw out frostbitten flesh if there's a chance it may be refrozen again soon. Freezing, thawing, and refreezing will cause even more damage to the tissue.

Although many people confuse the two, frostbite is distinct from hypothermia, a condition that occurs when core body temperature drops below 95°F (35°C), which is required for normal metabolism and body functions.

David took Jim back to his house and began to organize the search, an uncertain undertaking given that yet more snow was in the forecast. After providing detailed information regarding the location of the cave, Jim was taken to a hospital in Cedarville. Meanwhile, David and his friends headed out in search of mother and child. They searched for hours, to no avail.

Then, shortly after 5 P.M., one of the men saw something odd in the distance, a flash of color on the otherwise bleak horizon. It was Jim's sweatshirt. They approached the cave cautiously, worried about what they would find inside, but were relieved to hear Jenn answer their calls. They were cold and hungry, but alive. The family was reunited several hours later at the hospital in Cedarville.

The following day, the young family was transported by ambulance to Washoe Medical Center in Reno, Nevada. Amazingly, baby Clayton suffered little from the ordeal, other than from severe dehydration and diaper rash. During their time in the cave, Jennifer had nursed Clayton often, but felt she wasn't producing much milk for the infant. To keep Clayton hydrated, she had taken to drooling melted snow into his mouth. She also used bits of clothing to soak up water from the small puddles that had formed in the rocky crevices around her. From what I can tell, they were the best decisions she made during the ordeal.

Yet where Jennifer fell short was in keeping herself active and warm. Even if she found it impossible to walk, she could have turned to the muscle tensing/relaxing technique I often use in cold-weather situations, which is incredibly effective at warming the core. It shows that moving and generating blood flow is the best way to stay warm in cold-weather situations.

There was nothing that could be done for their feet, though. Jim and Jenn's trek through the frozen desert had taken its toll on their extremities, especially their toes and feet, which suffered third- and fourth-degree frostbite. Two weeks later, Jim and Jennifer had all their toes and parts of their feet amputated.

JIM & JENNIFER STOLPA

ELEMENTS OF SURVIVAL

Knowledge 10%
Luck 60%
Kit 5%
Will to Live 25%

The Stolpas had little else on their side other than luck. Knowledge was minimal, which I find surprising in light of Jim's military training. Their kit was woefully inadequate, a difficult shortcoming to forgive, since they knew what they were getting themselves into. Their will to live started out fairly weak, but finally kicked into gear when they thought Clayton might have died in the suit bag. Luck saw them get stranded on a road instead of the middle of the wilderness, helped them find the cave when they did, and ultimately brought Jim in contact with his rescuer, David Peterson. This is a case where the joined additive forces of good luck and will to live came to the rescue.

10

Surviving Sharks (Part Two)

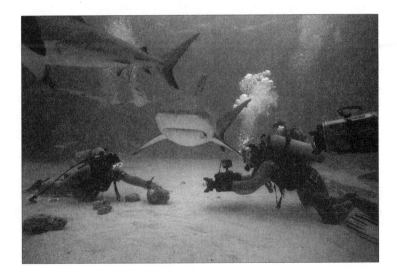

A few miles off the south coast of Australia, I don my 7-millimeter wet suit and slink into a steep reinforced cage just big enough for my body. The cage is lowered into the water, and I immediately start to panic as I discover that my breather tube is being pinched by the cage lid. I am about to drown eight inches below the surface in the cold ocean water. With no air in my lungs, I repeatedly punch up hard on the lid until they finally pull me out, asking what's wrong. The crew quickly learns of my excellent command of life-threatening expletives! Back in the water, air now flowing freely, I float in a one-person shark cage, waiting for a great white.

There are sharks, and then there is the great white. Sometimes called the white death, the great white has earned much of its ass-kicking reputation from the book *Jaws*, which was subsequently made into a movie by Steven Spielberg. In more recent times, the shark specials on cable television channels have done much to overdramatize and focus solely on the attacking and killing power of sharks rather than the benign reality. I have come to regret my involvement with some of these programs over the years. Yet the great white also comes by its reputation honestly. Great whites are carnivores, feasting on anything from fish to seals to dolphins. Despite their well-deserved spot at the top of the food chain, they are stealthy beasts, typically ambushing their prey from below.

And from my vantage point inside the cage, *beast* is the correct description. Two sixteen-footers come in again and again, swimming right past the cage and taking bits of bait the crew has been throwing off the boat.

Then *it* comes. An eighteen-foot behemoth that swims into the scene with the confidence only an apex predator of its size could exude. The two sixteen-footers take off and are not seen again. The sight of this huge animal coming straight at my tiny cage from the unending depths below is one I will never forget. The trick of its size is actually not its length, which is terrifying enough, but its sheer mass and girth. It could, quite simply, open its jaws fully and take my entire body in one bite, or maybe two! It rises slowly, with barely even a torque of its body, as if it can just think its way through the water. I can't help but think of the two flimsy ropes that hold the cage to the boat. This shark could rip the whole boat apart, never mind my little cage!

Over in the much larger filming cage, my buddy Mark Rackley, the extreme videographer, is running his camera when the big beast suddenly makes a run straight for me. Were I in the bigger enclosure, I could slink to the bottom, or even back up a couple of feet. In the solo cage, my face is inches from the opening, out of which I dangle bait by hand. There is nowhere to go, no place to hide.

The behemoth rams the cage right in front of my face; I bounce wildly, but the cameraman gets the shot he needs, from his safer vantage point. Thankfully, the metal has turned the shark away and he makes no attempt to fit his massive jaws around my tiny cage.

I am pulled back up, determined to do the rest of my dives in the big cage, where I'm hoping there is a greater margin of safety. But this assessment is soon proven wrong. Mark and I are in the large cage when a great white is mistakenly led to a piece of bait dangling between us and the boat, partially trapping the shark in the narrow space. It thrashes about viciously until it finally cuts through the bait line and smashes its way out, almost ripping the cage off its ropes.

Tiger Beach

I'm breathing hard into my mask and regulator as a dozen nine-foot lemon sharks and a few eleven-foot tiger sharks swim around me. Overhead, several tons of steel boat are about to come crashing down on me after being thrown into the air by a ten-foot ocean swell. Bulky scuba gear weighing me down, I frantically swim a few feet out of the way as the boat again threatens to land on me and my two safety divers, Don Schultz and Jessica Templin.

In the relative safety of the boat, the camera crew is trying hard not to be thrown into the water. "There's another tiger down there! Hurry up!" one yells at me. All I have to do is utter two short lines from my script—"Just where are the deadliest waters on earth, and more importantly, what makes them so deadly? Let's find out"—then simply dunk my head beneath the surface and take off on an underwater scooter. Easy stuff in a swimming pool, not in raging seas!

For the third straight year, the Discovery Channel has asked me to host a Shark Week special. Last year, I floated in a life raft above a group of frenzied sharks, only to puncture a hole in the raft myself and have the cameras watch me sink. Talk about setting your bar high! This year they asked, "Hey Les, how do you feel about jumping out of a helicopter into a frenzy of sharks?"

To be honest, this one took some convincing. We all have our demons, and mine is heights. Yet here I am, zipping up my wet suit and getting last-minute jumping instructions from the pilot. In fact, both cameraman Andy Mitchell and I will have to jump out, as he is to film from the chopper and would have no way to get back on the boat without jumping himself. He has no problem with heights—he has even been skydiving. Yet it doesn't escape my attention that he calls his wife right before takeoff. The seas have been rough all week; today they are at their worst. The winds are high, and swells rise to as much as twelve feet in the waters below. The *Dolphin Dream*, our former shrimp boat turned dolphin and shark tourism boat, is bobbing like a cork beneath us, in an area known as Tiger Beach. Just last year, a man was attacked and killed by a tiger shark here.

We have been chumming the waters with dead fish for two days to keep the sharks around and ready for my plunge. I make no bones about it, though, and tell the pilot I am scared of heights. This will definitely be a challenge for me. He assures me he can bring me within a foot of the swells if I want. Just when I was hoping we'd cancel due to high winds!

When you push your limits, you sometimes notice that your mouth goes dry. Mine is like sawdust as I climb into the chopper. I have an hour in the air before we reach Tiger Beach to consider my future. I can see the sand at the bottom, only thirty feet below the surface. At least this is slightly reassuring. "Looks pleasant enough," I tell myself. I can do this. As we fly over the lemon and tiger sharks, the pilot can't stop saying, "I don't care what kind of sharks they are, they're sharks! You guys are f***in' crazy!"

We circle a few times, trying hard to line up the shot for Andy. Finally, my time has come. Andy gets his shots, looks at me with an apologetic expression, and cries out, "Let's do this!"

When I used to perform on stage, I always had to deal with nervous bowels. When I first started to paddle class four or five rapids, I always had to pee. Jumping from a helicopter into an ocean filled with sharks for the first time requires an extra boost of adrenaline, though, so for some reason I let out a loud grunt and beat my chest.

Now, even though I'm not jumping from hundreds or even dozens of feet in the air, there's still a catch. The pilot says, "Oh, by the way, I'll have to keep the chopper moving while you jump, and you have to make sure you jump straight out, or the skid will flip up and could knock you out cold before you hit the water." Great.

The bite from a Caribbean reef shark is still healing on my wrist, and I realize that chain mail would be nice to wear. Somehow, though, our chain-mail suits were lost during one of the flights. In any event, the chain mail would do little against a lemon or tiger shark, which could rip right through me as an afterthought. Unfortunately for Andy and me, we know that a few small fish thrown in the water to attract the sharks is one thing, but the sound of something large—say, a human body—will bring the big sharks in fast. Tiger sharks determine what you are by biting. You lose an arm while they realize you aren't actually a fish. Small mistake for them. Big one for you.

Steady . . . a little slower . . . a little lower. Three slaps of my hand on the pilot's back, my feet resting gingerly on the skid of the chopper, and it's time. Out I jump, hoping I can do this without being decapitated by the prop or knocked out by the skid.

In the end, I surprise myself; the height is no issue. Down I go. Huge swells take me as soon as I hit the water, but my safety divers are there quickly to pull me to safety, all the while watching the sharks below.

I'm only underwater for a few seconds, but it feels like eternity. Soon I'm up again, choking and spluttering on the salt water. Success!

This may be difficult to believe, but I don't take risks. Everything must be calculated; everything must be in place for a great stunt to be only a stunt and not an act of lunacy. We get the shot, and I recite my lines at the back of the boat while trying not to be crushed. Hopefully, we've created what will be an opening shot to rival the knife-plunging scene from the year before.

Sharks are some of the most beautiful and powerful apex predators on the planet. I'm writing this on a plane and will soon be driving on a highway. I feel safer with the sharks.

11

Top of the World

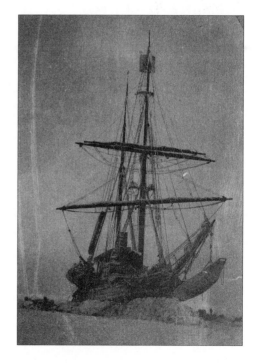

In 1913, only weeks into a highly touted arctic expedition, THE KARLUK became cemented in the unyielding grip of a MASSIVE ICE FLOE. For months, the *Karluk* and her crew floated helplessly through frigid waters, waiting for the inevitable force of the ice to CRUSH the overmatched vessel and set them adrift in one of the most INHOSPITABLE places on earth. Only fourteen would live to tell the HORRIFIC TALE of what happened in the months to come.

Vilhjalmur Stefansson, a Canadian born of Icelandic parents, is often considered one of the towering figures in the annals of arctic exploration. By 1913, he had already made two wildly successful ventures to the north. He lived off the land with Inuit people during the winter of 1906–07, and in 1910 discovered a group of Inuit—then called the "blond Eskimos"— who had never before encountered a white man. His latest venture, the Canadian Arctic Expedition, which was charged with exploring the area west of the Parry Archipelago on behalf of the Canadian government, was supposed to be his crowning achievement. It was anything but.

The trip seemed doomed from the start. As Magnus Magnusson so brilliantly states in the foreword to William Laird McKinlay's book, *Karluk: The Great Untold Story of Arctic Exploration and Survival,* the expedition was "ill-conceived, carelessly planned, badly organized, haphazardly manned, and almost totally lacking in leadership." Of all the survival stories I've come to know, from the smallest solo journey to grand expeditions, this one is the king of the hill when it comes to unorganized, poorly planned, misguided adventures.

McKinlay's first hint of impending doom should have come when he was asked to be part of the *Karluk*'s scientific team without ever having met the leader of the expedition, Stefansson. In the world of polar exploration,

this would be a huge red flag. Invariably, crew members would have had to endure a series of interviews to determine their suitability for the hardships ahead. McKinlay, a twenty-four-year-old Scottish math teacher who had never been to sea, received his appointment via telegram.

But McKinlay was young and adventurous, and despite the fact that he was given a mere seventeen hours to outfit himself for a journey to the top of the world—a monumental task by today's standards, let alone in 1913—he soon found himself on a ship bound for Canada.

McKinlay's rushed journey across the Atlantic was indicative of the entire expedition. From the minute he arrived in Victoria, British Columbia, the departure point of the expedition, McKinlay noted the uneasy, frenzied air that seemed to envelop the preparations for the voyage. Even the captain of the *Karluk*, a Newfoundlander named Bob Bartlett, was uncomfortable with the ship he was meant to command.

The *Karluk* was an old and largely underpowered ship that had started its life as an Aleutian fishing ship and been converted into a whaler in the 1890s. Although the *Karluk* had been reinforced prior to the journey north, Bartlett only accepted the mission under the assumption that he would not spend the winter in arctic waters. Stefansson did not seem as concerned: he did not arrive in Victoria until a mere three days before the *Karluk* and the expedition's other two ships—the *Mary Sachs* and the *Alaska*—were scheduled to sail.

Perhaps Stefansson was comfortable enough in his choice of crew that he knew he could rely on them. Perhaps he was just so confident in his own famous skill level that he had grown complacent, or at least too casual about the organizational process. I've done this when putting together various adventures: life becomes too stressful, and the time to properly examine your team seems to run out. And besides, when you've done something so many times, it's easy to believe you can fix problems as you go along. Such thinking can lead to fatal consequences when dealing with high adventures.

Equally critical to an expedition of such enthusiastic proportions is a strong, competent, and *available* leader. This was even more important as Stefansson's crew prepared for what might have been several years in the Arctic, where life and death hang in delicate balance at the best of times. Yet Stefansson was hardly there.

Most of the people he had chosen for the expedition—crew members and scientific staff alike—had no ice experience whatsoever. Yet there was one characteristic that Stefansson could not seem to resist: they were available on short notice and would work cheaply for the chance at adventure.

Stefansson was the product of his own fame and had grown dangerously overconfident. In the years to come, he would go on to publish a book called *The Friendly Arctic*, where he essentially espoused the notion that survival north of the Arctic Circle was relatively easy. Yet, as the crew of the *Karluk* would learn, surviving the arctic winter—no matter how many supplies you may have with you—is never easy, and far from friendly.

Stefansson had a rather unique view of the importance of his expedition. He seemed to consider its scientific achievements—and perhaps the fame they would heap upon his shoulders—more important than the well-being of his men. Indeed, McKinlay and the others were well on their way north when Stefansson began sending telegrams proclaiming messages such as this one to the outside world:

> ... the attainment of the purposes of the expedition is more important than the bringing-back safe of the ship in which it sails. This means that while every reasonable precaution will be taken to safeguard the lives of the party, it is realised both by the backers of the expedition and the members of it, that even the lives of the party are secondary to the accomplishment of the work!

I wonder how many would have signed on had they read that *before* they left. But they never got the chance. The *Karluk* departed Victoria on June 17, 1913. Three weeks later, the ships arrived in Nome, Alaska, where tons of supplies needed to be sorted and redistributed between the three ships before the journey north and east into Canadian waters.

The crew's activity level in Nome reached a fevered pitch. But there was little rhyme or reason to their method of packing. No one seemed to be in charge. Crew members ended up on the wrong ships, separated from their scientific gear, unable to perform the tasks that had brought them there in the first place. Some ships carried excessive amounts of one vital supply, only to have none of another. With little organizational leadership from Stefansson, the crew began to sing a familiar tune: they would sort

things out on Herschel Island. But Herschel Island was more than a thousand miles away, around the northern coast of North America. The *Karluk* would never make it.

Stefansson seemed to consider Herschel Island the beginning of the expedition, when in reality it was the halfway point. I have found myself in similar situations at the start of an expedition (while still at home, where supplies are easily found and organized), saying things like "We can pick it up at the little store by the put-in" or "We can get it on the way" or "We can lay things out by the lake and pack there." What usually happens, though, is that you run out of time and never manage to stop to pick up whatever "it" is, and your packing by the lake becomes a mishmash of throwing things together. This is exactly what the members of the Stefansson expedition were experiencing, though on a much larger scale.

McKinlay wasn't the only one to doubt Stefansson's leadership. Several crew members sought a private meeting with their leader, during which they questioned his plans. Stefansson was not happy with their audacity, yet another indication that his ego had grown too large for comfort. It seems to me that Stefansson considered himself a turn-of-the-century rock star, and they had no right to question his methods.

Yet this type of arrogant attitude, combined with Stefansson's haphazard approach to organizing, is a common refrain when it comes to disaster stories. The problem is that all too often you can't find the time or the things you need once the adventure gets underway. Sorting things out and getting the proper supplies and equipment needs to be handled before you leave home. If not, there must be absolute certainty that you can get what you need later. It may not be a big deal when you are only missing a few spoons and forks; it's a different story altogether when it's gear that your life may depend upon.

Not surprisingly, the expedition was in complete disarray after Nome. Cargo was strewn everywhere and nothing could be found. Everything was hinging on Stefansson's firm belief that it would all be sorted out on Herschel Island. The voyage was a disaster waiting to happen.

Early August saw the *Karluk* pass Point Barrow, Alaska, the northernmost point of the United States, and steam steadily toward Herschel Island. Yet travel in arctic waters is a fickle proposition at the best of times, and the ice pack the wooden-hulled ship had been weaving through for

the past ten days began to close in. Captain Bartlett tried valiantly to steer her into open water—he was successful on a few brief occasions—but the power of the ice was too much. By August 12, the *Karluk* was stuck for good, about two hundred miles from her destination. The *Mary Sachs* and the *Alaska* suffered similar fates, becoming permanently locked in ice near the Alaska–Yukon boundary. Unlike the *Karluk*, however, these ships were built to make it through the winter unscathed.

The *Karluk* spent weeks stuck in the unmoving ice pack, which stretched from the ship to the mainland. The crew members were hobbled by boredom, but did their best to pass the time. They often ventured out onto the jumbled mass of ice to hunt birds and seals, fish through cracks in the ice, or simply admire the strange shapes and hues of the eerie landscape.

By mid-September, Stefansson announced that there was no way the expedition would be able to proceed any farther that year, and should prepare for winter on the ship. Apparently feigning concern about the amount of fresh meat on board, Stefansson also said that he had decided to walk across the ice to the mainland, where he could hunt caribou. Stefansson, along with a team of five, set out. They never returned to the ship.

Two days later, a vicious gale whipped up, breaking apart the massive floe that imprisoned the *Karluk*. The ship was still trapped, but in a smaller floe no longer attached to land, and was being swept away at a rate of thirty miles per day. McKinlay watched in horror as an ever-widening expanse of black arctic water separated the ship from its so-called leader. There were now twenty-five people on the *Karluk*: thirteen crew members, six scientists, John Hadley (an employee of the Cape Smythe Trading Company, whom Stefansson had recruited shortly after leaving Nome), and five Inuit guides (including two children).

For decades, people have questioned Stefansson's decision to go ashore. Some say he knew the ship would eventually break away and he figured that to be stuck on the *Karluk* was to be stuck in a coffin. I'm not sure. He might simply have been trying to alleviate the intense boredom that characterized his life at the time. Either way, his excuse that the ship was running out of meat was transparently false: the *Karluk*'s Inuit guides had killed plenty of seals and there was a substantial store of fresh meat on board.

With the *Karluk* gone, Stefansson modified his plans, though they were no less ambitious. After meeting up with the *Mary Sachs* and *Alaska*, he designated a southern party to spend the next three years in an arduous program of scientific discovery. For his own part, Stefansson led a northern party that would roam the Arctic for five years.

Before setting out, though, Stefansson did the right thing and informed Canadian government officials about the loss of the *Karluk*. Word soon spread around the globe, and newspapers near and far had a field day with Stefansson's decision to continue with his own agenda after what they saw as a monumental tragedy. How could he carry on when twenty-five lives had seemingly been lost?

Well, we know Stefansson's feelings on the topic: in the grand scheme of things, the acquisition of new scientific knowledge was worth the sacrifice of a couple dozen lives. Stefansson was even quoted as saying, "I could never see how any one can extol the sacrifice of a million lives for political progress, who condemns the sacrifice of a few dozen lives for scientific progress." This was certainly Stefansson's dark side, and one he had the responsibility to share with his crew before he signed them up. But he didn't. As far as he was concerned, the *Karluk* was a part of history.

Consider the difference between Stefansson and a true leader of men, Ernest Shackleton, who is said to have placed the following newspaper advertisement before his legendary travels at the bottom of the world:

Men wanted for hazardous journey, small wages, bitter cold, long months of complete darkness, constant danger, safe return doubtful, honor and recognition in case of success. Ernest Shackleton

Shackleton certainly wasn't holding anything back from *his* men!

My good friend Gord Laco, a naval history expert, had this to say about the difference between Stefansson and Shackleton: "Stefansson was most certainly a different sort of leader. Shackleton made a practice of keeping the weakest, and sometimes the most troublesome, member of his crew as a tent-mate while on his incredible ice and sea journey. He also made a practice of bringing morning cocoa to his men personally and chatting a moment with each and every one of them. He wasn't just being nice. . . . With the choice of tent-mates he was keeping personal touch with his

people's condition and getting negative gossip first hand. With the morning cocoa routine he was doing the same thing but also making each and every man in the company feel he had a personal connection with their leader. And Shackleton knew very well how important his men's perception of his own morale was to the strength and will to live of the whole crew."

CONDUCTING A RECONNAISSANCE MISSION

A reconnaissance mission is the safest way to properly assess the surrounding landscape. Choose a destination and take note of the time you left, as well as the general speed and direction of travel. If you don't have a watch, you can count your steps.

Whenever you come to a major landmark (such as a stream, rock, or cliff), note the landmark itself, how long it took you to get there, the speed you were traveling, what side the landmark is on, and which way you turned (or didn't turn) at this spot.

You can cover many miles of exploration this way, repeating the process as often as necessary. Of course, you need some way to write the information down, preferably as neatly as possible. On the return journey, simply reverse the information. Now you can come back out this way again any time you want, using the reconnaissance map to keep you from getting lost.

The *Karluk* wasn't part of history, though. Not yet. The ship floated along as part of the ice floe for weeks, with no end in sight. In early October, McKinlay and his mates could see open water stretching tantalizingly around the floe to the south, but were powerless to do anything about it. And so they sat, waiting for something—anything—to happen.

They did their best to keep busy. McKinlay took to handicrafts, at one point making a medicine chest for the ship's doctor. The *Karluk*'s mechanics overhauled virtually every moving part in the engine room, preparing for a quick getaway should the possibility of escape ever present itself.

This not only kept them busy and staved off boredom and depression, but also allowed them to hold on to the only thread of hope they had, a sound survival strategy.

Despite the otherwise dire circumstances, the crew never stopped appreciating the awe-inspiring beauty of the landscape. Stark though it may have been, here was a world few of these young men could ever have imagined, including the teacher McKinlay. The sun reflected off a landscape that stretched seemingly to the end of the world. The ice floes around them rose and fell as if with minds of their own, sometimes crashing together with such force that they would form huge ridges rising dozens of feet into the sky. Polar bears and seals were their constant

THE LONG, DARK WINTER OF THE ARCTIC

The regions north of the Arctic Circle are characterized by bright summers when the sun never sets and dark winters when the sky never brightens. The farther north you get from the Arctic Circle, the longer the respective periods of light and dark. And for all the increased energy that around-the-clock sunlight brings, twenty-four hours of murky darkness for months on end can be a maddening proposition.

Most seasoned arctic explorers planned for the psychological challenges brought about by the darkness of arctic winters and filled their men's time with enough activities and chores to keep them occupied when the land around them faded into the inky night. Whether the crew was taking apart and rebuilding parts of the ship, listening to readings by the captain, or preparing for the day's slate of physical contests, there was always something to do among the most organized expeditions.

With good reason. Light deprivation has been linked to depression and seasonal affective disorder and can also throw a person's sleep-wake cycle completely out of whack. Add to that the hopelessness and lack of purpose that often accompany a survival situation, and you can see why keeping busy is so critical. Too bad Captain Bartlett never clued in.

companions. When darkness fell, the northern lights danced eerily across the night sky.

As strange as it may seem, it is a good strategy to appreciate the beauty of nature around you, even if you are in peril. Most survivors report doing this at one time or another during their ordeals. It is the same as maintaining a sense of humor in your darkest hours. It takes your focus away from the misery of your current situation.

In the meantime, Captain Bartlett was now in charge of the ship. And while he would go on to make some very wise decisions in the months to come, he fell flat in those early days aboard the *Karluk*. In early October, the ship's doctor presented Bartlett with a letter requesting that he hold a meeting with the entire crew, where he would lay out his plans for their future. Bartlett confidently replied that no such meeting was necessary, and let the matter end there. So when the doctor presented Bartlett with another letter ten days later, the skipper refused to accept it altogether.

I think Captain Bartlett made a big mistake in avoiding the meetings. It seems like he was living in a world of hope and disbelief, and was essentially denying the grave nature of their situation. To the contrary, he should have done what all good leaders do in survival situations: realistically assess the situation, share that knowledge with the others, and prepare for the worst.

Yet he didn't. The days passed into weeks, and an oppressive feeling of hopelessness began to take hold of the crew. This sense of overwhelming and contagious apathy can sometimes be worse in a large group than a small group. Among a large group, people can sometimes become distractions for one another, forget the gravity of their survival ordeal and focus on the boredom. Small groups usually don't have the luxury of distraction, however, and tend to focus on—and tackle—the survival situation almost immediately.

So Bartlett missed another opportunity to lead. It was his responsibility to assess the morale of the crew. He should have sensed their despondency and organized games, contests, and activities that have kept other arctic exploration parties eager and vital under similar circumstances. This is especially important when the fundamentals of life—food, water, shelter, clothing—are accounted for and there's little else to do.

As October turned into November, Bartlett finally seemed to kick into gear when he realized that there was little hope the *Karluk* would make it through the winter. He chose an area of what he thought to be the oldest and most stable ice on the floe, and ordered the crew to begin moving the ship's supplies there. Bartlett now recognized that their only hope of survival was to move as much of their cargo as possible off the *Karluk*, because she was in danger of being crushed and sinking.

It was a good decision, but I believe the captain waited far too long. In the end, they moved all the necessary supplies off the ship, but Bartlett never seemed to consider the mental well-being of his men. He should have started the work effort much earlier, when the men were at risk of sinking into depression. This would have given them something to do to pass their time, a reason for being.

In fact, why not dismantle the ship completely and rebuild it somewhere safe? Of course, it's easy for me to ask that as I write this, in warmth and comfort. And what if the opposite had happened and a lead opened up and set them free? Either way, if radical action such as dismantling the ship were to be taken, it should have been much earlier. Six days later, McKin-lay and the others had moved a massive store of supplies out onto the ice:

alcohol (5 drums)
beef (5 casks)
biscuits (114 cases)
coal (250 sacks)
coal stoves with piping (3)
codfish (6 cases)
codsteaks (3 cases)
dried eggs (4 cases)
gasoline (33 cases)
molasses (19 barrels)
sleds (9)
timber (2,000 feet)
wood stoves (2)

Bartlett then very wisely had the men use the supplies—particularly the wooden cases that held various items—to construct the walls of the

two houses that would soon become their homes. The tops of the crates all faced the interiors of the houses, for easy access to their contents. The extra timber they carried was used to make floors and the roof rafters, over which was spread sailcloth.

Building the houses seems to be Bartlett's first real bit of survival thinking, much more so than having the supplies removed from the ship, which was more reactive than proactive (the *Karluk* was about to be crushed). It shows that Bartlett was beginning to think about their long-term survival.

Bartlett also had the men insulate the outsides of the houses with blocks of snow, another smart move. As counterintuitive as this may seem, snow is an excellent insulator. It is dense, keeps the warm air in and the cold air out, and is especially useful at keeping out the wind, which is the greatest killer of all in the cold.

Bartlett's inspiration for using snow as insulation may have come from Kuraluk and Kataktovik, the two Inuit men on board (the other Inuit on the *Karluk* were Kuraluk's wife and two children). Quiet and reserved, the Inuit were tireless hunters who provided a constant supply of seal and polar bear meat to the captain.

Although the crew did not need to move into their makeshift houses right away (the ship was still intact), they proved useful almost immediately for housing injured dogs. When Stefansson left, he had taken the twelve best sled dogs with him, which meant that extra care had to be lavished upon those remaining on the *Karluk*. It wasn't easy, since they often seemed hell-bent on killing each other.

The aggression of true Inuit sled dogs is not particularly well known, but a frightening sight to behold. They can be utterly vicious to one another, and they often fight to the death. For three years, I ran Inuit sled dog teams, taking clients on wilderness trips and adventures. I have lost count of how many times I needed to jump into the middle of a five-dog fight with my fists and boots flailing. The dogs barely noticed me—so intent were they on fighting one another. I had to be as tough and strong with them as many ranchers are with horses, or they would have maimed—or killed—each other, a fate far worse than being kicked in the head by a musher.

As time passed, it became apparent that as seaworthy as the *Karluk*

might have been as a fishing and whaling ship, she was ill equipped for a winter in the Arctic, both inside and out. The tables were too small, there were too few plates and mugs, and there weren't enough stools and chairs on which to pass the monotonous days. Even the few lamps they had soon stopped working properly, so McKinlay took it upon himself to restore them to perfect working condition.

He meticulously took apart the lamps, boiled down every part, then put them all back together again. This is a classic example of how obsessing on a small detail can make survival more bearable. For many survivors, it's okay to spend what may otherwise seem like an inordinate amount of time focusing on a small task. It occupies your mind and your hands, and may help you live to see another day.

McKinlay certainly did; his survival instincts were top-notch, even if they were tempered by his meek personality. Rather than become bogged down in misery and boredom, he used his time productively. To keep his body fit and sound, he spent hours running around the deck of the *Karluk*. I'm not sure if this exercise regimen was copied by the other members of the crew, but they would have been wise to do so. They still had plenty of food, so the activity would only have served to help. The alternative would have been to eat very little during times of inactivity and more when working hard.

I know I've used exercise as a way to keep warm and sane during many of my survival ordeals. During my first-ever *Survivorman* shoot in the boreal forest of northern Canada, I had to do jumping jacks and push-ups to keep my core temperature from falling dangerously low. My primary motivation was to create warmth, but the beneficial physical and psychological effects of such exercise should never be overlooked.

McKinlay's survival instincts certainly did not stop with exercise, as he tried to make himself as ready as possible for the ordeal he knew would come. He even went so far as to study books from the ship's library (he read an entire book about the arctic exploration ship the *Jeannette*) to learn lessons from explorers who had passed that way before. If anything, McKinlay was proactive.

But the schoolteacher was not beyond making mistakes. During one of his excursions off the ship, he was stricken with a case of frostbite on his hands. As a sign of the times, the ship's doctor advised that the best way

to treat the malady was to rub the affected area with snow, which we now know can cause permanent damage.

The months passed. November became December, and soon the crew was thinking about Christmas on the ship. Yet the Yuletide spirit did not extend to all members of the crew, as three of them began to make plans to leave the *Karluk* and strike out on their own. This news did not sit well with Captain Bartlett at all.

One morning shortly after Christmas, the crew was shaken from its torpor by the sound of a shot outside, which proved to be a huge crack that had opened up alongside the entire starboard length of the ship. It was the last thing any of them wanted to see, for they knew that pressure ridges formed around cracks in the ice. And if a pressure ridge—those places where massive ice floes smash and grind together like tectonic plates—formed anywhere near the ship, the *Karluk* was doomed.

Preparations for abandoning ship took on a new sense of urgency, a development that helps illustrate just how complacent they had been. Even though they were helpless in one of the most unforgiving climates on earth, they still weren't thinking like people in a perilous survival situation. They knew the sinking of the *Karluk* was likely, yet they didn't prepare themselves to the point of being a finely oiled machine. That was a serious mistake.

Clothing was a big concern for the crew. In Stefansson's hurry to leave Nome, winter clothes were not evenly distributed between the three ships, so there was little of use on the *Karluk*. Luckily, Kuraluk's wife—affectionately known as Auntie by the crew—was an excellent seamstress who worked tirelessly at making sealskin clothing from the supply of skins the hunters had provided. Unfortunately, the process was extremely labor intensive, and there was no way she would be able to outfit the entire crew before the *Karluk* was lost.

McKinlay and his mates did little to help her, as they thought the process too exacting to be properly undertaken by their untrained hands. That was a pathetic excuse. Here they were, staring squarely at spending a winter north of the Arctic Circle with inappropriate clothing, and they spent their time doing nothing in terms of long-term survival. The men were likely too old-fashioned in their thinking, and convinced themselves they *shouldn't* do it. So they didn't. All they needed to do was take the time

to learn, and they had ample time on their hands. The captain should have assigned a group of men each week to the task. In fact, the only time they finally got their act together and started sewing was when the crack appeared at the side of the ship and they realized their days aboard the *Karluk* were numbered.

On January 10, a harsh, grating sound woke the crew and a shudder shook the ship. The cracks in the ice had widened and begun to move. Later that evening, the movement of the ice tore a hole in the side of the *Karluk* that nobody could repair.

With sinking inevitable, the crew mobilized quickly, removing every last useful item off the ship. By the afternoon of January 11, the *Karluk* was at the bottom of the Arctic Ocean. The additional supplies taken off the ship were as follows:

bearded seal skins (2)
Burberry gabardine (3 rolls)
Burberry hunting suits (4)
butter (2 boxes)
chocolate (2 boxes)
coal oil (3 drums)
coal oil candles (15 cases)
cocoa (1 box)
deer legs (2 large sacks)
deer skins (20)
fawn skins (100)
fleece suits (6)
heavy winter skins (6)
Jaeger blanketing (hunter or military style, 2 rolls)
Jaeger blankets (50)
Jaeger caps (30)
Jaeger mitts (100 pairs)
Jaeger socks (200 pairs)
Jaeger sweaters (6)
mattresses (20)
milk (200 tins)
pemmican (5,222 pounds, Hudson's Bay; 4,056 pounds, Underwood)

seal skins (12)
skin boots (100 pairs)
sugar (250 pounds)
tea (2 boxes)
underwear (70 suits)
woolen shirts (36)

Life at the so-called Shipwreck Camp proceeded much as it had on the ship, until January 25, when Captain Bartlett sent seven men with three sleds, eighteen dogs, and 1,200 pounds of supplies in search of Alaska's Wrangel Island, which lay somewhere to the southeast. In the meantime, Bartlett also called for smaller parties of two and three men to travel behind the advance group, establishing a chain of supply caches toward Wrangel Island.

I think the captain's decision to split the group up was a serious mistake. It's one thing to leave people behind who are too sick or injured to travel, as in the case of Nando Parrado and his teammates in the Andes, but I think history has shown that, when you split up a large, healthy group, you are almost always asking for trouble. Why? You divide your reserves (even though they were convinced they had plenty), your strengths, and your expertise. Sure, you might cover more ground, but I believe that keeping a group together—whether it be in travel or in staying put—is the best thing to do unless you have no choice.

On February 3, three of the seven-man Wrangel Island party returned. The group had not yet reached its destination, but the trio believed the others were not too far off when they decided to return to Shipwreck Camp. The four others were never seen again. It was not until 1929 that a passing ship found the skeletons of the four men on a barren island known as Herald Island. What deprivations they suffered there can only be imagined.

The Arctic had begun to take its toll on the members of the *Karluk*. Shortly after the trio from the Wrangel Island party returned, four others decided to set out on their own. None from this group would survive.

Bartlett was very worried about the four Wrangel Island party members who had been left behind and sent a three-man team back in search of them. At the same time, he sent two other crew members on another caching trip. His various attempts at sending out small parties

was unwise, and ultimately resulted in the needless loss of four men.

Yet it took a variety of failures for the captain to finally decide to move the whole group, which he did once the three-man team returned without having found the advance party. It helps illustrate that, as good a sea captain as Bartlett might have been, he had very little experience when it came to arctic survival. Was he the right man for the job? It's something Stefansson should have considered.

The remaining seventeen survivors departed Shipwreck Camp on February 18, 1914, with four sleds, twenty-two dogs, and as many supplies as they could carry. They believed Wrangel Island to be some forty miles away, a distance they underestimated by at least half. I believe they would have been better off trying to determine exactly how far away the island was, then doubling that estimate and using that revised figure to be the true distance they would need to travel.

It wasn't long before they realized that traveling over arctic sea ice is a hellish undertaking for inadequately outfitted people unaccustomed to the terrain. Yet through a combination of determination, luck, and the knowledge of their Inuit guides, the various parties made it to Icy Spit on Wrangel Island on March 12, two months after the *Karluk* originally sank. Their party of twenty-five had been reduced to seventeen and was showing the ill effects of the arduous journey they had undertaken from Shipwreck Camp.

To his credit, Bartlett immediately began making plans to go to the Siberian mainland, which he knew to be populated, to seek help. Although his original strategy had been for everyone to make the journey, the crossing from Shipwreck Camp to Wrangel Island had taken such a toll on them that he knew it was no longer viable. Bartlett decided to go alone, with one Inuit guide, Kataktovik. This was the first splitting of the group that actually made sense. It was necessary, and it had to be a small, capable group that went.

But Bartlett made a huge mistake before he left: he failed to recognize the importance of strong leadership among the remaining survivors. To the contrary, he actually allowed them to split into four groups, each with an equal amount of provisions, to seek their own destiny. Although Bartlett appointed Chief Engineer John Munro to be in command after he left, he essentially left the group adrift and leaderless, which can be very

dangerous in a survival situation. You can't just arbitrarily make someone a leader and hope everyone else listens to him or her. Personality, strength of character, and actions in times of need must dictate the choice.

In retrospect, Bartlett was hot and cold as a leader. He made some good decisions and his fair share of bad ones as well. Prior to leaving, he had a long discussion with McKinlay, who, he hoped, would help ease the rising tensions among the survivors. It was a good choice, as McKinlay would prove to have the temperament for the job, but it vividly illustrates Bartlett's lack of leadership acumen when it came to dealing with personalities, egos, and difficult circumstances.

Tensions began to rise almost immediately after Bartlett left. The camp was in disarray, many of the crew were sick and weak, and the survivors were beginning to realize that their stores of food were not as limitless as they had once imagined. Quarrels began to break out about the rationing of food; not surprisingly, Munro did little to help the situation.

In late March, assistant topographer Bjarne Mamen decided to move his group to a place called Rodger's Harbor, on the south coast of the island, where Captain Bartlett had promised to meet the crew in mid-July. At around the same time, Munro took some men in search of the original advance party that had vanished after leaving Shipwreck Camp. The search proved fruitless.

The arctic days grew longer and longer, and the weather improved steadily. That didn't stop a surprising number of the survivors from getting frostbite, which they continued to treat by rubbing snow on the affected area. It shouldn't have happened as often as it did, especially given the large number of furs and other materials on hand. Again, this speaks to their lack of experience with the climate, as well as a general lack of care. I realize you can't prevent all episodes of frostbite in this type of survival situation, and they would even have been prone to it in their state of poor nutrition, but they had both the materials (animal skins) and the expertise (their Inuit guides) at their disposal. They were simply not protecting themselves enough. At one point, a crew member's big toe had to be amputated with a pair of tin shears—and no anesthetic!

McKinlay enjoyed the sunshine immensely, and was overjoyed on those days when he could leave his dark and squalid quarters and enjoy the fresh air. His sense of survival was reaching new heights, and while

he may not have been the vocal leader of the survivors, he did his best to lead by action. He went to great pains to stave off monotony. Even when he was sick, he implemented a daily exercise routine. He also did his best to mend the rifts that sometimes grew between himself, an educated scientist and teacher, and the largely uncultivated crew. As he so aptly stated in his book, "When you're sick, hungry, and freezing in the middle of the Arctic, it's no time to put on airs."

One thing that helped maintain the morale—and well-being—of the survivors were the fires they kept roaring on the shore of their camp. This helps illustrate one of the great misconceptions about the Arctic: that there is no wood. Quite to the contrary, I don't know that I've ever set foot on an arctic shore where I haven't found either driftwood—often from thousands of miles away—or old lumber from wrecked boats and Inuit hunting camps. You can actually get a great fire going in the middle of a treeless landscape.

Yet, as in many survival situations, the primary focus at Icy Spit was now food. The supplies they had brought from Shipwreck Camp had been almost continuously supplemented by the Inuit hunters, but game had grown scarce. In late April, Hadley had set out with Kuraluk in search of food.

Kuraluk returned in early May with one seal, and notified the others that Hadley was on a nearby ridge with three more in tow. When Hadley did not return, Munro did not immediately send anyone out to retrieve the remaining seals (which would likely have been eaten by polar bears anyway had they been left alone). Even when Hadley returned days later with only two-thirds of a seal remaining, Munro did nothing to address the fact that they all thought Hadley had simply gorged himself on seal. If lack of leadership is one of the greatest causes of poor group dynamics, then Icy Spit should be a case study. Consider Yossi Ghinsberg, who was smart enough to try to talk to his friends when tensions ran high during their Amazon trek. Munro, it seems, was afraid of confrontation.

What the group really needed was a Nando Parrado, someone willing to step up and take charge of the situation. Munro was not the one to do so, and nobody else filled the void. McKinlay was intelligent and motivated, but was viewed as an outsider by most of the rest of the seamen and was hampered by his meek disposition. Perhaps Stefansson's decision to

leave the group so many months before had taught them that it's better to fend for yourself than worry about others.

Though the weather continued to improve, the condition of many of the survivors at Icy Spit worsened. Many were afflicted by an inexplicable swelling of their legs and arms, a condition we now know to be protein poisoning.

RABBIT STARVATION

Protein poisoning is also known as "rabbit starvation," and it's actually a form of malnutrition caused by the combination of excessive consumption of lean meat (such as rabbit) with a lack of other nutritional sources. The addition of other stressors—such as being stranded on a tiny island in the middle of arctic nowhere—adds to the severity of the illness.

Protein poisoning is characterized by a variety of symptoms, the most common being general discomfort, swollen extremities, diarrhea, headache, fatigue, low blood pressure, and low heart rate.

Interestingly, Stefansson would later point to the expedition's vast stores of pemmican as the cause of the protein poisoning that afflicted so many of its members. Yet he never accepted any responsibility for the pemmican's deficiencies. Clearly, he held a different view than did Admiral Robert Peary, who, in *Secrets of Polar Travel*, had this to say about pemmican: "Next to insistent, minute, personal attention to the building of his ship, the Polar explorer should give his personal, constant, and insistent attention to the making of his pemmican and should know that every batch of it packed for him is made of the proper material in the proper proportion and in accordance with his specification."

In my experience, the proper formula seems to be half fat and half ground or powdered dried meat, along with (if possible) some dried berries for flavor. When prepared correctly, fifty-year-old pemmican has been found to still be edible.

On May 17, McKinlay decided to leave Icy Spit and join Mamen and the rest of his group at Rodger's Harbor. Yet he was only about halfway to

his destination when he came across Mamen in a ramshackle camp near a place called Skeleton Island. It was there that Mamen broke the devastating news to McKinlay: one of the members of his group, a man named Bob Malloch, had died the night before.

I find it almost inconceivable that in mid-May—when the sun was shining long and bright in the sky, the weather was tolerable, and supplies of food and water were adequate (others in the party had been denying themselves to give Malloch extra)—that this man had to die. It seems that the will to live was quite low, and that there was more apathy than will. I find it surprising, with so many in the party, but it shows just how leaderless they were, and illustrates the beneficial effect a strong leader can have on a group—or, in this case, the detrimental effect of the absence of one.

They were not helped by the fact that they had split up into various factions that kept moving from camp to camp according to their own whims. Nobody was courageous enough to take command and develop a cohesive, comprehensive plan of attack. Everything they did was reactive instead of proactive. So people started dying.

McKinlay realized that both Mamen and his sole surviving camp mate were in very bad shape, so he decided to head back for more provisions. He arrived at Icy Spit a few days later to find that the mystery disease had spread. Many more survivors were now suffering with swollen extremities.

By early June, a few more of the group decided to make their way toward Rodger's Harbor; McKinlay accompanied them. While on the way, they encountered two other crew members who had ventured out some time earlier to check on the state of Mamen and his camp mate. Their news was predictably bad: Mamen had died on May 26. Although they were all upset at the loss of yet another in their party, McKinlay was the most stricken. Mamen had been the last of his scientist colleagues on the island.

McKinlay dropped his plans to move to Rodger's Harbor and instead worked like a dog at Munro's command, helping the remaining crew at Icy Spit move to a location called Cape Waring, about halfway to Rodger's Harbor. It was a monumental task. Many people were now suffering such pronounced effects of the mystery disease that they could barely walk, and the dogs were exhausted. Yet somehow, McKinlay helped get everyone moved.

Once everyone was settled in at Cape Waring, the issue of food began to assume monumental importance. Their pemmican stores were getting

extremely low, large game such as seals and polar bears were becoming scarcer as summer set in, and they were running out of ammunition. Perhaps not surprisingly, each of the various factions in the group had its own method of rationing food. The Inuit with which McKinlay shared his tent were expert rationers. They could turn one small bird into a meal for four people, while just a tent away, men would be gorging themselves on a bird each, only to be complaining of hunger a few hours later.

By this time, the entire operation was breaking down. There were petty arguments over just about everything; it seemed that luck was the only thing keeping some of them alive. It got so bad that people started cheating on food, stealing from one another, and withholding information when a hunt had been successful. Now the lack of leadership had become a dangerous issue.

And although everyone was certainly hoping that Bartlett would return in July or August with a rescue ship, I am amazed that nobody ever seemed to consider what they would do if he didn't return. June, when the sun was high and the weather getting warmer, was the time for them to be thinking about winter. They should have been finding a place to spend the winter, building shelters, fortifying their camp, and collecting food. Instead, they were entrenched in trivial disputes and self-serving motives. It was like a historical episode of *Survivor!* Even Kuraluk, who became snowblind at one point and was not particularly happy when asked to work, seems like the old man in the neighbourhood who never grew up.

The fact that Bartlett had put Munro in charge was the worst thing for the company. Not only was he incompetent, but he seemed to be corrupt, and used the power bestowed upon him to suit his own agenda. At one point, McKinlay learned that Munro and another crew member had killed ten birds and eaten them all without sharing with anyone else. Munro even went as far as to order Hadley, who proved to be a dogged hunter during their time on the island, to hand over some of his ammunition. There was a huge uproar, but eventually Hadley acquiesced, since Munro was in charge. When all was said and done, Munro had 170 rounds left for himself and two other men camped at Rodger's Harbor, while there were 146 rounds for the ten people at Cape Waring.

I also fault McKinlay and the others for not standing up to Munro. I realize there is a strict line of authority in the naval world, but there comes

a point when someone has to stand up for what's right. Munro's authority should have been challenged. When it's a life-and-death struggle, I don't care who the captain put in charge. Munro was not fit for the job. The problem was that nobody else seemed up to the task, either.

Yet they somehow managed to keep themselves alive. There were thousands of cliff-dwelling birds at Cape Waring, which provided enough meat and eggs to keep the crew alive, though just barely. There were still terribly disparities between the amount of food being eaten in the various tents. By late June, McKinlay and the Inuit, who continued to ration stingily, had enough food to last them five more days. The others had consumed their last bits of pemmican, seal, and birds, and were either hoping for a miracle or had more insidious plans.

The next few hunting forays saw the residents of one tent keep all the spoils for themselves, while McKinlay and his mates relied on the stores they had been so carefully rationing. Yet the apparently short-lived bounty did not help bolster spirits much. On the morning of June 25, the camp was awakened by the sound of a shot, followed by shouts. Apparently, Breddy, a member of the other Cape Waring tent, had shot himself dead.

It wasn't long after Breddy's death that the primary thought around camp again turned to food. Each tent had now completely exhausted its supplies, and hunting was the only available option. Fortunately, Kuraluk continued to have sporadic luck hunting seals, but even three seals seemed meager when divided among the seven men, one woman, two children, and three dogs still calling Cape Waring home.

In what was likely one of the few strokes of brilliance the survivors had, someone realized they could make a kayak to help get them closer to the seals. Of course, they relied on Kuraluk to design and build the craft. He used an ax head to fashion the sides and ribs of the frame from two large driftwood logs. Two weeks later, Auntie sewed a series of seal skins together over the completed frame. On July 19, the kayak was launched for the first time.

In the meantime, Hadley and Kuraluk continued to hunt. They were occasionally successful, but not nearly as successful as you might think. In July, Kuraluk fired at eleven seals, killing six and missing five. That same month, Hadley fired at ten seals, killing four and missing six. And as McKinlay so rightly points out, those figures don't account for seals that

were stalked but escaped before the hunters could squeeze off a shot.

Hunting is certainly a viable way to get food in a survival situation, but its success rates tend to be vastly overrated. People are always amazed at how unlucky I am when it comes to hunting during my survival experiences. The reality of the situation, though, is that even in the best circumstances, hunters often come up empty-handed. And if someone is trying to do it while exhausted, on the brink of starvation, perhaps injured, lacking a gun (or having one unsuited to the prey)—and, in my case, running my own cameras—it is easy to see how difficult it is and how lucky one needs to be.

But Kuraluk was an expert hunter, had a good gun on hand, and was a member of a race that had been hunting those waters for millennia. At the end of July, he killed three huge bearded seals on consecutive days, providing a feast the likes of which the survivors had not seen since their days on the *Karluk*. McKinlay also added to the camp's food supply by discovering a small edible plant that was plentiful near running water.

Perhaps bolstered by this newfound bounty, the survivors finally began to consider the possibility of wintering on the island. They selected a site for a hut and began drying meat for the long, cold, dark days that lay ahead. Finally!

But, while McKinlay and the Inuit continued to ration wisely, the men in the other tent did not. So, by the third week in August, the others were asking for a handout. Grudgingly, McKinlay's tent agreed, but only in fixed and limited amounts, and only in exchange for some precious tea.

The rations had to last a long while, as hunting would prove unsuccessful for the next four weeks. Again, however, when all hope seemed lost, it was Kuraluk who provided for the group. He realized that, although their waning ammunition was too precious to waste on the sea birds that swam in the waters off the cape, it might be possible to catch them with a net that had lain long ignored under a snowbank. The technique proved to be wildly successful, and I am utterly flabbergasted that it took them so long to remember they had this very valuable tool on hand. It's a wonder anyone other than the Inuit survived.

On September 6, the Inuit woman helped the food situation immensely by catching fish through a crack in the nearby sea ice. The pile of fish was beginning to build on the seventh, when the camp was shocked

by a scream from Kuraluk: "*Umiakpik kunno!*"—Maybe a ship! Some three miles offshore, a small schooner was steaming to the northwest. Nobody could tell if it was a relief ship or a walrus hunter on the prowl for prey, but their hopes were dashed when the ship hoisted its sails. It was sailing off!

The survivors didn't wait for another signal. They knew this might be their only chance at rescue. Those on shore started screaming and waving for all they were worth. Hadley used up most of his ammunition firing his revolver into the sky, and Kuraluk went racing over the ice in hopes of heading the ship off. Then McKinlay and the others saw what they thought must be an illusion. The ship lowered its sails, and a party of men disembarked and began walking across the ice toward camp.

Though salvation had come at last, the survivors could still only think of one thing: food. They immediately turned to their store of fish. When the rescuers arrived in camp, the survivors were just putting on pots for a meal of fish and tea, their last on Wrangel Island.

Like many of those who suffer through a survival ordeal, McKinlay found it surprisingly difficult to bid farewell to the camp and the precious items that had kept them alive those many months. Dr. Francis Bourbeau, a survival expert and good friend of mine, once spent thirty days surviving in the boreal forest of Quebec. Once he was safe and sound in the plane at the end of the ordeal, even though he knew he was on his way home, he insisted that the pilot give him matches—just in case. I too always find myself reluctant to give up my survival supplies until I am actually back in civilization—again, just in case.

As McKinlay had suspected, the ship—the *King and Winge*—was a walrus hunter whose captain had promised to look for the lost party if it ventured near Wrangel Island. It had first arrived at Rodger's Harbor and picked up Munro and two others, who directed it to Cape Waring.

At 11:30 A.M. on September 8, 1914, the survivors stood on the deck of the *King and Winge* and spotted a steamship, the *Bear*, approaching from the distance. As the two ships pulled alongside one another, Captain Bartlett could be seen standing on deck. After a seven-hundred-mile sledge journey through Alaska and into Siberia, Bartlett had gotten through after all.

As for Stefansson, he continued his explorations over the Arctic Ocean and Beaufort Sea, living largely by shooting game. He continued exploring until 1918.

THE *KARLUK*

ELEMENTS OF SURVIVAL

Knowledge 10%
Luck 30%
Kit 30%
Will to Live 30%

A little bit of everything, partly the result of the diverse parties involved. Their collective knowledge was surprisingly poor, as most crew members and scientific staff were there for one specific purpose. Add the Inuit, and the knowledge rating goes through the roof! Luck did not play too heavily into their survival, although bad luck certainly got in the way of Stefansson's return to the ship after his fateful hunting expedition. Although their kit was relatively poor (the product of Stefansson's disorganization), they still had a fair bit of food and supplies. Will to live was neither inspirational nor pathetic, and seemed largely reactive to circumstances as opposed to being focused and driven.

12
Bottom of the World

HE WAS THE POLAR WORLD'S MAN OF STEEL, A FIELD-HARDENED **EXPLORER** WHOSE ANTARCTIC EXPLOITS EARNED HIM WORLDWIDE RENOWN FOR HIS ENDURANCE, **TOUGHNESS**, AND LEADERSHIP ABILITIES. AND YET, THE NAME **DOUGLAS MAWSON** IS RECOGNIZED BY RELATIVELY FEW PEOPLE THESE DAYS. IT'S A SHAME, REALLY, FOR THE WAY MAWSON MANAGED TO SURVIVE IN THE FACE OF **DIRE** CIRCUMSTANCES FOR THREE **HELLISH** ANTARCTIC MONTHS IN **1912** IS ONE OF THE GREATEST SURVIVAL STORIES EVER TOLD AND A TESTIMONY TO THE ENDURING **WILL** TO LIVE.

An Australian geologist and dedicated scientist, Douglas Mawson first proved his mettle in the world's harshest climate as a member of Ernest Shackleton's *Nimrod* expedition in search of the South Pole between 1907 and 1909. A few years later, Mawson set out on an expedition of his own. The Australasian Antarctic Expedition of 1911–14 had a wide range of scientific and exploratory goals, the most significant of which was to chart two thousand miles of previously unvisited Antarctic coastline directly south of Australia.

As these things often go, Mawson's expedition encountered troubles almost from its start on December 2, 1911. The first goal of the expedition was to drop a party of men and establish a base at Macquarie Island, a windswept spot more than six hundred miles south of New Zealand. Mawson's team did this without incident in mid-December.

From Macquarie Island, Mawson planned to continue to a point on the Antarctic mainland called Cape Adare, more than two thousand miles south of Australia. There he would establish the first of several bases, from which he and his men would begin their westward exploration of the coastline. Yet, as their ship, the *Aurora*, drew closer to the Antarctic mainland in early January, it became apparent that the countless icebergs that peppered the water would prevent them from making land safely.

Day after day, the boat was driven westward, searching for a way through the maze of ice to shore. It was not until the *Aurora* was eight hundred miles west of Cape Adare that she finally found a suitable landing spot: a broad, rocky sweep of beach that Mawson named Commonwealth Bay. It was January 8, 1912.

It was a less-than-ideal location: there were a few flat stretches of land where the crew could build its huts, and everything else was encased in a tomb of ice like none Mawson had ever seen before in the Antarctic. But with the brief summer passing swiftly and no other options, Mawson decided it would have to suffice. He named the place Cape Denison.

That Mawson was forced to alter his original plans is a common theme among those who find themselves thrust into survival situations. He knew that the safest and most logical place to begin his expedition was Cape Adare, but the ice conspired against him and he was forced to Cape Denison. Situations such as this, where you are not able to stick to your well-conceived plans, often contribute to the downfall of otherwise well-organized expeditions and turn them into tests of endurance and survival.

In Mawson's case, Cape Denison itself did not create his survival situation, but it certainly didn't make exploring the surrounding coastline any easier. The area proved to be numbingly windy and brutally cold, even by Antarctic standards. As January faded into February, the incessant gales became so strong that anything not tied down was lost. The *average* wind speed for the year they spent at Cape Denison was fifty miles per hour, but regularly gusted to well over one hundred and sometimes even topped out at two hundred.

For the most part, life at the camp was busy. Mawson and his men undertook scientific investigations in a number of areas, including geology, cartography, meteorology, aurora, geomagnetism, and biology. Yet as fall rolled into the long, dark, cold days of winter, life sometimes proved boring and tedious for the men. But Mawson's sense of preparation was unparalleled, and he used his downtime wisely. He established rigid training regimens in preparation for the arduous sled journeys he and his men would undertake once spring finally arrived. It's something Captain Bartlett might have done with the crew of the *Karluk* to prepare for the ship being crushed in the ice.

In addition to participating in an exercise regimen, each man was trained to pack and unpack his sled in the dark, cold, and wind, and manage his equipment by feel and instinct. Mawson had them set and strike camp in the middle of blinding whiteouts and would often redesign equipment on the spot. Nothing was taken for granted; he was always looking ahead.

In early August, Mawson and two of his most trusted associates headed south to establish a supply depot for the sledging parties that would be fanning out across the land in the months to come. They struggled across the ice for five and a half miles into a blinding gale before finding a suitable place to dig an ice cave. The vertical shaft, replete with shelves and room to accommodate four sleeping men and a host of extra provisions, was named Aladdin's Cave. It would prove to be one of the most important things Mawson ever did in the tapestry of catastrophic events that would unfold months later.

As September rolled around, unusually calm weather allowed the men to break into several sledging parties, test equipment, and begin mapping of the rugged coastline. These sorties came to an abrupt halt when October's weather became unrelentingly fierce. Mawson was anxious. The Antarctic "summer" was exceedingly short, and any unforeseen delays would significantly hamper his crews' ability to map and complete the very task that had prompted the journey.

As November dawned, the weather showed no sign of abating, but Mawson was undaunted. He gathered his men around the mess table one evening and declared that the sledging parties would be leaving within a week, regardless of what Mother Nature might throw at them.

It is here that Mawson's tenacious personality, which would serve him exceedingly well through the ordeals he was yet to endure, caused him to make his first mistake. Mawson was an extremely ambitious man and simply couldn't accept defeat. So, even after experiencing the fury of the Antarctic weather for almost a year, the knowledge that the *Aurora* was coming back in mid-January forced him to decide that all the sledging teams would embark on their journeys in the next week, regardless of the weather.

In those final frenzied days before departure, the camp was abuzz with activity. Mawson meticulously counted out the trekking rations and weighed everything to the last ounce. This is not only an important bit of

knowledge to have (in case you end up in a survival situation), it is also reassuring to be that comfortable with your gear and your rations.

In total, Mawson sent out five separate sledging parties. The consummate leader, he handpicked each team's members according to their strengths and weaknesses. Three parties traveled to the east to map the coastline, one south to the magnetic pole, and one to the west. Mawson planned to lead what was likely the most treacherous trek of all: the Far Eastern trek, using three sledges and seventeen of the Greenland dogs they had kept since arriving at Cape Denison some ten months before.

On November 10, 1912, Mawson—along with Dr. Xavier Mertz and Lieutenant Belgrave E. S. Ninnis—set out. Although the wind and weather beat at them mercilessly, Mawson and his companions were tough, experienced antarctic travelers, and they made excellent progress during the early stages of their journey.

Their trip was aided by their collective ingenuity, as they made constant revisions to improve their gear. This ability to improvise—I call it MacGyverism, after the 1980s television character with an uncanny ability to instantly rig up a solution to a life-threatening problem—is an important skill in any wilderness situation, but it's paramount in a survival situation. There are times when you have to sacrifice one object to make it into another, more effective one. You also have to be aware of the risks the environment may throw at you and use your survival smarts to keep yourself alive. In Mawson's case, doing something as simple as tethering the sledge to his body kept him alive on more than one occasion.

Mawson kept his group on strict rations every day. He employed a food-consumption strategy he called "No work, no hoosh." The team members were prohibited from consuming large amounts of rich food on days when they were idle because of bad weather. Instead, these foods were saved for days when the men worked hard and expended lots of calories. It was a brilliant bit of rationing that kept the men strong and fit—and excited to work hard.

Yet Mawson also erred a bit when it came to food rationing. He insisted that he, Mertz, and Ninnis all receive the same amount of food at every meal, even though he was much bigger and stronger than his comrades. Whether Mawson ever actually considered his size and strength advantage over the other two remains a mystery, but I think he should

have accounted for it when doling out the food, just as I would do if I found myself in a survival situation with my kids. I believe Mawson short-changed himself when it came to food, which may have played a role in the neuralgia he later developed on the left side of his face and in his shoulder.

As November waned, the trio successfully navigated across the treacherous crevasses of the newly dubbed Mertz Glacier, though the glacier claimed its victims. They lost several dogs to various injuries and accidents along the way, and Ninnis was slowed by an acute case of snowblindness. The ever-ready Mawson knew just how to deal with such a setback, though, and inserted small tablets of cocaine and zinc sulfate under Ninnis's eyelids, leaving them there to dissolve and ease the burning. Mawson advised his

PREVENTING SNOWBLINDNESS

Snowblindness, also known as photokeratitis, is a serious concern in snowy terrain under most conditions, but is particularly acute on bright, sunny days. In essence, snowblindness is a sunburn on the cornea, caused when eyes are not well enough protected from the ultraviolet rays of the sun. Snowblindness causes an excruciating burning sensation in the eyes that can last as long as several days.

The best protection again snowblindness is protection from the sun's UV rays. Sunglasses and ski goggles work particularly well, though Mawson and his mates likely would not have been fortunate enough to have anything so civilized on hand. They would have had to become more creative.

Ultimately, anything that cuts down on the amount of light reaching the eyes will suffice. On a survival outing in the Arctic, I once cut strips of foam from a snowmobile seat cushion to make snow goggles. Traditionally, the Inuit carved snow goggles from caribou antlers.

Making snow goggles is not that difficult. You simply need to use something, anything, into which you can cut two small slits for your eyes, then incorporate a tying system so that it can be secured to your head.

friend to wear his dark goggles as often as possible, and to screw his eyelids nearly shut in those instances when it was necessary to remove the goggles.

Eventually, the Mertz Glacier fell behind them and progress picked up. But they now faced an even bigger challenge: the far riskier ridges and cracks of the so-called Ninnis Glacier. Progress amid what Mawson described as "rolling waves of ice" was maddeningly slow.

As if the deathly maze of ice ridges and yawning crevasses of the Ninnis Glacier wasn't enough, the trip was compounded by an infection that Ninnis had developed on the second finger of his right hand. Mawson was shocked to find one afternoon that the finger had swelled to nearly double its size and was turning a putrid combination of black and green. This was a huge judgment error on Ninnis's part, one that not only jeopardized his own well-being, but that of the entire expedition. In adventure racing—where, like exploration, your personal well-being is intricately interwoven with that of your teammates—you run the risk jeopardizing the entire race if you do not let your teammates know as soon as you begin to develop an injury, even something seemingly as minor as a blister. These types of things must always be group knowledge. It's nothing to be embarrassed

TREATING SEPTICEMIA

Infections are nothing to fool around with, especially in the middle of the Antarctic wilderness. If left untreated, any infection has the potential to lead to septicemia, also known as blood poisoning or bacteremia. Ninnis was lucky the infection in his finger didn't kill him. Had full-blown septicemia developed, it likely would have killed him.

Septicemia typically begins with a series of spiking fevers, which can be accompanied by chills, rapid breathing, and elevated heart rate. Symptoms progress to shock, falling blood pressure, disruptions in mental capacity, and the appearance of red spots on the skin. If left untreated, adult respiratory distress syndrome, septic shock, and death follow.

Septicemia is difficult to treat once it sets, so the best medicine is prevention by appropriately treating localized infections before they progress.

about; it's showing consideration for the team before the individual.

Mawson tried to reduce the swelling with a poultice, to no avail. By the next morning, Ninnis's pain had become unbearable. With life-threatening septicemia—the presence of bacteria in the blood—a real risk at this point, Mawson had no choice but to perform surgery. He sterilized his knife in the open flame of the Primus stove and sliced open the bulging digit. After the green-yellow pus finished spurting out, Mawson wrapped the finger in an iodine-soaked pad. It worked. Once the finger healed, Ninnis experienced no more trouble with it. It may be sobering to remember that all of this took place in the frigid temperatures of the Antarctic, with no running water, soap, or painkillers.

The group was still crossing the dizzying maze of crevasses and pressure ridges of the Ninnis Glacier in mid-December when Mertz, who had been traveling on skis, pointed out a snow bridge across a nearby crevasse. Mawson was riding on his sledge behind the dogs and made it across easily, his weight evenly distributed. Ninnis, however, was running beside his team of dogs. He had barely set foot on the snow bridge when it collapsed beneath him and he disappeared into the heart of the glacier, along with his sledge . . . and the dogs that were pulling it.

Mawson and Mertz rushed to the edge of the gaping chasm and stared into the abyss. On a narrow ledge some 150 feet below, they could see a dog, its back apparently broken from the fall. Beneath that was nothing but void.

Mertz and Mawson called into the depths for hours, but heard no response. As the reality of their comrade's death washed over them, they were faced with another, starker reality: Ninnis's sledge had been pulled by the six strongest dogs and had carried most of the team's indispensable supplies, including the tent and most of the food, and spare clothing. The remaining sledge had only ten days of rations for the two men, and absolutely nothing for the six dogs. They were 315 miles—and almost five weeks—from main base.

Ninnis's death is one of those bitter twists of fate that sometimes occurs in the wilderness and that seem particularly common among turn-of-the-century explorers. Mawson, Mertz, and Ninnis had seen themselves through weeks of trials and tribulations, were very close to their turnaround point, and were crossing a glacier as they had done dozens of times before. But this time, fate dealt them a deadly surprise.

Mertz was hysterical at Ninnis's death. Mawson was stricken, too, but tried to remain calm. With adversity staring him squarely in the face, his survival instincts now kicked into overdrive. Mawson allowed himself and Mertz time to grieve for Ninnis, but he never lost focus. He soon brought Mertz back to the task at hand and immediately set to sizing up the situation and devising a plan of action. Survival thinking in the face of deep grief is the toughest mindset of all.

Their equipment was spare, to say the least. They had the cook stove, some kerosene, and extra tent cover material. To make matters worse, they had not cached any food while they traveled west, since they had decided they would return to the main base by a different, easterly route.

In these dire circumstances, Mawson again demonstrated his innate leadership skills and began explaining to Mertz the difficult decisions that lay ahead. The worst? They would have to eat their beloved dogs, one by one, over the course of the return journey. Coming to grips with this reality was brutally difficult, but making these types of decisions is often the key to survival, and Mawson was not one to dance around a difficult choice. Making tough decisions ahead of time is equally critical in a survival situation, as it gives you purpose and focus. However you must make sure you don't rigidly stick to them in the face of newer (and better) information.

Their first destination was a spot some fourteen miles back, where they had dumped a sledge and some extraneous supplies a few days before. Mawson was fueled by a desperate sense of urgency to recover anything they could get their hands on, and surprisingly, he let that urgency get in the way of prudence . . . for a while. He had acted this way before, of course, when he ran out of patience at base camp and vowed to start the expedition no matter what the weather threw at them.

To make it back to the dump site as quickly as possible, he (on the sledge) and Mertz (on skis) rushed down any slope they encountered, with blatant disregard for the same risks that had taken Ninnis's life. And as surprised as I am that someone as dogged and meticulous as Mawson let his guard down so early in the return journey, I also understand why he did it. It was a classic example of how people in survival situations often throw their hands in the air and say, "Screw it," throw caution to the wind, and put themselves in greater danger by pushing too hard.

Mawson and Mertz made it back to the site safely, however, and picked up a few potentially useful items and disposed of everything else they deemed extraneous. From then on, Mawson became the Antarctic's version of MacGyver. He began improvising immediately. With no tent, they needed shelter against the brutal Antarctic wind, so he set about making one by cutting one of the wooden runners off the discarded sledge, sawing it in half, and lashing the two pieces to a pair of snowshoes, thus fashioning a rudimentary frame for their tent material. There was no food for the dogs, so Mawson again put his creativity and ingenuity to work, salvaging from the dump site two old wolfskin mitts, a pair of reindeer-skin boots, and a piece of rawhide strapping. Mawson carefully sliced each into pieces and fed them to the ravenous dogs. The gloves were, after all, just animal hide, and therefore completely edible.

Progress from the dump site was steady in the days that followed. But, without adequate food, the dogs weakened quickly. It wasn't long before the first one was unable to proceed. Mertz could not bring himself to do the deed, so Mawson shot old George through the head with his .22-caliber rifle. They fed part of George to the other dogs and saved the rest for themselves, but not before Mawson fashioned two spoons out of a piece of spare wood.

As resourceful as he was, Mawson made a serious mistake when shooting George. It would have been a better choice to suffocate the dog by simply kneeling on its chest, thereby preserving the nutrient-rich brain for him and Mertz to eat. Putting a bullet through George's brain removed that possibility—and wasted a bullet.

Mawson used the sacrifice of the first dog as an opportunity to realistically weigh his and Mertz's chance of survival. Always planning, he reduced their food intake from thirty-four to eight ounces per day, hoping that the dog meat would give them enough energy to complete the journey. They scorched the stringy meat in a pan and choked back the musty meal.

Not long thereafter, Mawson and Mertz dug into what they believed to be the choicest part of the dog: the liver. What Mawson didn't know was that the liver of the Greenland husky—just like those of polar bears and bearded seals—was capable of storing enormous quantities of vitamin A, in concentrations toxic to humans. So, with each bite Mawson and Mertz took of the dog liver, they were slowly poisoning themselves.

This was perhaps the most significant bit of bad luck to strike the two men on their long journey home. There is little evidence to show that hypervitaminosis had become public knowledge at that point in history. If it had, Mawson, one of the most meticulous and well-prepared explorers the world has ever seen, would certainly have known about it. Yet he didn't, and as a consequence, only one would survive the journey back to main base.

In the mind-numbing days to come, Mawson and Mertz fought their way back across the frozen landscape. Their compass was useless, so Mawson estimated their westerly path by the north-south alignment of the windblown ridges in the snow. As they traveled, they did what so many people do in desperate situations: they obsessed about food and made plans for their return. Mertz fantasized about butter, chocolate, and tea, all the while repulsed by the idea, and taste, of dog. Yet as torturous as it may seem to obsess about creature comforts in a survival situation, this kind of psychological exercise is vital to motivation. And motivation is a key element in the struggle to survive against all odds.

And so they trudged along. One by one, the dogs died off, their carcasses not much more than fur-clad skeletons. Eating their meat was like chewing leather; Mawson and Mertz looked forward only to the relative

HYPERVITAMINOSIS

Hypervitaminosis, also known as vitamin overdose, tends to result from an excess of fat-soluble vitamins, the sort that are stored in the liver and fatty tissues of the body. These vitamins, including the vitamin A that Mertz and Mawson were consuming in massive amounts, remain in the body far longer than water-soluble vitamins.

Both Mertz and Mawson began to demonstrate some of the classic symptoms of hypervitaminosis A, which would worsen as their journey back to base camp continued. These symptoms include blurred vision, headache, fatigue or dizziness, nausea and vomiting, loss of appetite, irritability, hair loss, skin that is yellowing, itching or peeling, and cracking at the corners of the mouth.

tenderness provided by each dog's liver, each bite of which brought them one step closer to the grave. Though he was certainly as repulsed by the taste of dog as Mertz was, Mawson remained undeterred. He did his best to use every bit of the animals, even boiling their paws into a thick soup.

A cheerless Christmas eventually arrived for Mawson, Mertz, and their lone remaining dog, Ginger. Mawson used the holiday as an opportunity to again assess their rations and their chance of survival. Their progress had been much slower than he originally expected, so rations were cut yet again. At this point, Mawson realized that if they were to have any chance of making it back to main base alive, they would have to lighten their load even more. Reluctantly, Mawson discarded some of the gear he held most precious: Ninnis's box camera and heavy glass plates, a host of heavy scientific instruments, the rifle and bullets. Finally, Mawson spent hours boiling down the remaining dog bones into a tasteless brew.

As much as I admire Mawson, I think he waited much too long to dump extraneous materials from the sledge. Until that point (when they had only one dog left) they were still were pulling a camera with glass plates, a rifle and bullets, scientific instruments, almanacs, and logbooks! There's only one reason why he would have made this choice: his overwhelming resolve, ambition, and dedication to science. But with 160 miles to go, it was a foolish ideal to hold on to.

A few days after Christmas, Ginger finally reached the point where she could proceed no longer. Mawson lovingly laid her on the sledge as she quivered with her remaining stores of energy, and actually pulled her for a few miles, by which time it became obvious she had walked her last. Mertz—whose own condition was rapidly worsening—could not bring himself to finish her off, so Mawson broke her neck with one quick swing of the spade.

That night, as they ate the boiled remains of Ginger's skull, a new sense of desperation and loneliness seemed to wash over both Mertz and Mawson. Mertz was in terrible physical shape, and in the coming days saw his strength fade to nearly nothing. Mawson took it upon himself to keep Mertz alive, and fed Mertz what he believed was the only nourishing thing he had left: dog liver. In the days to come, Mawson would give up all of his own rations of liver and feed them to Mertz. It was this act of self-sacrifice that ultimately might have kept Mawson alive. But it killed Mertz.

Mawson tried to coddle, urge, and cajole his fading companion into activity, but there was little left to be done for Mertz. At one point, when Mertz could walk no longer, Mawson placed his friend on the sledge, strapped himself into the harness and actually began pulling it *on all fours*. Mertz was unmoved by this act of kindness, but rather took offense at being hauled around like a dying dog. In an act of rage that evening, Mertz bit off his yellowed and frostbitten pinky finger and spit the severed digit onto the tent floor.

All through that dreadful night, Mertz alternated between moments of calm and fits of rage. Finally, near midnight, Mertz fell into a restless sleep; Mawson crawled into his bag and did the same. A few hours later, Mawson inexplicably awoke, troubled by the profound silence of the tent. He reached over to touch Mertz, and found him stiff, cold, lifeless. It was January 7, 1913. Mawson was one hundred miles from main base.

Yet as desperate as the situation may have been, Mawson was not one to turn his back on protocol. Recognizing his final duty to Mertz, Mawson spent several exhausting hours cutting snow blocks to make Mertz's burial cairn. Mawson placed Mertz, still in his reindeer-skin sleeping bag, into the cairn and read the burial service. It was a noble act, but in my mind it was foolish and unnecessary. Mertz's life was over, and Mawson had honored Mertz on every day of their journey together, particularly near the end of Mertz's life, when Mawson spent hours caring for him. Now Mertz was gone, and Mawson's only responsibility was to himself and those who cared for him back home, thousands of miles away. His sense of duty might have been appeased by the labor, but his own survival would have been compromised.

At a minimum, Mawson should have kept Mertz's reindeer-skin sleeping bag, either for food or warmth. And I don't know whether Mawson ever considered cannibalism—he doesn't allude to it in his writing—but eating Mertz, as inhuman and barbaric as that may seem, was certainly an option. But Mawson never touched his friend, instead choosing to occupy his mind—and time—with tasks such as repairing broken equipment and planning the weeks ahead. Mawson knew his chances were slim and was sorely tempted to lay down and rest until eternal sleep took him. But somewhere in the back of his mind, his will to live was not so easily muted.

Indeed, just when he was at his lowest, Mawson found motivation in the words of the famous poet Robert Service:

Buck up! Do your damndest and fight:
It's the plugging away that will win you the day.

Mawson himself was a great motivator, one who had often spoken of character. With Service's words ringing in his ears, he recalled the words he had spoken when discussing the men he had chosen to accompany him to Antarctica:

I have done my best to choose men of character. The important thing to look for in members of an expedition like this—is character. It is impossible to tell how men are going to act until circumstances arise. . . . In that land of desolation, in that land of great loneliness, there are conditions that measure a man at his true worth.

Back on track, Mawson rediscovered the resolve that made him legendary among polar explorers. He reassessed his situation, his needs, the equipment he had at his behest. He spent an entire day modifying his remaining gear for one-man travel. He cut down the sledge to carry a half-load, and even crafted a mast and sail for speedier travel should conditions permit. Mawson also wisely dedicated some time to doctoring his rotting body.

He planned the remaining journey with painstaking detail, and broke it down into palatable increments. This was another brilliant tactic: it's easier to think in small steps than the big picture when it comes to survival. He also dwelled over his food rations for the remainder of the trip. He calculated that he had enough food for twenty days. But he did not stop there. Mawson also considered that some of the food he carried required cooking, and would therefore be useless to him if the Primus stove broke. So he decided to eat all of that food during the first ten days, saving the remainder for the final half of the journey.

Mawson bade farewell to Mertz, slung the sledge harness over his skeletal shoulders, and continued his westward trudge. He was stabbed by pain with each step he took, yet he continued on. Later that first day, he

stopped to examine his feet and was horrified by the raw, weeping meat he found inside his socks. The entire bottom of one foot had come off, and he needed to wrap it back on to continue.

He spent some time doctoring his wounds and actually lay down to enjoy the feeling of the sunshine on his naked body, a brilliant move that not only bolstered his spirits, but probably did his body some good as well. There is an Indian guru, Hira Ratan Manek, who claims he can live for years at a time without eating, deriving all his energy from the sun. Mawson should have started his sunbathing weeks earlier; in the frigid polar world, sun on exposed skin is like manna from heaven. He would continue the practice in the weeks to come.

Such opportunities were few, however, as blizzard-like conditions ensued and slowed Mawson's progress to a crawl. He was stuck in his tent for days at a time as the wind tore across the land. Mawson was frantic, and vowed to continue on despite the weather. Yet he had the wherewithal to harness himself firmly to the sledge he pulled behind him, a safety precaution as he entered the deadly maze of the Mertz Glacier. Mawson hoped that if he fell into a crevasse, the weight of the sledge would be enough to prevent him from plummeting to his death.

On January 17, he was still picking his way across the glacier when he twice stopped just short of yawning crevasses. Soon thereafter, he fell into a crevasse to his knees. He clambered out and walked north to where he believed the crevasse stopped, where he again turned to the west.

In an instant, the ground collapsed beneath his feet and Mawson was flung downward. A second later, the harness yanked violently at his midsection and he came to a painfully sharp stop. He was now dangling inside a bottomless chasm, with the rope around his waist as the only thing holding him back from certain death. Yet as he hung there, he could feel himself dropping slowly as the sledge above was pulled across the snow toward the crevasse that now held him captive. He knew what was to come: the sledge would break through the snow and tumble into the crevasse, and his life would end. Miraculously, though, the movement stopped. The sledge had become stuck on a pressure ridge. Mawson hung there, fourteen feet from the surface, sheer walls of ice three feet on either side of him, pondering his fate.

Steeling himself against the pain, Mawson pulled his skeletal frame up the rope, hand over hand, until he reached the edge of the snow bridge. He was crawling to safety—mere feet from solid ice—when the bridge collapsed again, and he again plummeted the full length of the rope toward his death. Once more, the sledge above held. Mawson considered suicide as he dangled there. A swipe of his knife on the rope and all his suffering would come to a swift end. His hands were raw and bloodied, his energy was draining fast, and he was deathly cold in the icy tomb. Yet Douglas Mawson was not one to give up, no matter how grim the circumstances.

With superhuman effort, he resolved to try one more time while he still had the energy to do so. Although he was never able to recall how he mustered the strength, Mawson pulled himself hand over hand up the rope and to the Antarctic daylight, and flung himself in one desperate move to the safety of the ice, where he collapsed, exhausted but alive.

By this point, Mawson had come to fervently believe that a spiritual presence was with him, guiding him through the trials of the Antarctic spring. As he fumbled to set up his camp for the night, he thanked providence for sparing him. From that day forward, Mawson believed the spirit was always there, moving with him across the snow and ice back to main base.

The timing could not have been better, for Mawson hit a new low in the hours after the fall into the Black Crevasse. He was trapped in a maze of crevasses, the light was gray and flat, making visibility poor even just a few feet in front of him, and the incessant wind had wiped out all evidence of where one opening stopped and another began.

Undaunted, Mawson made another modification that would save his life several times over. He realized that one wrong stride in any direction could send him to his death, especially given the deplorable condition his hands were now in: he was physically unable to pull himself up along the rope again. So he spent the better part of a day fashioning a rope ladder and using it to connect himself to the sledge he was pulling. It was yet another in a litany of brilliant moves Mawson pulled off during the journey, and illustrates his near-obsessive focus on survival, which would ultimately save his life.

Mawson tied one end of the rope ladder to the front of the sledge, draped the other over his shoulder and set out the next morning. It was not long before his handiwork paid off: he broke through a snow bridge and fell into another crevasse. Luckily, the sledge once again held firm on the surface, and Mawson was able to climb up his handmade ladder to safety. A few steps later, he fell into another one, but climbed his lifeline to safety yet again.

He picked his way across the glacier, partly emboldened by the success of the rope ladder. He walked across snow bridges and maneuvered around yawning crevasses, always drawing nearer to safety. Days later, he finally made it across.

Still, the fickle Antarctic weather worked against him. The wind blew incessantly, slowing Mawson's progress to a crawl. He was stopped for days at a time as blizzards pounded his meager shelter. He also had to battle the icy slopes of the hills that formed the headland between the Mertz Glacier and Cape Denison. He struggled up and down, always hampered by the wind, which cut his visibility to nearly nothing.

And though his spirits continued to sink, Mawson tried to tend to his physical needs as best he could. When he undressed to examine himself, he was shocked at his corpse-like appearance. All of his muscles had withered to nothing. His fingernails had blackened; most had fallen off. His teeth had become loose in their sockets, his hair was falling out in clumps, and there were wide patches of raw skin all over his body. He realized that he might be suffering from scurvy, a disease caused by a deficiency of vitamin C, but refused to entertain the thought because he needed to keep both hope—and the will to live—alive.

Mawson's tending to his wounds and injuries was a critical activity, especially when his morale was at its lowest. It gave him a focus and a purpose on those long days when he could do little else. Most important, it filled him with hope that he would survive. For why bother if there is no hope?

The weather finally lifted on January 28, and Mawson continued to trudge ahead. He had about two pounds of food left, but was encouraged by the knowledge that Aladdin's Cave could not be far off. He steeled himself for a final push to that little bit of underground paradise. He would make it there . . . or die trying.

Hypervitaminosis may not have been on Mawson's radar, but every arctic explorer worth his salt was well versed in the dangers of scurvy, that dreaded illness that had caused the downfall of so many men who sought fame and fortune at sea.

Scurvy is caused by an acute deficiency of vitamin C, an important element in maintaining the health of the body's connective tissues. Take away the vitamin C, and the ability of these tissues to bind deteriorates, causing a series of telltale signs and symptoms: weakness; lethargy; irritability; purple, spongy, and bleeding gums; loosening teeth; reopening of healed scars; and hemorrhaging in the mucous membranes and skin. Advanced cases of scurvy are characterized by open, festering wounds and loss of teeth.

In Mawson's day, scurvy killed countless sailors and explorers who had little access to perishable fruits and vegetables while at sea. The disease is said to have killed more British sailors in the seventeenth century than did enemy action, and it is often cited as one of the primary factors behind the deaths of John Franklin and his men during their tragic search for the Northwest Passage in the mid-1800s. Yet for all those who died from scurvy, it's remarkably easy to treat. Full recovery requires little more than the resumption of normal vitamin C intake.

The next day, Mawson spotted a dark smudge on the horizon, an unexpected bit of color against the white backdrop. Mawson made for the spot, where he found a rock cairn. It had been built by three of his men—McLean, Hodgeman, and Hurley, who had been out searching for Mawson and his men at that very same time. They had missed each other by only a few hours! Inside the cairn was a note and food.

The note told Mawson that he was twenty-one miles from Aladdin's Cave, the other parties had returned safely from their sledging journeys, and the *Aurora* was anchored in Commonwealth Bay. Mawson knew there was no conceivable way he could catch up with his friends, so he focused on the food in the bag: tins of pemmican, butter, sugar, cookies, cocoa, chocolate sticks—even three oranges. For the first time in weeks,

Mawson was sure he would survive. But Mother Nature was not through with him yet.

The cairn helps illustrate that in a survival situation, luck is always a fickle bedfellow. She may be there to help you, such as when Mawson found the cairn and the food, but she'll also abandon you at the worst possible times, as when Mawson realized that his three comrades had camped the previous night just five miles from where he had set his patchwork tent, but he still had no chance of catching them.

Mawson struggled onward toward Aladdin's Cave, though he lost his bearing on several occasions, once coming dangerously close to plummeting off a cliff. He cursed himself for having discarded his crampons days before in an attempt to lighten his load, as his progress across the ice was maddeningly slow. He probed his fertile mind for a way to solve the problem of slipping on the polished, windblown surface, and (of course!) devised a solution. In a fit of sheer MacGyver genius, he pried apart the mahogany case that held his theodolite—a navigation tool—cut wooden sandals for his boots, and hammered nails from the box through the sandals to project downward.

Though they were far from perfect (the nail heads were often driven upward into the soles of his raw and rotting feet), the makeshift crampons helped Mawson across the crevassed fields. On more than one occasion, he fell through the ice, only to have the sledge again save his life. He continued in much the same way until the evening of February 1, when he made it to Aladdin's Cave! For the first time in almost three months, he would sleep without the incessant flapping of the windblown tent walls around him.

Although it was really not much more than a vertical shaft cut into the ice, Aladdin's Cave was heaven for Mawson. The cave seemed to have been hurriedly used by the other teams, but the provisions scattered around the floor seemed like a royal banquet to the starving explorer. Here he found cookies and pemmican, milk powder, and cocoa tins.

But Mawson was not satisfied with making it to Aladdin's Cave. It was home base, a mere five and a half miles away, that he desperately sought. He searched the cave for a pair of crampons he had left there months before, hoping they would help him down the icy slopes that separated him from his destination. They were nowhere to be found,

however, and Mawson's notion of a quick meal and final dash to the base went with them. He decided he would spend one more night at Aladdin's Cave, rest up, and return triumphantly the next day. Or so he thought.

As luck would have it, the Antarctic wind kicked in with renewed fury that night. Mawson made frequent trips to the entrance of the cave, only to find that the winds had not abated. Dejected but not dispirited, he took advantage of the time to work on his makeshift crampons and eat. Yet the food seemed to do Mawson no good at all. Instead, he seemed to sink to his lowest physical state while in the cave. Whether it was the effects of the hypervitaminosis, scurvy, the stale food in the cave, or simply the toll of the previous three months, we'll never know, but Mawson became depressed and angry as the storm raged overhead. If ever there was a "so close and yet so far" situation, this was it.

For seven eternal nights, Douglas Mawson was trapped in that cave—a hellish week of dejection, loneliness, and illness. Then, on the eighth morning, Mawson awoke to find the wind and snow had abated to the point where he thought he could risk the trip to camp. Come what may, he told himself, today was his last day. He picked his way down the treacherous slope, the sledge still trailing behind. Eventually, the waters of Commonwealth Bay opened before him. Beyond it, he could see the *Aurora*, sailing westward. With that sight, Mawson knew that he may well have to spend another year at the camp by himself, but he was sure he would live.

The camp soon came into view, and Mawson was dejected to see no sign of activity anywhere, not even a plume of smoke from the huts' stovepipes. He was a mile and a half from deliverance, but the weight of his predicament almost dropped him to his knees. Then, when all hope seemed lost, he spotted three figures near the shore.

Mawson waved his glove and called to his friends with a weakened voice. After what seemed like an eternity, one of them looked in his direction. Seconds later, the three men were abuzz with activity, shouting, waving, and running in his direction. Salvation at last! It was Mawson's friend Bickerton who reached him first. Bickerton lifted the skeletal figure of Mawson onto the sledge, looked into his eyes, and burst out: "My God! Which one are you?"

The *Aurora* was recalled by wireless communication, but bad weather and ice conditions prevented the ship from coming to shore. Mawson

and the six men who had stayed behind to search for him faced the terrible reality of their situation: they would have to spend one more year in their small hut at Cape Denison before the ship would be able to make it through the ice pack during the Antarctic summer, reach land, and return them to Australia. In hindsight, it was likely the best thing that could have happened to Mawson. At the main base, he could at least spend as much time resting as he needed to heal himself; a long, rough ship voyage may well have killed him.

Though they seemed interminable to Mawson, the next ten months were spent in the relative comfort of the main base. The men were well stocked with supplies, and Mawson even made a sledge journey the following spring. The *Aurora* returned in December 1913 to pick up Mawson and his men. Moved by the image of the wild Antarctic landscape as the ship pulled away, Mawson made the final entry in the diary he had kept for more than two years in that accursed land:

> We bring no store in ingots
> Of spice or precious stones
> But what we have gathered
> With sweat and aching bones.

Late in February of 1914, Mawson and his mates set foot on Australian soil once again, more than two years after they first landed at Commonwealth Bay. Mawson was still pale, shaky, thin, and hairless—but alive.

DOUGLAS MAWSON

ELEMENTS OF SURVIVAL

Knowledge 30%
Luck 0%
Kit 10%
Will to Live 60%

If someone could add up to more than 100 percent, it would be Mawson. His knowledge was exceptional; there were few people on the planet who knew as much about cold-weather survival as did Mawson. His kit was inadequate, yet only because most of his supplies fell into the glacier with Ninnis. However, Mawson would have survived even if he had had no knowledge and no kit, so strong was his will to live.

EPILOGUE

Ninety percent of survival is said to be in the head. Yet the majority of suffering is felt in the skin—blistered, raw, bleeding skin.

While working on this book, I was also producing my new TV series, *Les Stroud Beyond Survival*, which focuses on the cultural and land-based survival of various indigenous peoples around the globe. During the writing of the *Karluk* story, I happened to be in Canada's high Arctic, hunting, fishing, and traveling on a frozen landscape with the Inuit. With the hard-learned stories of the *Karluk* still fresh in my mind, I organized my trip with an eye toward survival.

Although I had been reassured that my food, supplies, and all other pertinent necessities required for traveling in the Arctic would be taken care of, I decided to look after myself. In no way did I intend to insult my guides or undermine their own careful plans. But in reality, I still had to consider the worst-case scenario. What if their supplies were inadequate? What if they were injured or suffered a heart or appendicitis attack?

We were some 150 miles—a solid twenty-four-hour snowmobile ride at high speeds, through fairly unforgiving territory—from safety; temperatures were frigid. It was no slight to anybody for me to make sure I had my own survival covered. In fact, it kept me from being a potential liability should something go seriously wrong. This is the survival mindset.

In going through the ordeals articulated in these pages, a new reality has become clear to me: luck plays a more important role than I originally thought. When the will to live is weak and giving up a constant consideration, luck can be the one factor that turns things around, perhaps even leading to salvation. When the will to live is strong but the circumstances seem almost impossible to overcome, luck can provide relief and further open the door to rescue. When physical suffering is nearly unbearable and suicide seems like to only form of relief, luck can offer enough respite so that pushing through the pain becomes a viable option. And when the survival gear is scant and largely useless, luck can provide the tools to turn the situation around. For some, good fortune takes the form of a gift—the turtles the Robertsons used as food. Others make their own luck, as Mawson did when he built his rope ladder.

So, just how much of survival boils down to luck? Better yet, how much of survival is in the hands of fate herself? It's a powerful debate, but only one of myriad questions we can ask about survival ordeals. Was there really a guiding spirit that assisted so many of those who claimed its presence during their ordeals? Or were these simply the hallucinations of malnourished victims in desperate situations?

Equally fascinating is the role individual personalities play in survival. Juxtapose Mawson's powerful leadership with the pathetic squabbling of the *Karluk*'s crew. Consider the unbending will to live and passion of people like Yossi and Nando with the near-apathetic acceptance of circumstances by the Stolpas.

Knowledge, luck, kit, and will are the four additive elements of survival. Yet the scorecard doesn't end there. Add to these personality, fitness, ability to obsess over details, ability to forget the details and focus on the big picture, ability to MacGyver otherwise useless items into more useful things, humor, imagination, ability to endure physical suffering (that's a big one), ability to find motivation in emotions, and finally, intelligence. These are the many variables of survival. And there are likely even more.

Tell us that someone has a strong will to live, and we respond with a yawn. But listen to tales of Mawson wrapping the bottoms of his skinless soles back onto his feet and climbing out of deep crevasses in bone-numbing temperatures, and you jolt to attention. When Yossi was impaled in the anus while slipping down a muddy slope; when Jennifer Stolpa had

the presence of mind to drizzle precious ounces of water from her mouth into baby Clayton's; or when a group of Uruguayan rugby players looked on as parts of their dead teammates were slowly being revealed by melting snow . . . these are the stories of survival's final ten percent, stories that make me wince and shift uneasily in my chair.

That's where most of us tend to live these kinds of exploits—from our chairs. And that's how it should be. These stories aren't adventures, they're horrific ordeals. Many people lost their lives, others were scarred for life.

It's too easy to judge someone else's plight while sitting comfortably in our own homes. Why didn't they just . . . ? Why wouldn't they just . . . ? But if there is one thing I have learned about wilderness survival, adventure, and life in general, it's that there is no such thing as "just" doing something. The struggle to survive is a harrowing ordeal, a nightmare of monstrous proportions. Problems and challenges that, from our comfortable vantage point, have obvious solutions, can be insurmountable obstacles when you are really there. With that in mind, I can't ever truly say what any of the victims in this book did was right or wrong. They did what they had to, and nobody will ever understand that unless they go through the same thing.

I am often asked where the toughest place to survive is. But that's too general a question. Was it any tougher for Yossi in the jungle than it was for Mawson in the Antarctic? Did the Robertsons have it better than the Stolpas because they were in the tropics? Did Chris McCandless have an easier go of things than Nando Parrado? Can I—who have *voluntarily* placed myself in multi-day survival situations—even dare to relate to the intensely painful, soul-wrenching experiences of the people in this book? I doubt it. My perspective stems from the practical. My comparisons come from years of studying and practicing survival. But these people, for all their right and wrong choices, their strengths and weaknesses, their intelligence and idiocy, actually suffered through *real* survival ordeals. Most survived. And that's the fundamental difference.

Ten years from now, I could rewrite this book with a completely different set of stories. For as long as there are humans on this planet, we will find ourselves venturing into the remote wilderness. And even though the advent of technology like SPOT devices makes it much more difficult

to get truly lost, accidents will still happen, people will still be unprepared, and common sense will still be ignored. And so, we will continue to find ourselves falling into experiences we wouldn't wish on our worst enemies.

And when that happens, I hope we have, if nothing else, the will to live.

FURTHER READING

Bartlett, Robert A. *The Last Voyage of the Karluk, Flagship of Vilhjalmar Stefansson's Canadian Arctic Expedition of 1913–16, as Related by Her Master, Robert A. Bartlett, and Here Set Down by Ralph T. Hale.* Boston: Small, Maynard, 1916.

Bickel, Lennard. *Mawson's Will: The Greatest Polar Survival Story Ever Written.* South Royalton, Vt.: Steerforth Press, 1977, 2000.

Bredeson, Carmen. *After the Last Dog Died: The True-Life, Hair-Raising Adventure of Douglas Mawson and His 1912 Antarctic Expedition.* Washington, D.C.: National Geographic, 2003.

Ghinsberg, Yossi. *Back from Tuichi: The Harrowing Life-and-Death Story of Survival in the Amazon Rainforest.* Translated by Yael Politis and Stanley Young. New York: Random House, 1993.
———. *Lost in the Jungle: A Harrowing True Story of Survival.* New York: Sky horse Publishing, 2009.

Golden, Frank, and Michael Tipton. *Essentials of Sea Survival.* Champaign, IL.: Human Kinetics, 2002.

Kamler, Kenneth. *Surviving the Extremes: A Doctor's Journey to the Limits of Human Endurance.* New York, N.Y.: St. Martin's, 2004.

Krakauer, Jon. *Into the Wild.* New York: Anchor, 1996, 1997.

Logan, Richard. *Alone: Orphaned on the Ocean.* Green Bay, Wisc.: TitleTown Publishing, 2010.

Mawson, Douglas. *The Home of the Blizzard: A True Story of Antarctic Survival.* New York: St. Martin's Press, 1915, 1998.

McKinlay, William Laird. *Karluk: The Great Untold Story of Arctic Exploration.* London: Weidenfeld and Nicolson, 1976.

Niven, Jennnifer. *The Ice Master: The Doomed 1913 Voyage of the Karluk.* New York: Hyperion, 2000.

Parrado, Nando, with Vince Rause. *Miracle in the Andes: 72 Days on the Mountain and My Long Trek Home.* New York: Three Rivers Press, 2006.

Read, Piers Paul. *Alive: The Story of the Andes Survivors.* New York: Avon Books, 1974.

Robertson, Dougal. *Survive the Savage Sea.* Dobbs Ferry, N.Y.: Sheridan House, 1973, 1994.

Robertson, Douglas. *The Last Voyage of the Lucette.* Dobbs Ferry, N.Y.: Sheridan House, 2005.

ACKNOWLEDGEMENTS

I promised my publisher that my schedule would allow me much more time to concentrate on this book, free from the crazy time frame I dealt with when we published my first book, *Survive!* Of course, that wasn't the case; while writing this book I traveled around the globe ten times in eight months filming for my series *Les Stroud: Beyond Survival.* So, once again my good friend and ghostwriter Mike Vlessides came to my rescue, researching all of these stories with me, and helping me put together what you have in your hands. Once again, Mike, I couldn't have done this without you. In addition, Laura Bombier not only provided most of the photos for this book but also gave me the kick in the ass when I needed it to keep working and keep writing, just as she did for *Survive!*

I didn't take on all these stories on my own; I was blessed to have my survival cronies Doug Getgood, Fred Rowe, and Dave Arama throw in their thoughts on my perspectives on the various stories. Wes Werbowy, another extremely competent survival expert, who recently saved his own life by punching a massive polar bear in the nose, chimed in with some good advice. The author of *Alone*, Richard Logan, was gracious, too, in looking over my manuscript, as was one of the men of the hour, Yossi Ghinsberg, whose incredible tale is captured in this book as well as in his own. My

legal team of Rick Broadhead and Dave Dembroski fought hard as always to keep the deal real, and without them, getting this whole thing to start would have been a frustrating exercise.

Behind me, as always, is my wonderful office team of Wendy Turner, Kate Heming, Yvonne Crawford, Dawn Lawless, and Brian Brewster, and just downstairs from them my incredible post team of Barry Farrell, Andrew Sheppard, Max Attwood, Andy Peterson, Graeme Fraser, John Pyke, Ryan Welcher, and my sis, Laura Mugridge. Trudging along all around the world was the brilliant field team for the new series: Dan Reynolds, Johnny Askwith, Peter Esteves, Brett Rogers, and Barry Clark (my paramedic for both *Survivorman* and *Beyond Survival*).

Thank you to Dave and Andrea Beatty for watching over my house. Thanks go out to my former teachers, John and Geri McPherson of Randolf, Kansas. Thanks to Mom and thanks to my brother, Bob Wilson, who inspires me. As always, a big thank you to my cousin, partner, and good friend, Peter Dale, who set me on this path with some great guidance and a bit of cash too!

For fans of my work and viewers of my shows, thank you for the constant encouragement and reassurance—I do read my Facebook page and I do get your messages. They keep me going. Please support Solid Rock Foundation of Phoenix, Arizona, and War Child in Toronto.

Thanks to Brad Wilson and Noelle Zitzer of HarperCollins, which is once again a most gracious, understanding, and helpful publisher—I look forward to another six books!

Raylan and Logan, I love you now and forever—you are my reason for living. Love, Dad.